Paul,

Thank you for
being a part of our
2008-2009 Fall Planning
Conference.

Asheville, NC

Chattanooga Metro AFO
Chattanooga Lookout AFO
Johnson City AFO

HISTORIC PHOTOS OF
CHATTANOOGA

TEXT AND CAPTIONS BY WILLIAM F. HULL

Turner®
Publishing Company

Nashville, Tennessee • Paducah, Kentucky

View of downtown Chattanooga from the north side of the Tennessee River, known as Hill City. The two-story building to the right is the Hill City Post Office on Frazier Avenue. Directly behind it stands the Walnut Street bridge. In the center background the large building with the smokestack is the Chattanooga Brewery; to its left stands the distinctive tower of St. Paul's Episcopal Church. Photograph by W. H. Stokes (ca. 1896)

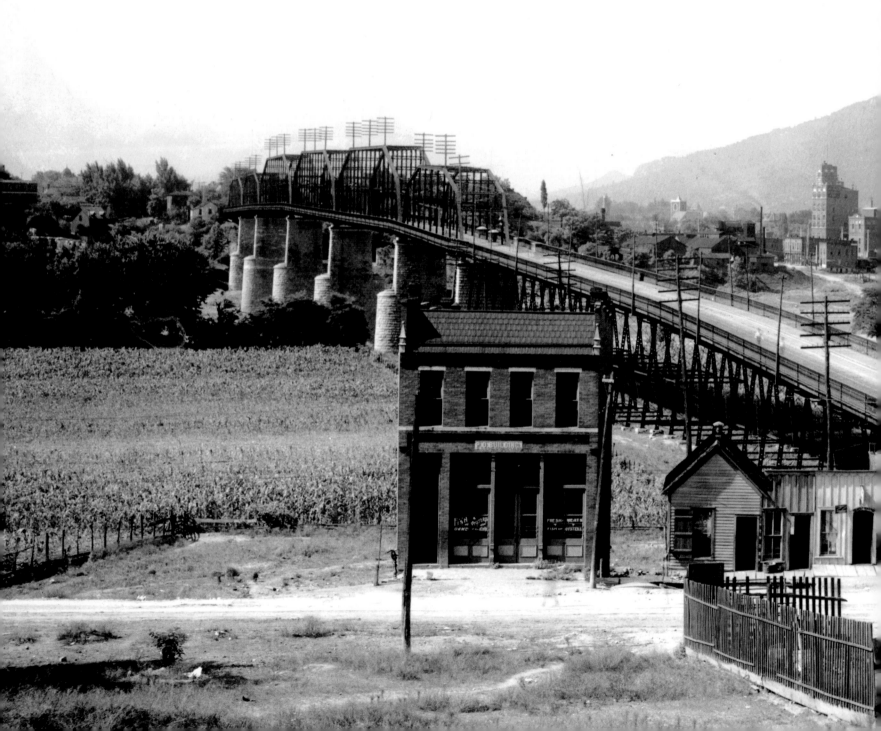

HISTORIC PHOTOS OF
CHATTANOOGA

Turner Publishing Company
200 4th Avenue North • Suite 950 412 Broadway • P. O. Box 3101
Nashville, Tennessee 37219 Paducah, Kentucky 42002-3101
(615) 255-2665 (270) 443-0121

www.turnerpublishing.com

Library of Congress Control Number: 2006902318
ISBN: 1-59652-246-1

Printed in the United States of America

0 9 8 7 6 5 4 3 2

Contents

A cannon at Point Park on Lookout Mountain is a
silent reminder of the great struggle that took place in
Chattanooga during the American Civil War.

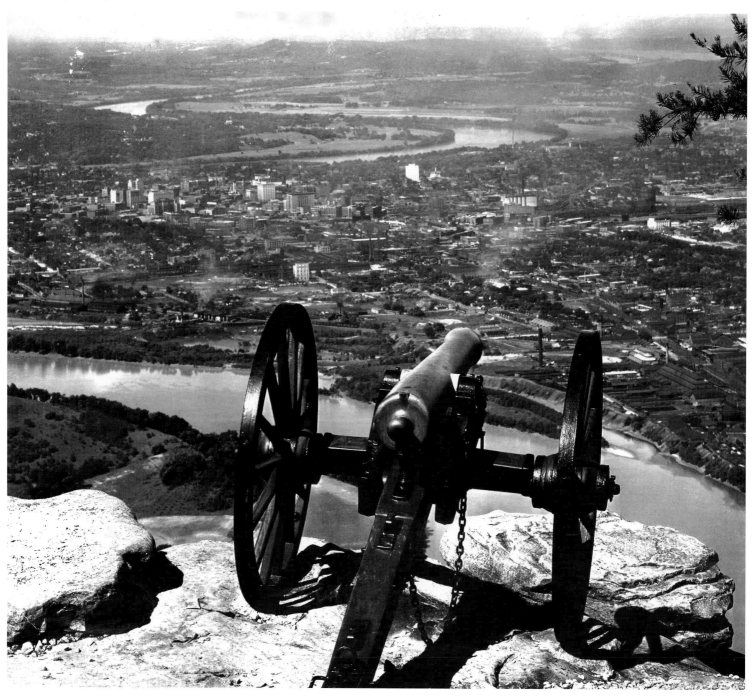

Acknowledgments

This volume, *Historic Photos of Chattanooga,* is the result of the cooperation and efforts of many individuals, organizations, institutions, and corporations. It is with great thanks that we acknowledge the valuable contribution of the following for their generous support.

Erlanger Medical Center
Chambliss, Bahner & Stophel, P.C.
Miller & Martin, PLLC

Chattanooga Fire Department
Chattanooga–Hamilton County Bicentennial Library—Local History and Genealogy Department
Chattanooga Regional History Museum
Tennessee American Water
Tennessee State Library and Archives

We would also like to express our gratitude to Karen Myrick for providing research, assisting the author, and contributing in all ways possible.

And finally, we would like to thank the following individuals for their valuable contribution and assistance in making this work possible:

Mrs. Earl E. Millwood, daughter of the late Paul Heiner
Bruce Garner, Chattanooga Fire Department
Randall Herron, Chattanooga Fire Department
Jim Reece, Chattanooga–Hamilton County Bicentennial Library
Karina McDaniel, Tennessee State Library and Archives

PREFACE

Chattanooga has thousands of historic photographs that reside in archives, both locally and nationally. This book began with the observation that, while those photographs are of great interest to many, they are not easily accessible. During a time when Chattanooga is looking ahead and evaluating its future course, many people are asking, "How do we treat the past?" These decisions affect every aspect of the city—architecture, public spaces, commerce, tourism, recreation, and infrastructure—and these, in turn, affect the way that people live their lives. This book seeks to provide easy access to a valuable, objective look into Chattanooga's history.

The power of photographic images is that they are less subjective in their treatment of history. While the photographer can make decisions regarding what subject matter to capture and some limited variation in its presentation, photographs do not provide the breadth of interpretation that text does. For this reason, they provide an original, untainted perspective that allows the viewer to interpret and observe.

This project represents countless hours of research and review. The researchers and author have reviewed thousands of photographs in numerous archives. We greatly appreciate the generous assistance of the archivists listed in the acknowledgments of this work, without whom this project could not have been completed.

The goal in publishing this work is to provide broader access to a set of extraordinary photographs that seek to inspire, provide perspective, and evoke insight that might assist people who are responsible for determining Chattanooga's future. In addition, the book seeks to preserve the past with adequate respect and reverence.

The photographs selected have been reproduced in black and white to provide depth to the images. With the exception of touching up imperfections caused by the damage of time, no other changes have been made. The focus and clarity of many images is limited to the technology and the ability of the photographer at the time they were taken.

The work is divided into eras. Beginning with some of the earliest known photographs of Chattanooga, the first section

records photographs from the Civil War through the end of the nineteenth century. The second section spans the beginning of the twentieth century to World War I. Section Three moves from World War I to World War II. Finally, Section Four covers World War II to the 1970s.

In each of these sections we have made an effort to capture various aspects of life through our selection of photographs. People, commerce, transportation, infrastructure, religious institutions, educational institutions, and scenes of natural beauty have been included to provide a broad perspective.

We encourage readers to reflect as they walk through the streets of downtown, along the riverfront, or atop Lookout Mountain. Cannons were once positioned around the city, riverboats once lined the banks of the Tennessee, and many buildings, long since demolished, stood where newer buildings of the late twentieth century stand today. It is the publisher's hope that in utilizing this work, longtime residents will learn something new and that new residents will gain a perspective on where Chattanooga has been, so that each can contribute to its future.

Todd Bottorff, Publisher

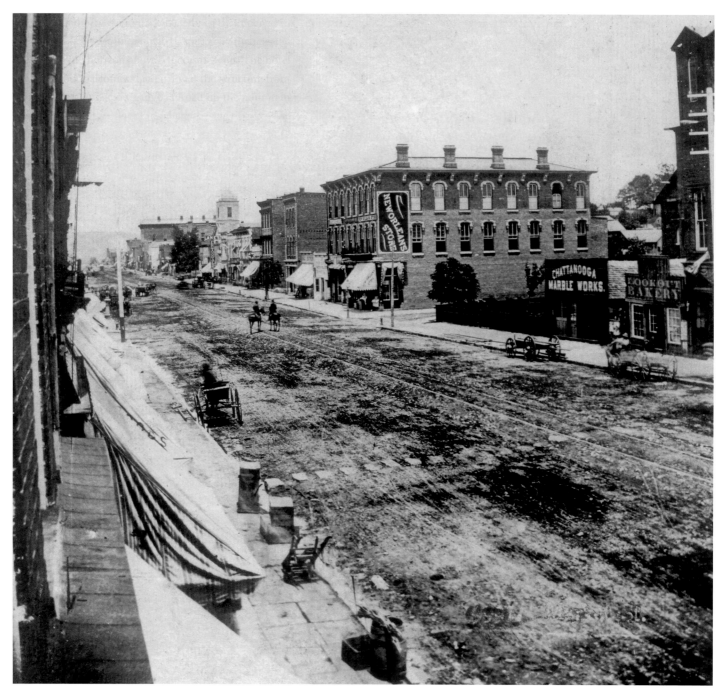

Ten years after the end of the Civil War, Market Street has been rebuilt. Lovemans Department Store will be built at the corner of Market and 8th streets where the marble yard stands. The steeple in the distance on the right side of the street belongs to the First Presbyterian Church. (1875)

Pre–Civil War to the Centennial

1860–1900

Forty years after the Declaration of Independence was proclaimed, a ferry was established on the banks of the Tennessee River at what would be known as Ross's Landing. Put in place by John Ross, the future principal chief of the Cherokee Nation, the city of Chattanooga was born; but, in 1838 the Cherokee were removed from their homeland on the tragic Trail of Tears. Settlers moved in, and by the 1850s the town was already served by three railroads. In a short time Chattanooga had become so important that Union generals would feel compelled to march on the city if the South was to be subjugated.

The year 1863 saw that event come to fruition in a monumental clash at nearby Chickamauga, which sent shattered federal troops streaming into Chattanooga to be hemmed in by Braxton Bragg's Confederate army. Desperate to break out, the Union armies, under General Ulysses S. Grant, would confront the rebel armies and drive them back into Georgia.

Chattanooga was converted into a supply and production center for the remainder of the war, and fed the avaricious Sherman as he split Georgia and marched to the sea. Once the war was over, some Chattanoogans returned to slowly rebuild their city. Still others, who had come to the city in blue uniforms during the war, returned to buy the rolling mills and other factories built here by the U.S. Army. By the 1870s, they would start Chattanooga on its way to becoming a Southern industrial center.

Chattanoogans were embracing change as well. In 1882, the miracle of electric lights thrilled the growing town when 26 lights were lit one evening on a downtown street. By 1888, the town was booming: factories and foundries were humming, neighborhoods were taking shape, trolley lines had become common, and a proposal to construct a major bridge across the unruly Tennessee River was on its way to becoming a reality.

By the end of the century the river port was busy. The town was the county seat of Hamilton County. Chattanooga had a fine newspaper, the *Chattanooga Times,* founded by Adolph Ochs, a man who would eventually control the *New York Times*. The Chickamauga-Chattanooga National Military Park was dedicated. And two rail inclines now scaled Lookout Mountain, where two hotels allowed visitors to view the natural beauty of the town in the valley below.

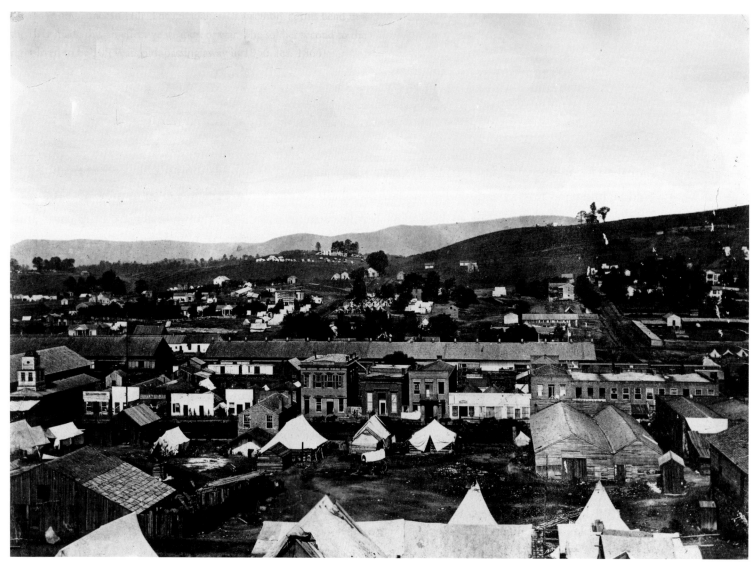

Wartime view of Chattanooga looking west toward Cameron Hill. Building at far left with the bell tower is City Hall, located on Market Street. Flag draped on Kennedy-Nottingham house in far background indicates that the body of General McPherson, killed in the Battle of Atlanta, lies in state there. (July 1864)

The Bluff Furnace was built under the ambitious guidance of ironmaster Robert Cravens. Completed in 1854, it was the first operation in the southern Appalachians to use coke to fire the foundry operations. When the Civil War began, parts of the operation were shipped to Alabama. Union engineers would salvage some of the remaining material to build a supply bridge across the river near the bluff. (ca. 1858)

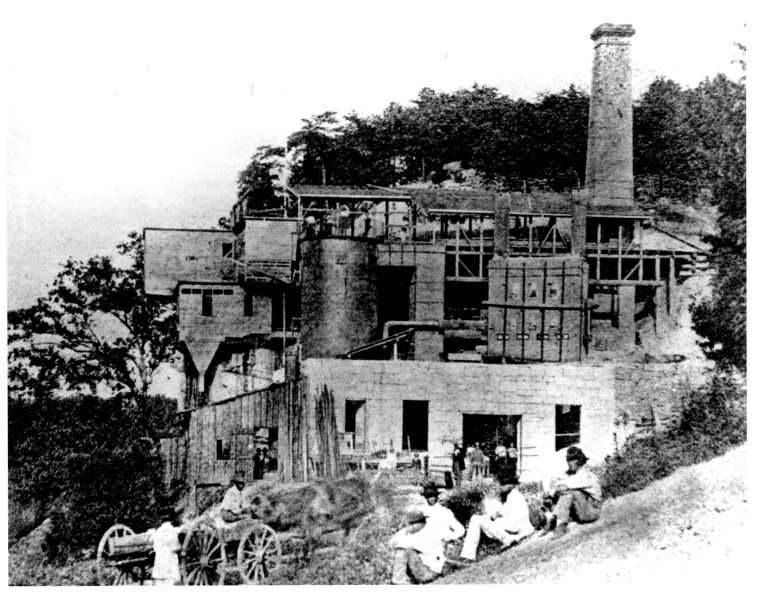

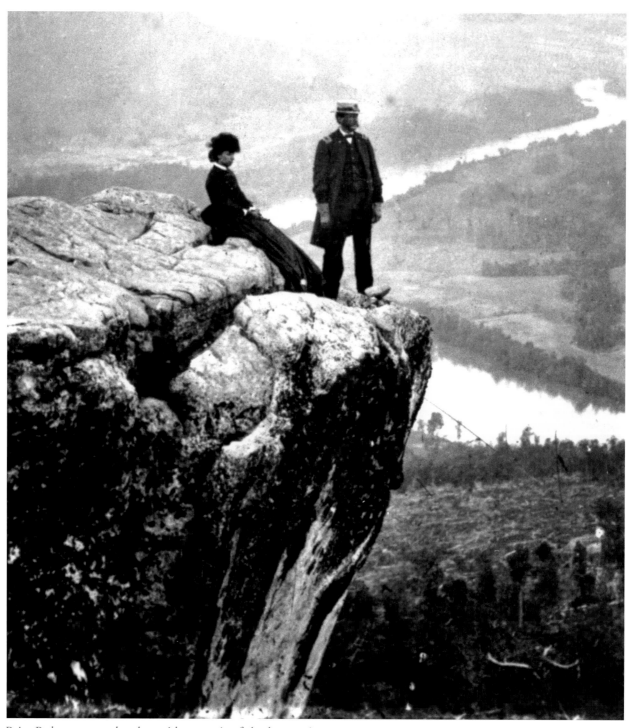

Point Park was a popular place with occupying federal troops in Chattanooga. An officer and a lady view the valley below with the Tennessee River in the background. (ca. 1864)

View of Chattanooga under Union occupation looking southwest with Lookout Mountain in the background. Church at left-center is First Presbyterian, which was shelled by Union artillery during a special service. Behind the church sits the long Western and Atlantic train shed. The locomotive station was situated across from the Crutchfield House on what was formerly Ninth Street. (1864)

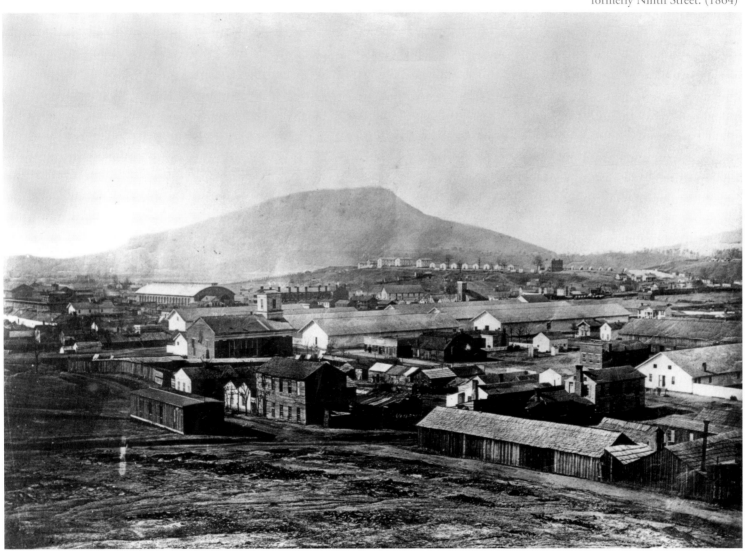

Navigating the rapids of the Tennessee River could be treacherous.
Here huge ropes "warp" or draw a vessel safely through "The Suck."
(ca. 1863)

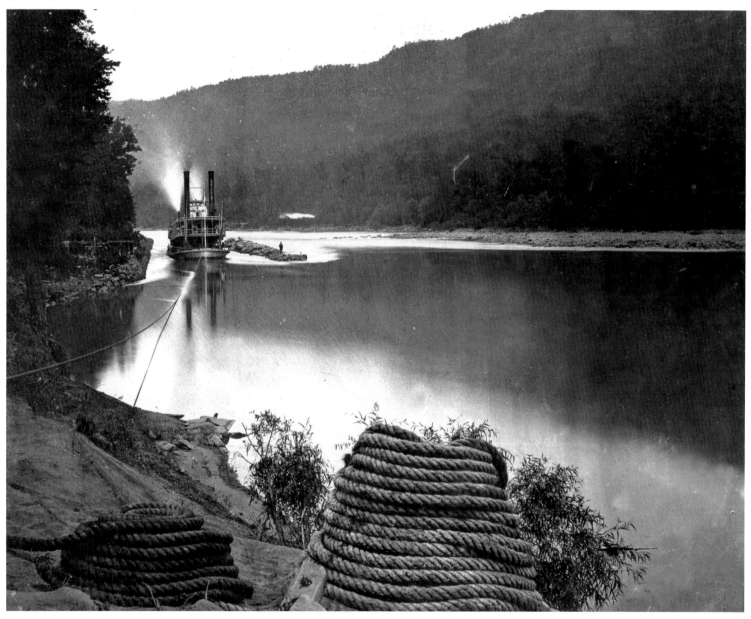

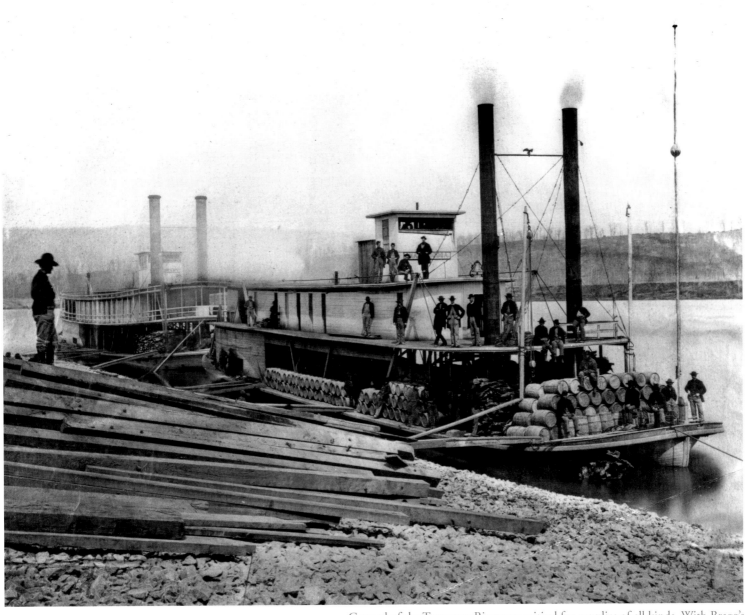

Control of the Tennessee River was critical for supplies of all kinds. With Bragg's army driven off Lookout Mountain, the waterway was clear for steamers like the *Chattanooga* and *Missionary* to bring food and materials to the Union army. By 1864 as goods came into the city, Chattanooga became a giant supply depot for Sherman's march into Georgia. (1864)

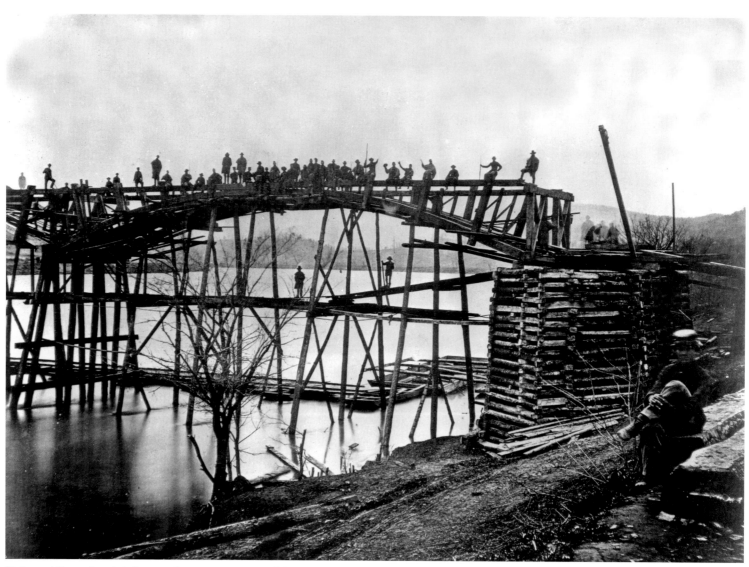

Union soldiers take a brief respite from construction of the Meigs Military Bridge. Spanning the Tennessee River near the present-day Market Street Bridge, the wooden bridge was torn from its moorings in the flood of 1867. The use of lumber for building projects by the United States Army Engineers left Chattanooga treeless and barren-looking.

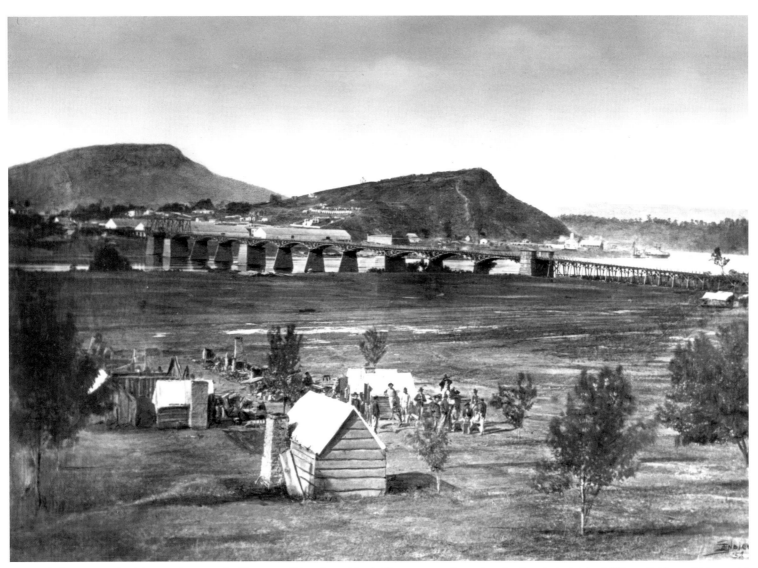

View of Chattanooga looking south across the Tennessee River from North Chattanooga. Spanning the river is the Meigs Military Bridge, which would remain until a raging flood in 1867 swept it away. Troop encampments are visible in the foreground of the photograph; Cameron Hill stands in the center; Lookout Mountain is in the background to the left.

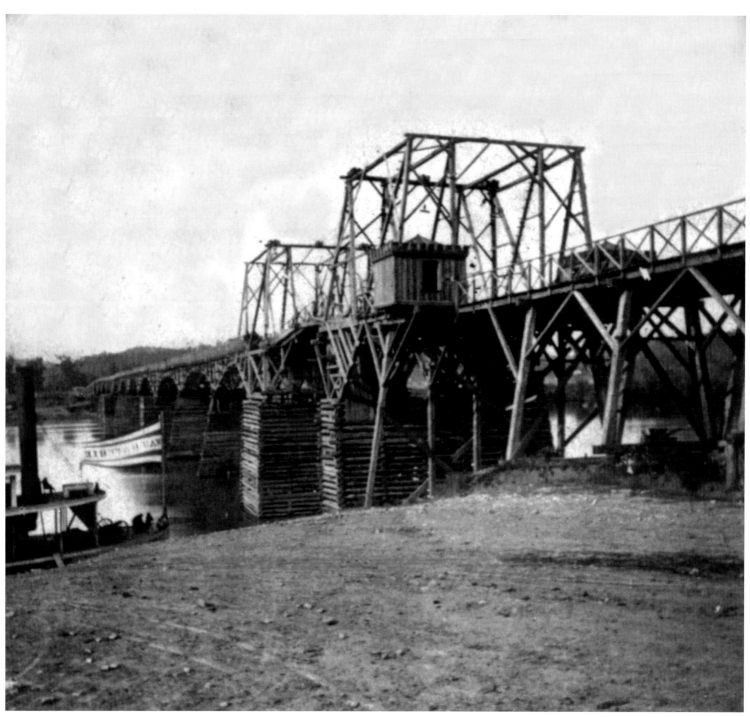

South end of the Meigs Military Bridge at Ross's Landing. This end of the
structure served as a drawbridge for taller steamboats. (ca. 1864)

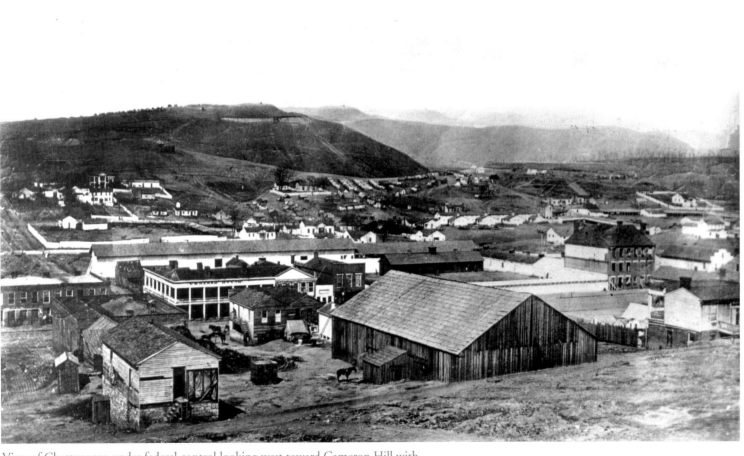

View of Chattanooga under federal control looking west toward Cameron Hill with
Raccoon Mountain in the background. Columned building at center-left is the Central
House at the corner of Market and 5th streets. Long white building behind it is a newly
built military warehouse; still farther back is a large fenced military corral. (1864)

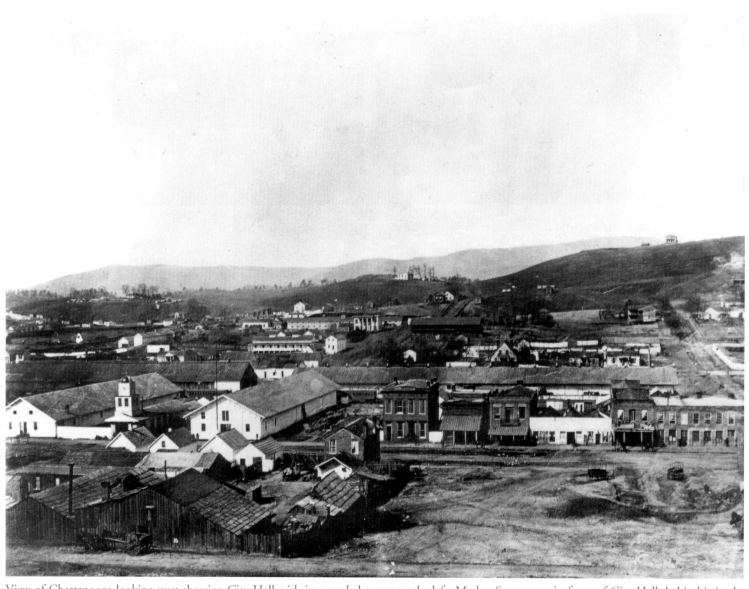

View of Chattanooga looking west showing City Hall with its rounded tower, to the left. Market Street runs in front of City Hall; behind it in the distance stands the columned Kennedy-Nottingham House. (1864)

Major General Joseph Hooker and his staff at their headquarters in Lookout Valley at the foot of Lookout Mountain. This scene from the winter of 1863 to 1864 presents them in camp after his troops had stormed the mountain in the famous "Battle Above the Clouds" and driven the Confederate forces back toward Georgia. (1864)

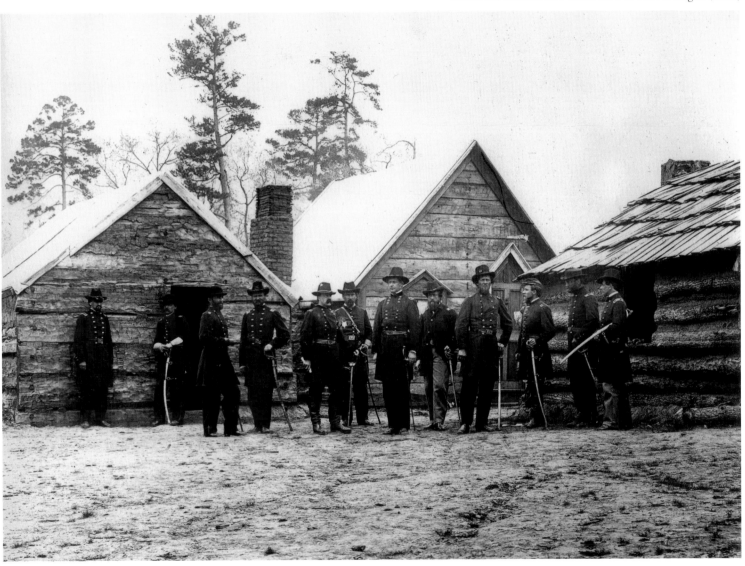

With Lookout Mountain looming in the background, a group of federal soldiers stands proudly with a two-hundred-pound cannon at Battery Coolidge on Cameron Hill. The circular track assembly at this bend in the river made this an effective weapon of war. The soldier second to the right lived to be 109 years old, passing away in 1956. (ca. 1864)

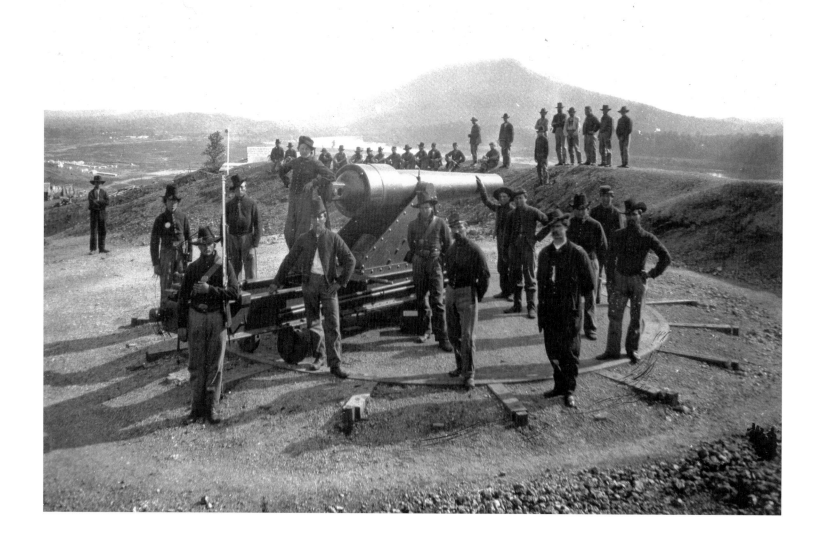

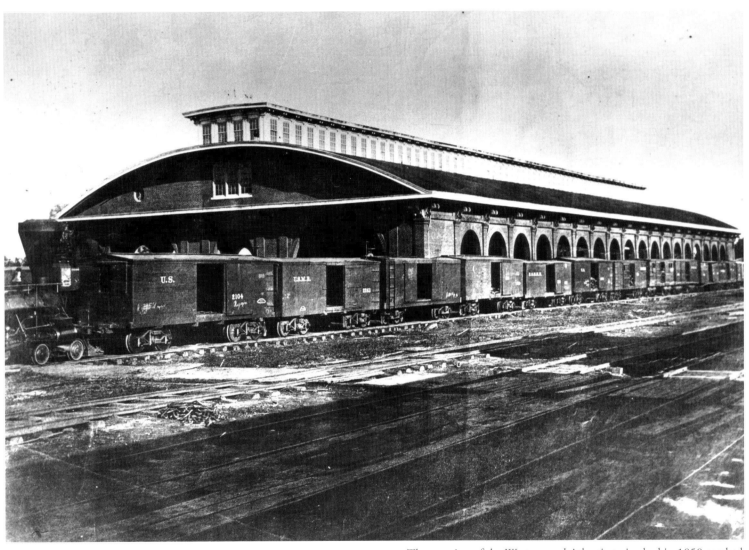

The opening of the Western and Atlantic train shed in 1858 marked
Chattanooga as a major rail center. The shed, which faced the Crutchfield
House, was three hundred feet long, one hundred feet wide, and served three
railroads at that time. Following the fighting at Stones River and Chickamauga,
it was filled with the wounded and the dying for days.

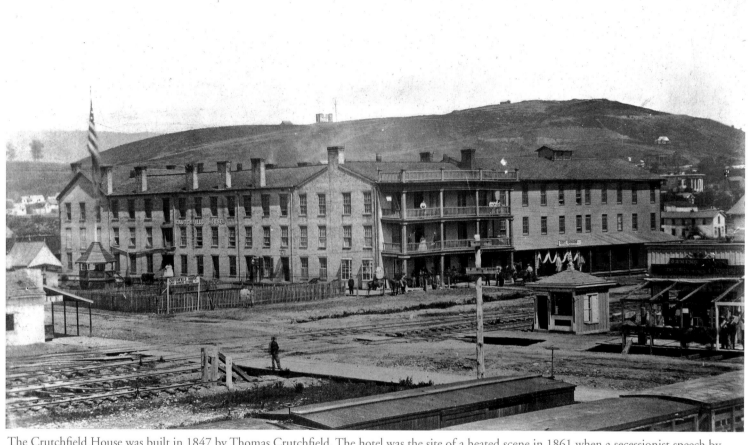

The Crutchfield House was built in 1847 by Thomas Crutchfield. The hotel was the site of a heated scene in 1861 when a secessionist speech by Jefferson Davis touched off political passions. The hotel burned in 1867 and was replaced by the Read House. (ca. 1865)

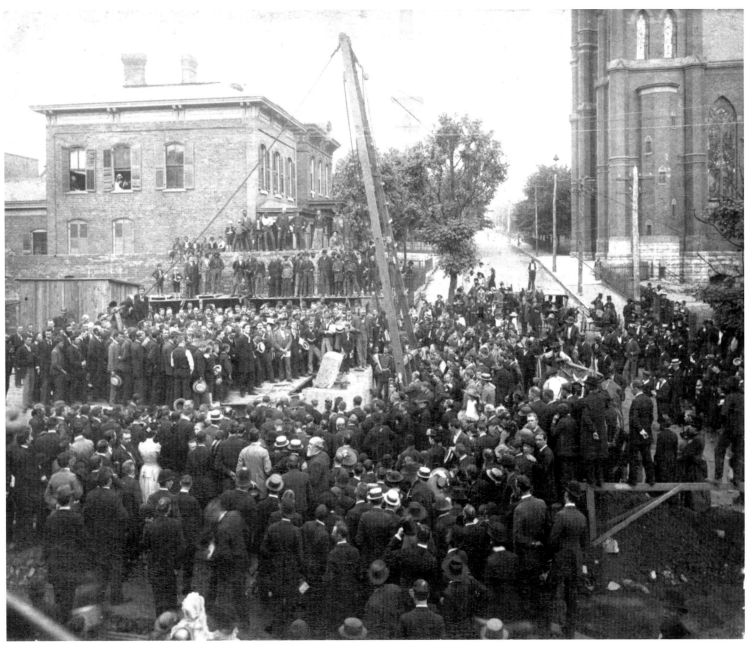

When Adolph Ochs purchased the *Chattanooga Times* in 1878, it was a struggling newspaper. By 1891 he was successful enough to finance his own building to publish the paper. Here a crowd gathers at Georgia and 8th streets to witness the laying of the cornerstone of the Dome building. (1891)

Legendary journalist Adolph Ochs began his successful career in Chattanooga by taking control of a small newspaper, the *Chattanooga Times,* in 1878 when he was only twenty. One of Chattanooga's most active community citizens, he created a journal of excellence that would eventually lead him to become owner and publisher of the *New York Times* in 1896. (ca. 1878)

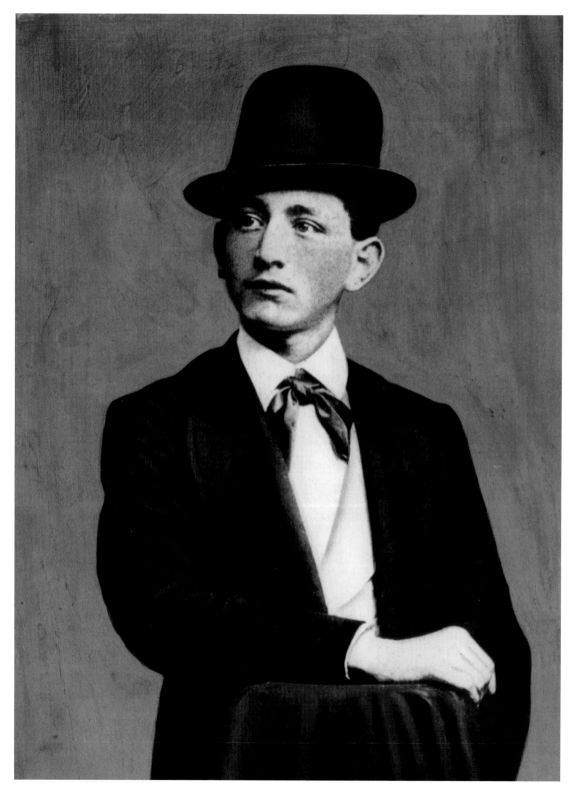

Soldiers stand outside the Lookout Mountain headquarters of General Joe Hooker during the Civil War. Located near the present-day intersection of Scenic Highway and Hermitage Road, the establishment was known as the Cottage Home Hotel. (1864)

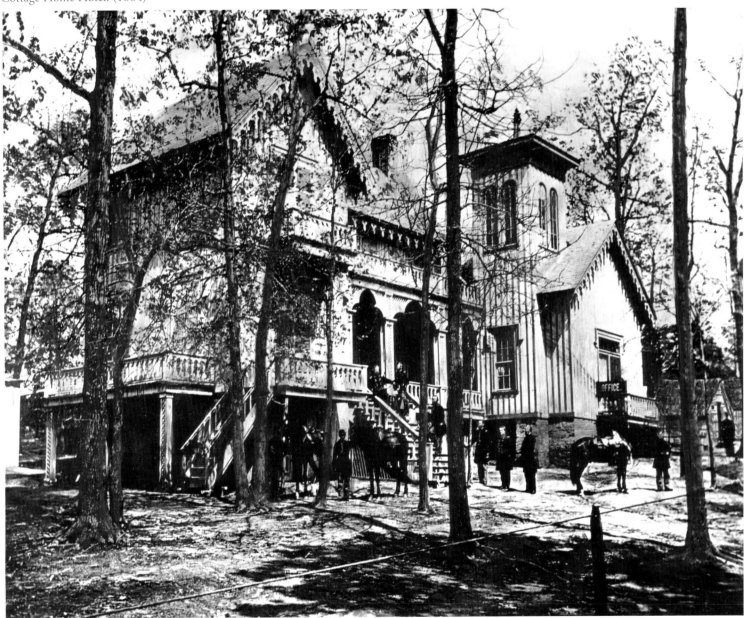

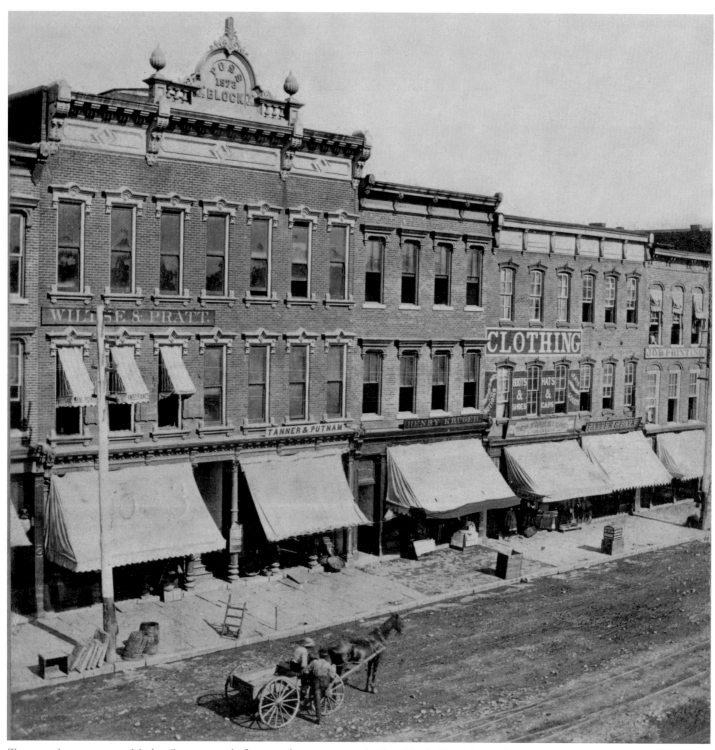

Two men in a wagon on Market Street pause before merchant stores on the Poss Block. Note the track to the lower right. Chattanooga had established a horse-drawn trolley line in 1875. (ca. 1880)

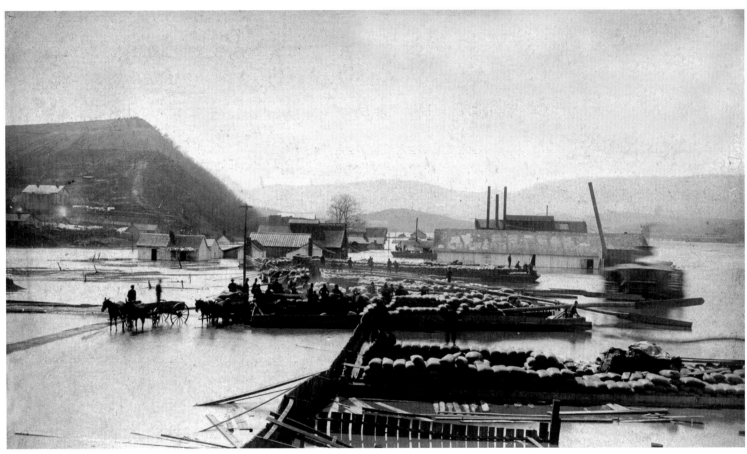

The flood of 1886 was one of Chattanooga's worst disasters on record.
This view shows the flooding at Ross's Landing with Cameron Hill
in the background. Floods were a constant problem, especially for
downtown Chattanooga. (1886)

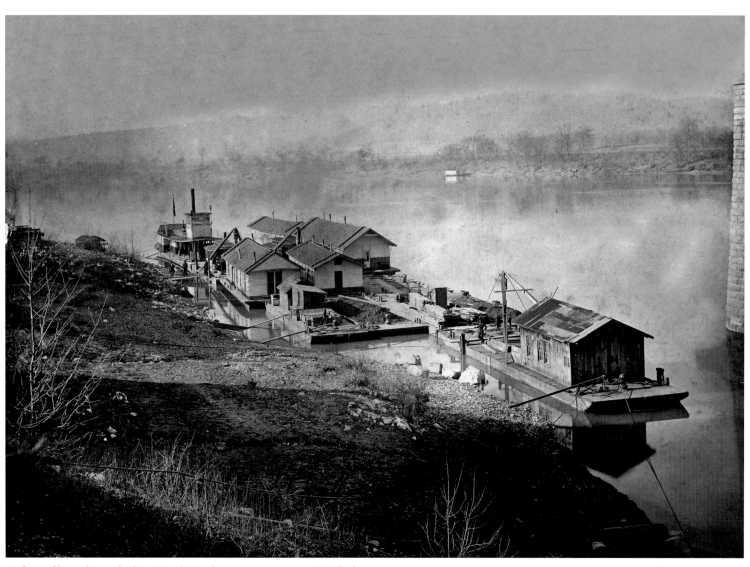

A fleet of houseboats docks at Ross's Landing in January 1897. With the *Stephen H. Long* in the rear the group appears to be headed upstream. Notice the stone pillar of the Walnut Street Bridge to the extreme right.

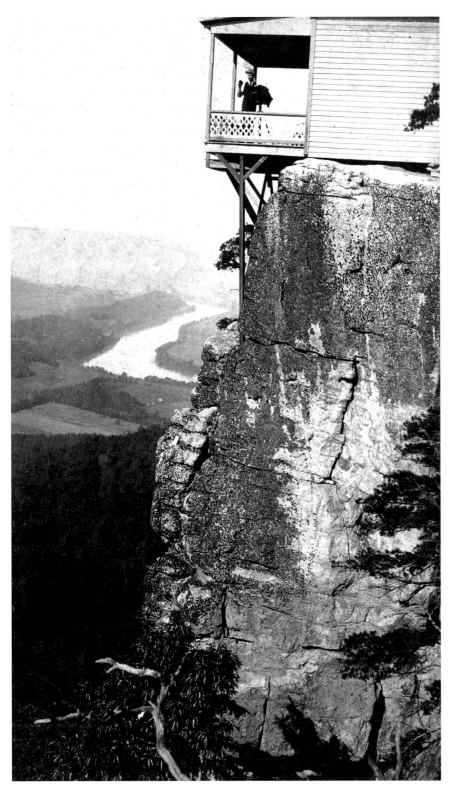

In an era before aviation, photographers sought high ground for captivating views. Here the artist makes an exposure with his view camera looking westward over the valley from his "photographer's perch" at Sunset Rock. Photograph by the Hardie Brothers (ca. 1895)

The Point Hotel was a remarkable edifice that opened in 1888 on Lookout Mountain with a spectacular panorama across the horizon above Moccasin Bend. The hotel featured four balconies that enclosed the structure from east to west. A narrow gauge railroad up the mountain brought visitors to its doorstep where they were treated to guest rooms each with its own bath. In 1902, President Teddy Roosevelt was one such visitor. Photograph by the Hardie Brothers (ca. 1895)

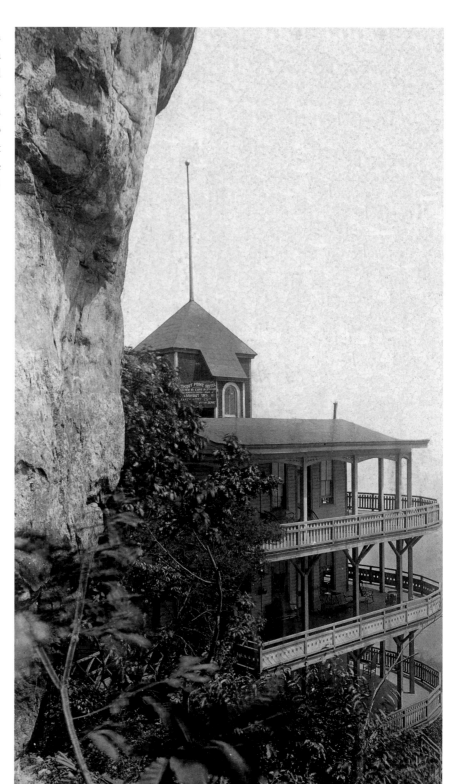

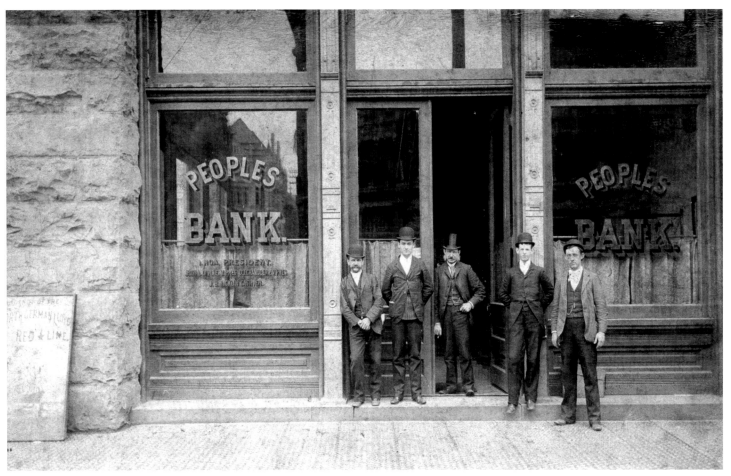

The Peoples Bank opened in 1887 amid an economic boom in Chattanooga Bank president, Ismar Noa, is easily identifiable in the center with his mutton chops and top hat. (1890)

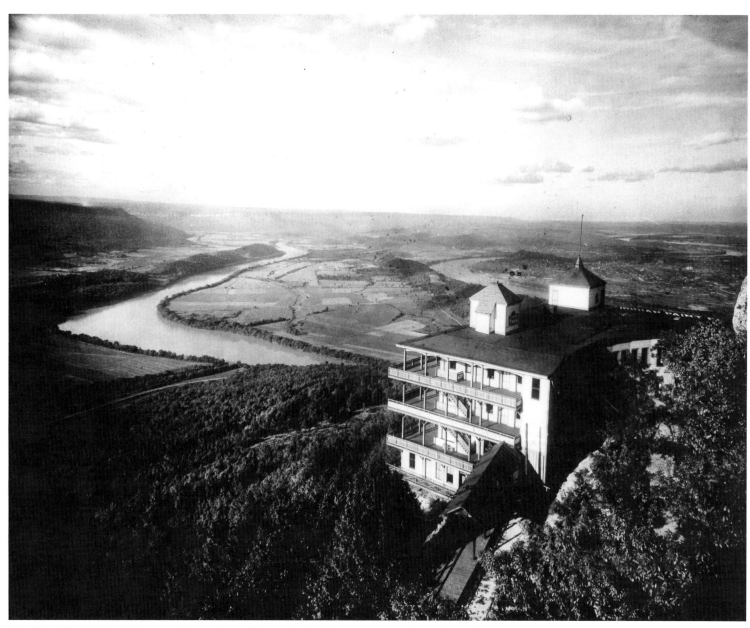

The Point Hotel offered this magnificent view of Moccasin Bend from Point Lookout. Opened in 1887, it was served by a narrow gauge railway. Visible on the roof of the hotel are the words "Iridian Paint Co." Photograph by W. H. Stokes (ca. 1895)

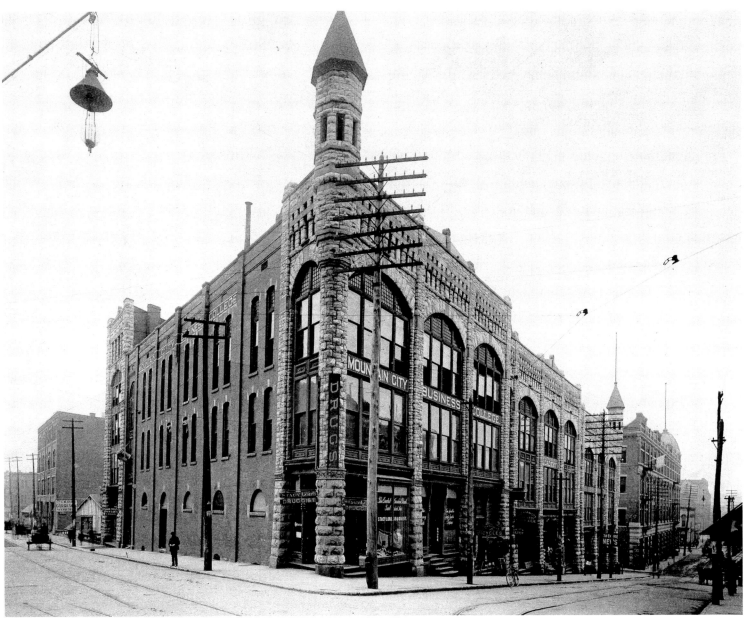

View of the Adams Block, built by John Wesley Adams in 1881, at the corner of Georgia Avenue and 8th streets. The striking tower and elaborate stonework stood for one hundred years, before it was demolished in 1980.

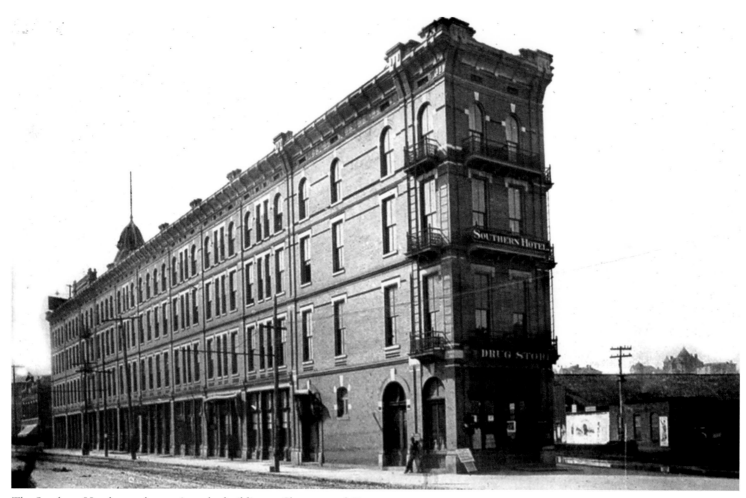

The Southern Hotel was a long, triangular building at Chestnut and Carter streets
near the Union Depot. Constructed as the Palace Hotel in 1887, it was taken down
in 1972 along with the rail depot. (1895)

The Stanton House was a handsome hotel built in 1871, shortly after the Civil War ended. Bostonian John C. Stanton was a carpetbagger who hoped to make the hotel a stop on a railway that he backed. In 1906 it was removed to make way for the Terminal Station, today a hotel known as the Chattanooga Choo-Choo. (1895)

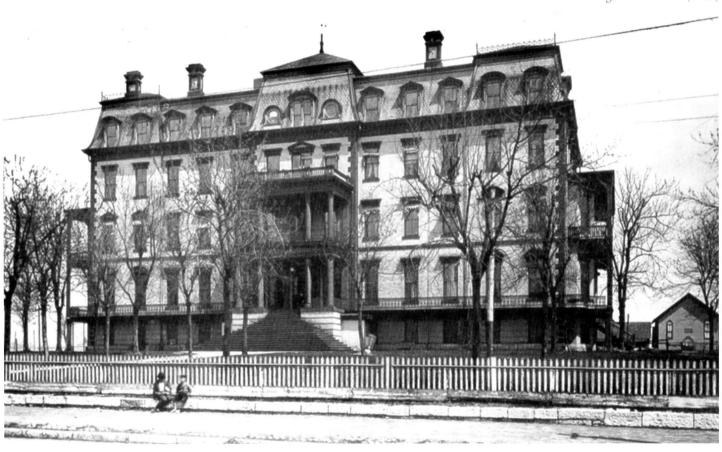

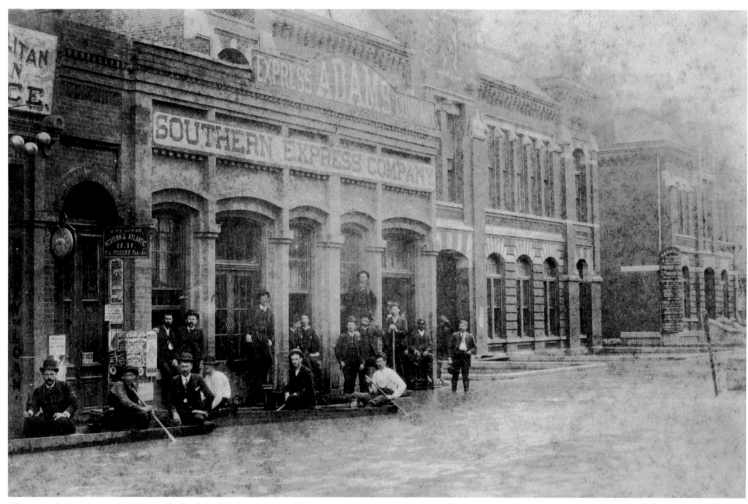

The unruly Tennessee River regularly flooded downtown Chattanooga for decades. Across from the Read House, some employees of the Adams Express Company maneuver the waters on skiffs, biding their time until the waters recede. (1886)

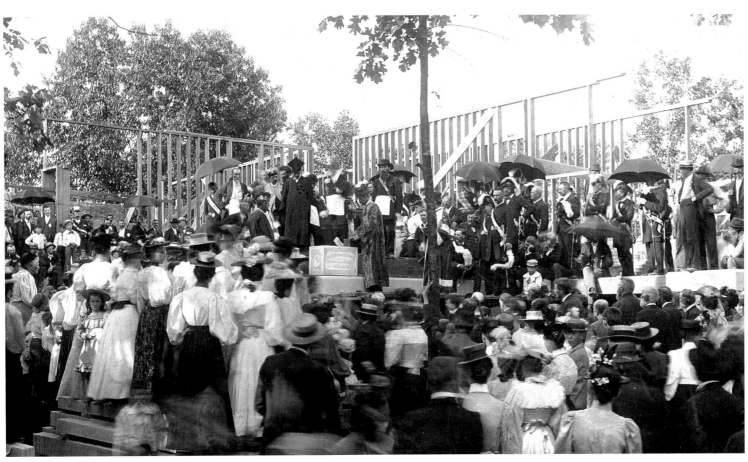

A crowd gathers to watch the laying of the cornerstone of Chattanooga Normal University on a high hill on Mississippi Avenue in 1896. Normal Park Elementary School was erected on this site in 1938 and still serves as a museum and magnet school today.

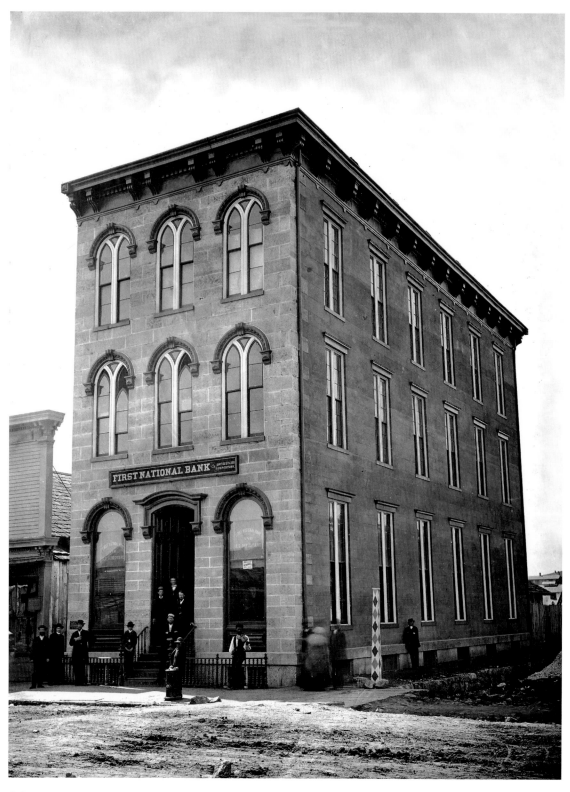

One of the first banks to open in Chattanooga after the Civil War was the First National Bank, which began operation on October 25, 1865. Its founders were William P. Rathburn and Theodore G. Montague. The business merged with the Chattanooga Savings Bank and Trust Company in 1929 on the eve of the Great Depression. (ca. 1869)

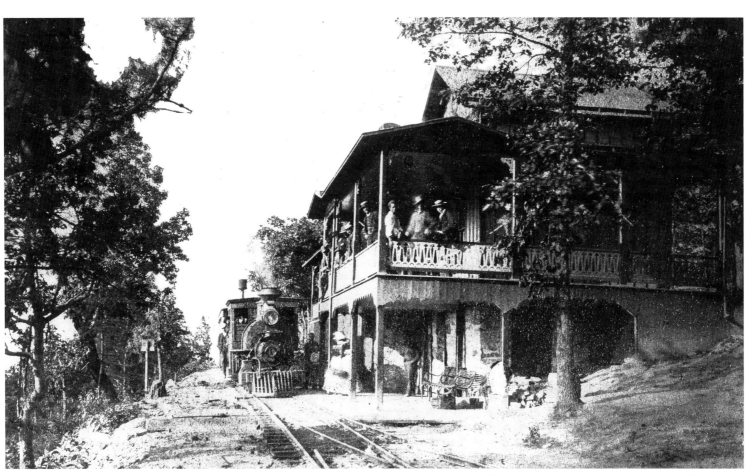

Guests wait on balcony for train to arrive at Sunset Rock Depot on Lookout Mountain. The depot was connected to the Point Hotel and Incline No. 1 by a narrow gauge railroad. (ca. 1897)

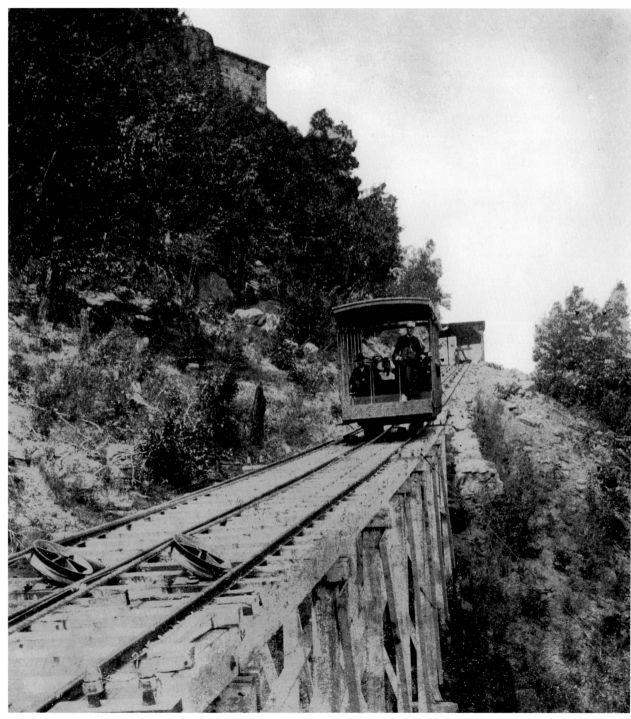

Following an economic boom in the 1880s and a yellow fever epidemic in 1878, Lookout Mountain became an attractive place to visit. Two incline railways would be built up the eastern side of the mountain to facilitate trips to enjoy the scenic beauty of the mountain. (ca. 1898)

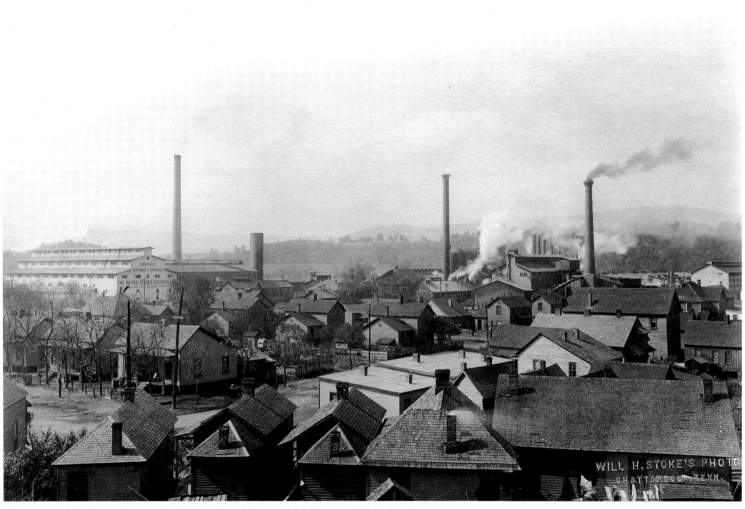

Chattanooga's industrial growth is displayed in this view of a factory neighborhood to the west of Cameron Hill near the Tennessee River. Workers commonly lived close to the worksite, such as the Lookout Factory Works on the far left or the Chattanooga Iron Furnace Company in the center background. Photograph by William Stokes (ca. 1890)

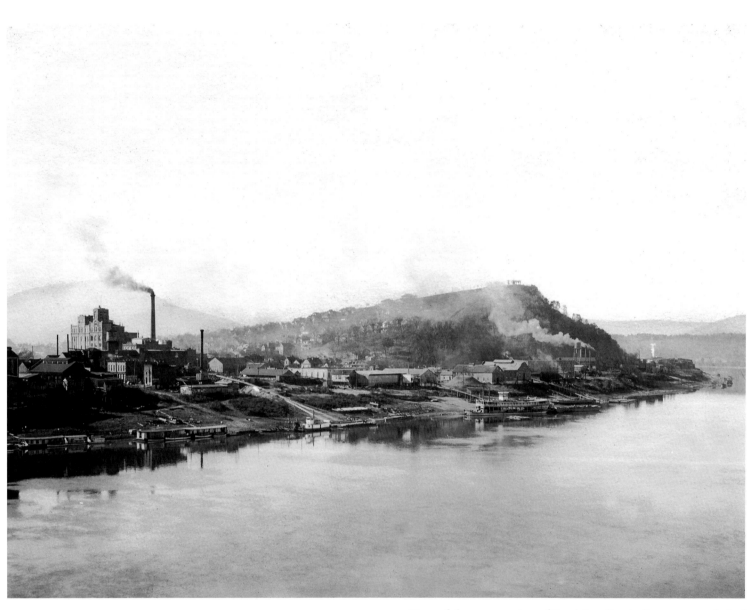

Turn-of-the-century view of Ross's Landing indicates a great deal of commercial activity. The tall building to the left is the Chattanooga Brewing Company. Notice the number of residences on Cameron Hill at center. Photograph by William Stokes (ca. 1900)

A City at
The Turn of the Century

1900–1917

Just months before the turn of the century in 1899, two Chattanoogans visited the owner of a small company in Atlanta, Georgia, that made a drink called Coca-Cola. They came home with an agreement that gave them exclusive rights to bottle this tasty drink and sell it over most of the continental United States. Amazingly, the contract was purchased for the price of one dollar. So began the Coca-Cola Bottling Company, one of the most prosperous enterprises in the city's history.

By the year 1900, Chattanooga had become a center of iron production and a nexus of rail transport. A second major railway terminal was opened in 1909, solidifying Chattanooga's importance as a rail center. In 1905, public transportation became a thorny issue, when African Americans began a boycott of the street car system because of new laws requiring segregated seating. Remembrance of the Old South continued as a presence when the United Confederate Veterans held a large reunion, commemorating the fiftieth anniversary of Chickamauga in 1913. Near the Chickamauga battlefield, a training base called Fort Oglethorpe was established in 1902. The barracks and parade field would be home to soldiers preparing to go overseas to fight for their country during World War I.

Meanwhile, the "Dynamo of Dixie" expanded in 1913 when Charles James built a 13-mile steetcar line to an inn on the top of Signal Mountain. Two years later a group of Chattanoogans gathered to form the Dixie Highway Association, to promote a national north-south highway that would bring thousands of automobiles through the city on their way to the sunny beaches of Florida. In 1917, a new Market Street Bridge would span the river, testifying to the growth of the city and the suburb north of the river as well. That same year also saw the creation of a local trademark—the Chattanooga Bakery began selling a marshmallow sandwich known as the Moon Pie.

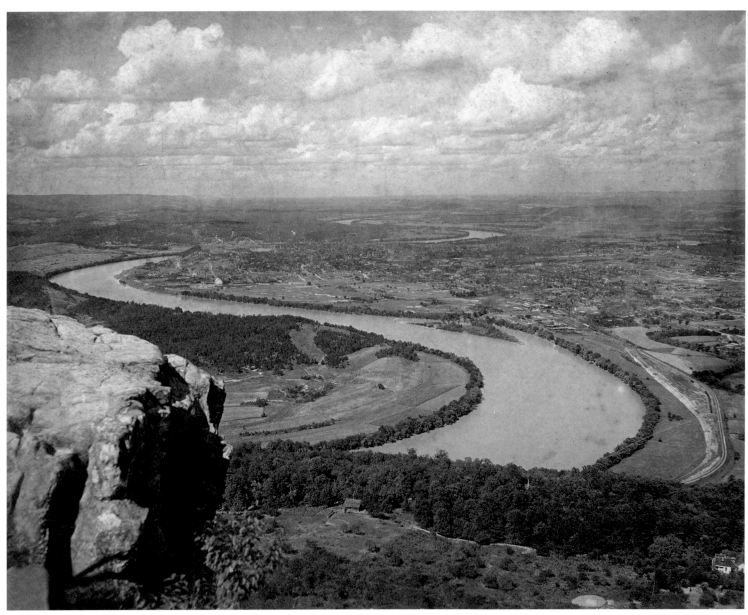

A view of Chattanooga's sweeping beauty as seen from the crest of Lookout Mountain. For those trying to envision the harsh engagements of the Civil War, Chattanooga offers an unparalleled view of the geographic positioning the two armies held during the fateful year of 1863 when the nation's fate hung in the balance. Photograph by Rollins and Linn. (ca. 1900)

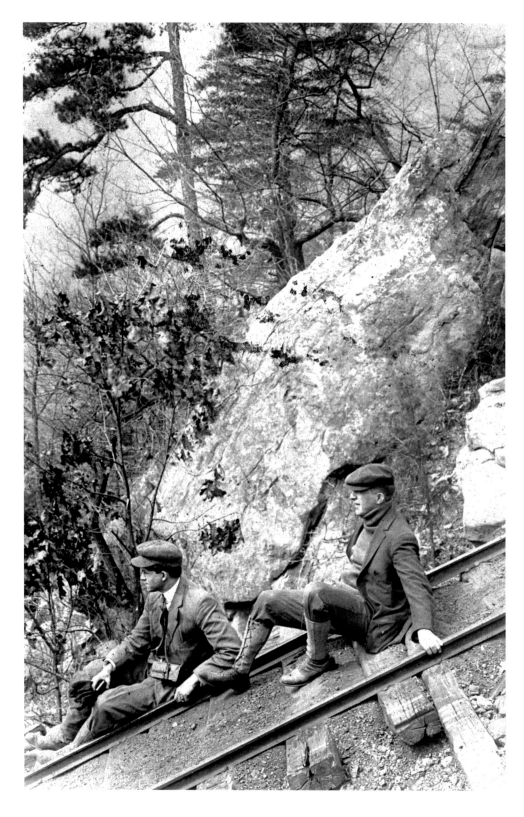

Hiking has always been a popular pastime in the Tennessee mountains. Here two hikers relax on the incline rails on Lookout Mountain. Note the box camera in the young man's hand. (ca. 1900)

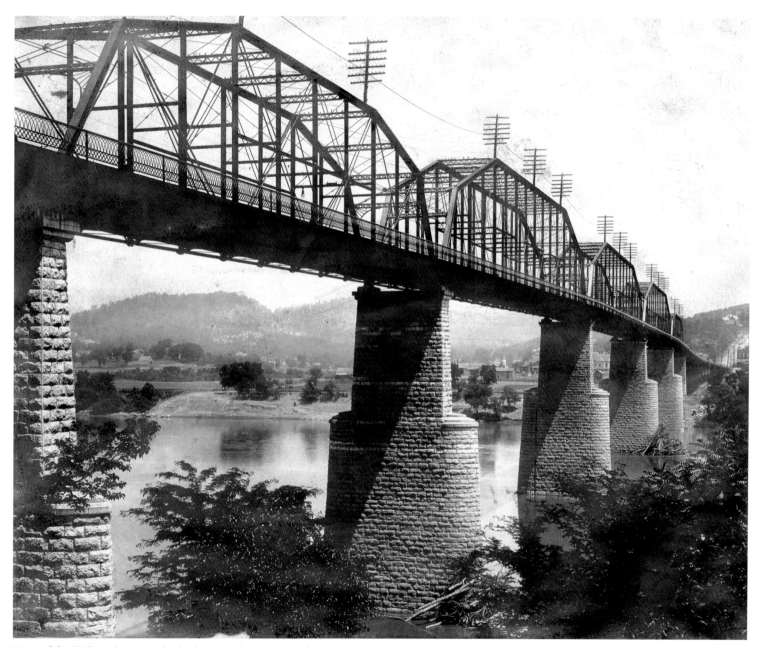

View of the Walnut Street Bridge looking north as it spans the Tennessee River. With the completion of the bridge in 1891, telephone poles placed atop the span made connections possible between Chattanooga and Hill City on the north side of the river. (1900)

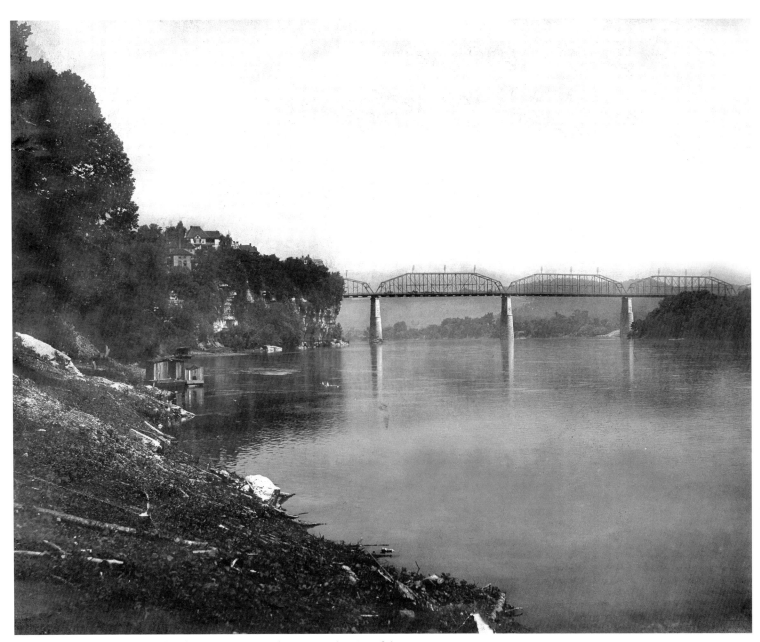

View of the Walnut Street Bridge from upriver near the present-day site of the
Manker Patten Tennis Center. The completion of the bridge in 1891 created the
first permanent roadway across the river since the Meigs Military Bridge washed
away in the flood of 1867. A portion of Chattanooga Island is visible to the right.
(ca. 1900)

Mounted soldiers on parade pass the Stanton House on Market Street. Even though the luxurious hotel featured an observatory and other amenities, it was dismantled in 1906 and replaced with the Terminal Station in 1909. (ca. 1902)

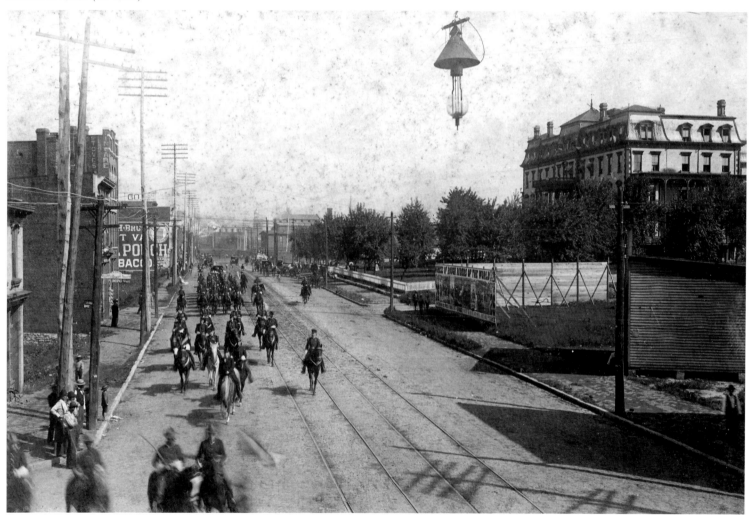

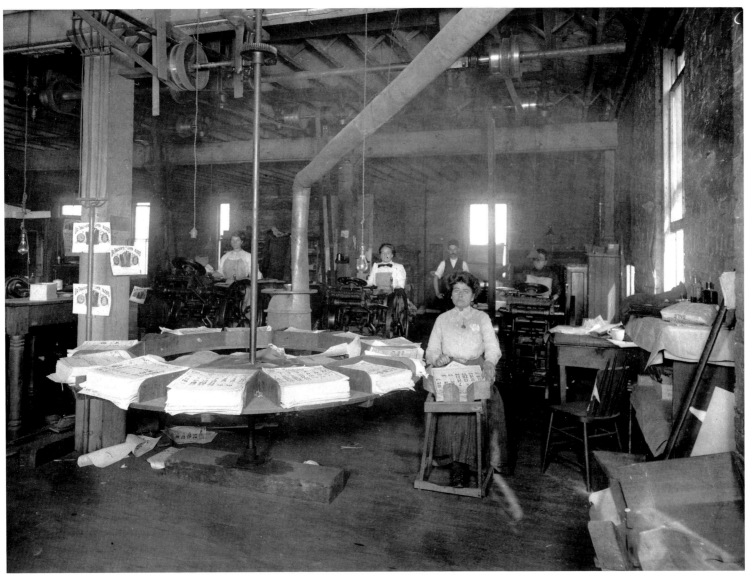

Women at Thacher Medicine Company assembling calendars. The company was known for a number of products including a "Liver and Blood Syrup" that "makes lazy livers lively." (ca. 1902)

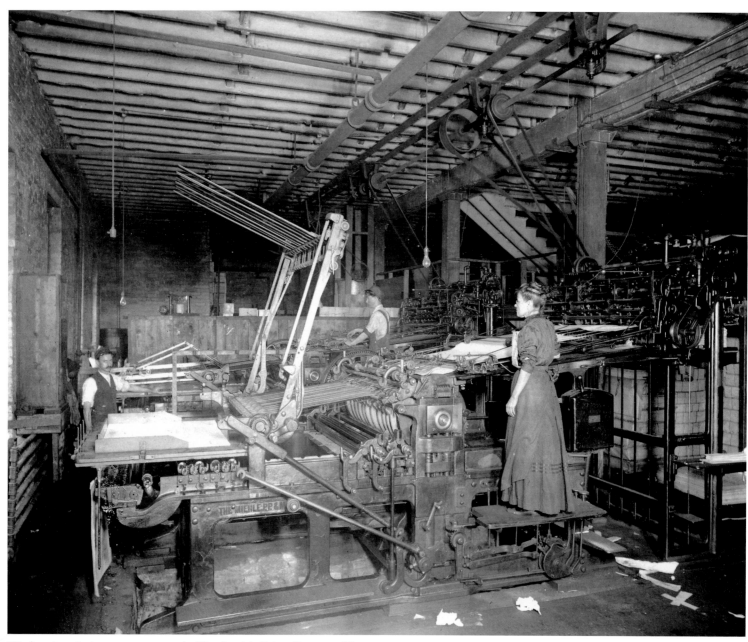

Workers in printing press room at the Thacher Medicine Company. The company
printed thousands of calendars and almanacs every year laden with advertisements and
health advice. (ca. 1902)

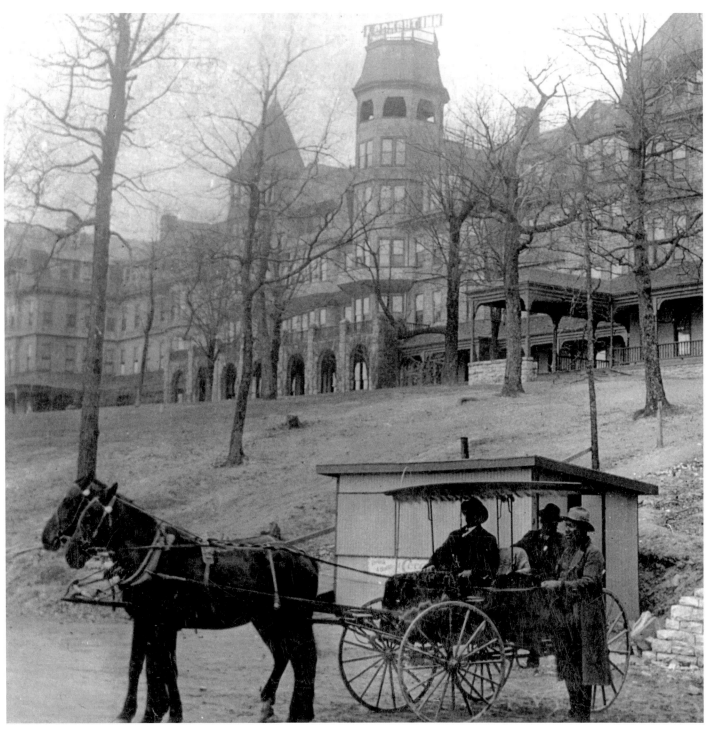

The Lookout Inn was a grand part of the development of Lookout Mountain that began in the 1880s. An impressive structure with two towers flanking the main entrance, the hotel burned in a spectacular fire visible to the city below in 1908. Notice the sign behind the carriage advertising locally bottled cola drink. (ca. 1902)

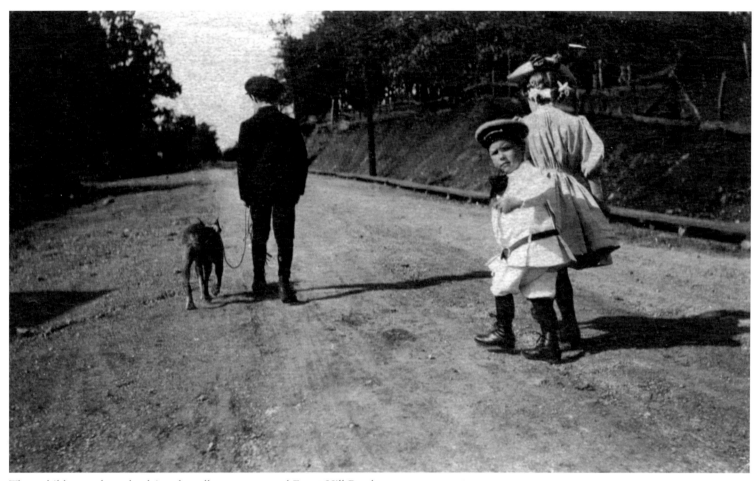

Three children and pet dog leisurely walk up an unpaved Forest Hill Road in Hill City. By the turn of the century Hill City, now known as North Chattanooga, was becoming an established residential neighborhood.

Mounted troops stand at attention while carriages with observers travel past them. This grand parade honored President Teddy Roosevelt's visit to the city. (September 1902)

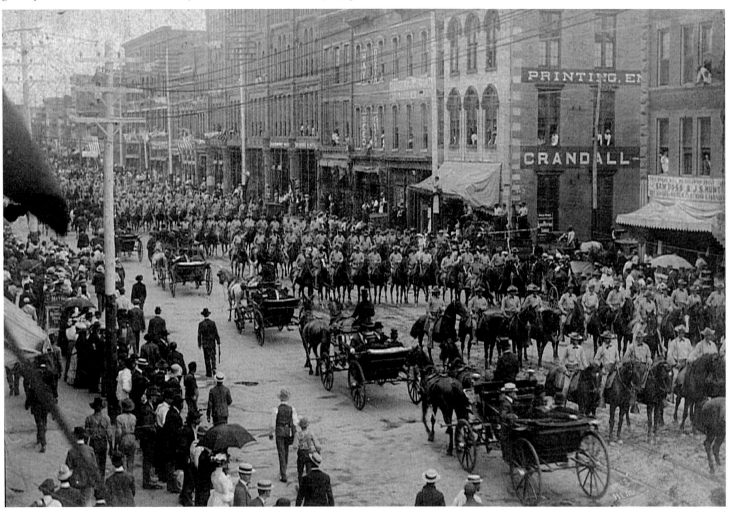

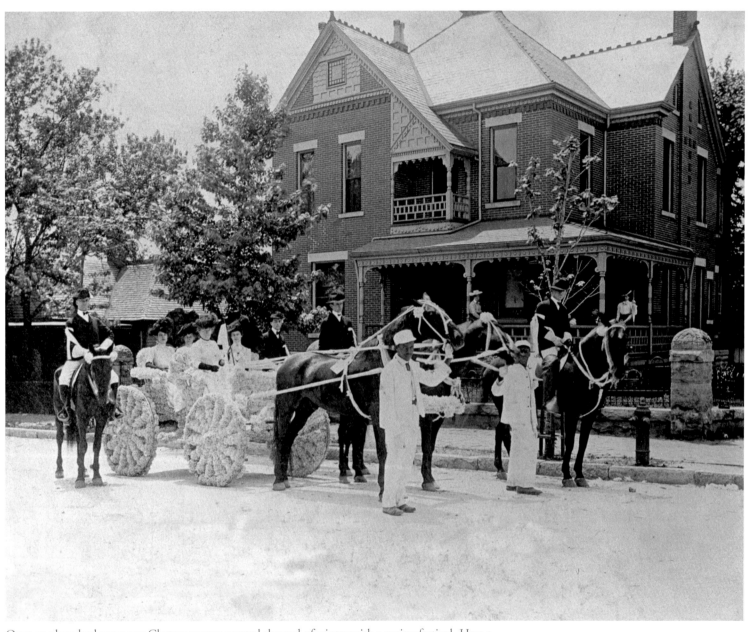

Over one hundred years ago Chattanoogans greeted the end of winter with a spring festival. Here a lavishly decorated trap waits in front of the F. Allen Gentry home at 201 High Street. (1902)

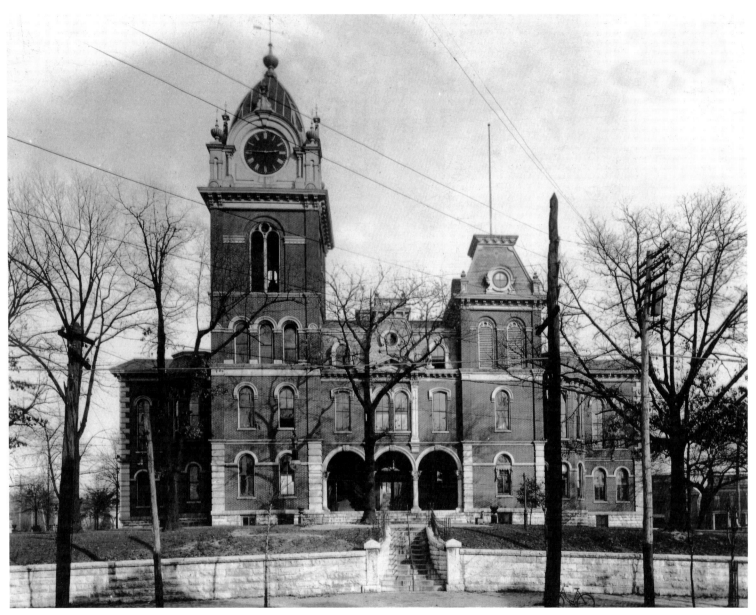

The afternoon sun shines on the Hamilton County Courthouse with its prominent clock tower. Built in 1879 after Chattanooga became the county seat, it was destroyed by a lightning strike in 1910. Photograph by Matt L. Brown & Co. (ca. 1900)

Young Harry Stoops, Jr., seems to be ready to join Stoops Advertising, the family business, as he puts his roller to a new poster. Note the sign behind him for Wine of Cardui, the popular women's remedy made in Chattanooga. (1904)

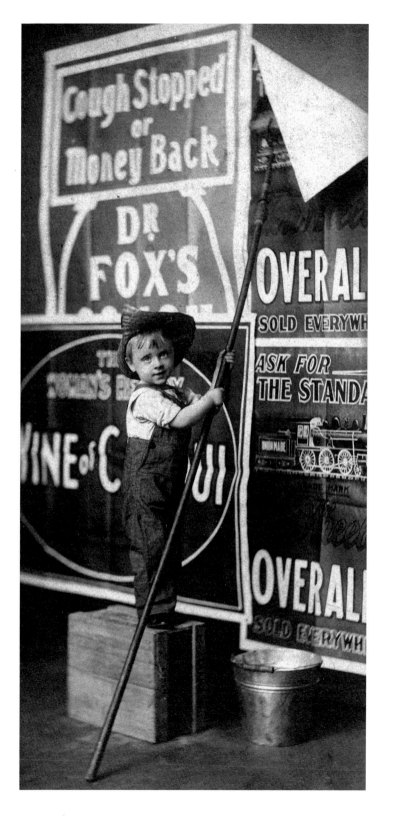

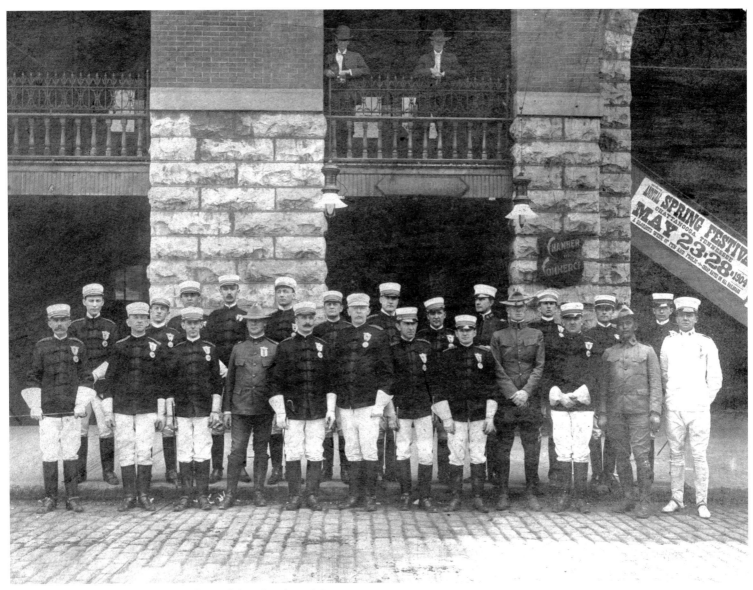

These Spring Festival guards pose in front of the Chamber of Commerce
and appear ready to march in the annual festivities. (May 1904)

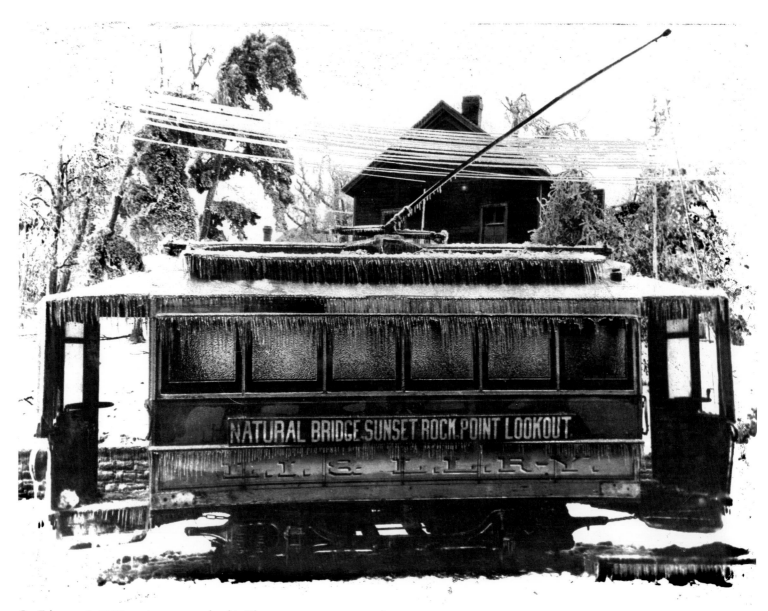

On February 5, 1905, a winter storm that hit Chattanooga was so severe that
streetcar service was suspended for the first time in the city's history. Large blocks
of ice were reported floating down the river. In this photograph a frozen Lookout
Mountain Incline and Lula Lake Railway streetcar is blanketed with icicles.

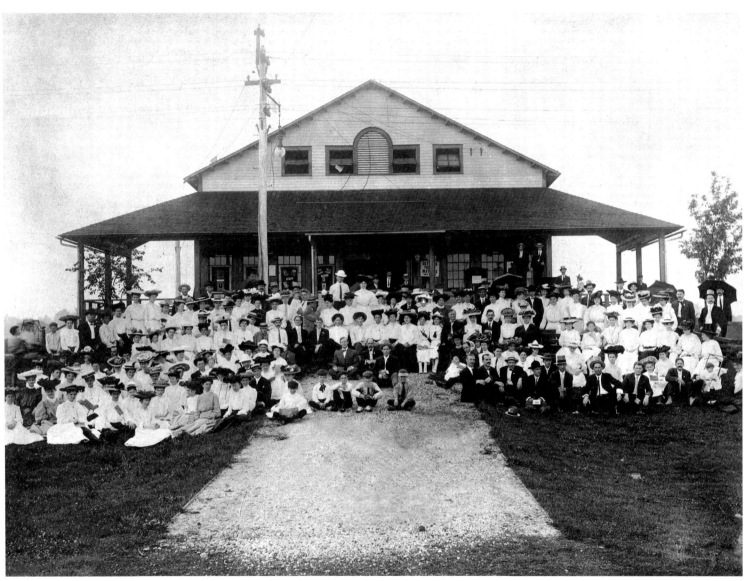

Employees of the Miller Brothers department store pose for a photograph during a summer outing at Olympia Park in June 1905. A popular location for gatherings, the newly established Olympia Park was purchased by the city of Chattanooga in 1912 and renamed Warner Park in honor of Commissioner Joseph H. Warner.

Known as Chattanooga's original skyscraper, the Pound Building stood across from the Municipal Building until it was razed in 1989. It was named for J. B. Pound, who was involved in the newspaper and hotel business in Chattanooga and was responsible for much of the initial development of 11th Street. (1906)

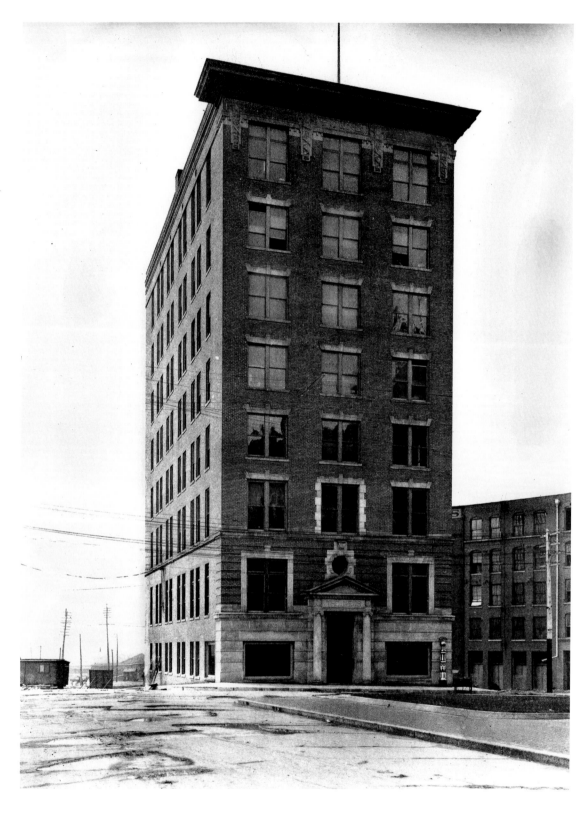

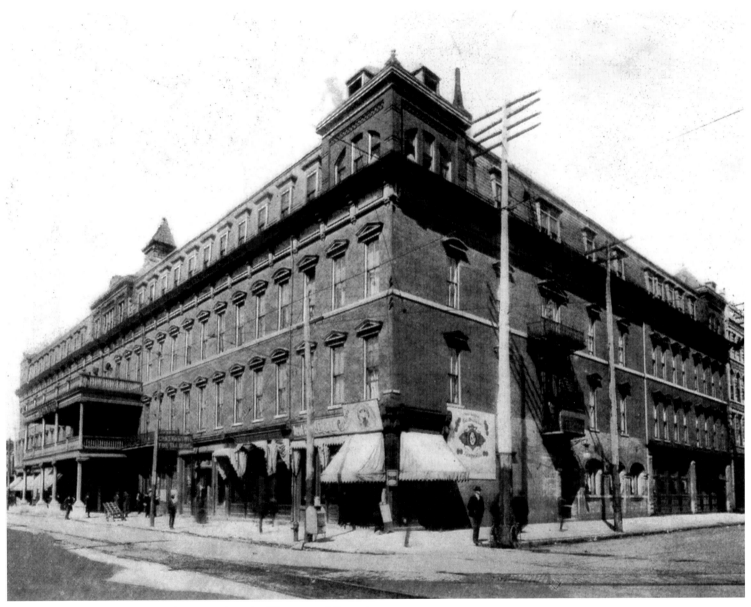

The original Read House was built in 1871 by John Thomas and Samuel R. Read. It stood on the site of the Crutchfield House, a famous hotel built in 1847. Located between Broad and Chestnut streets, this building was razed in 1925 so that the current Read House could be constructed. (1905)

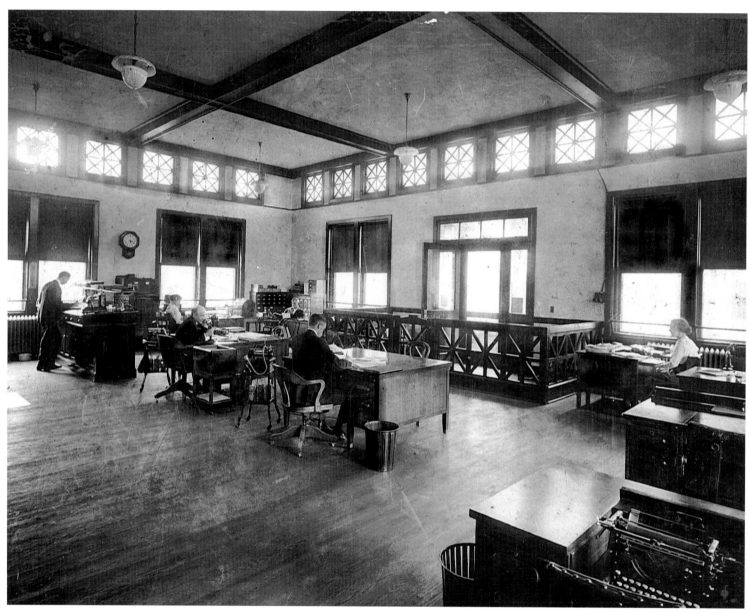

Another day at the office one hundred years ago. The workers at the Chattanooga Implement Company have plenty of light, room, and at least one working telephone. (1905)

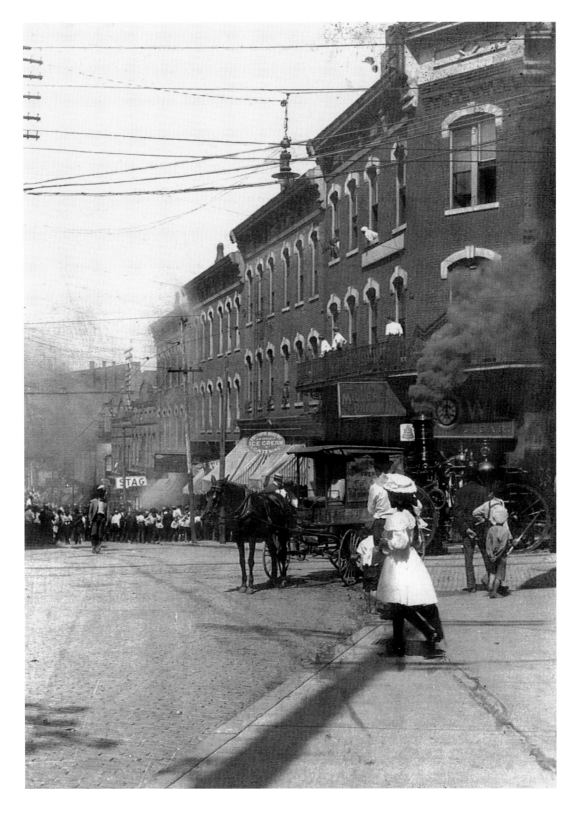

A young lady gazes raptly down the street as smoke billows from local establishment west of the Stag Hotel. Note the fire engine bellowing smoke in the right foreground, at the corner of Georgia and 8th streets. (October 1906)

The impressive Romanesque-style First Baptist Church stood at the corner of Georgia Avenue and Oak Street for eighty years. Designed by Chattanooga architect R. H. Hunt, it was built in 1887 with a bell tower that housed a one-ton bronze bell. (1906)

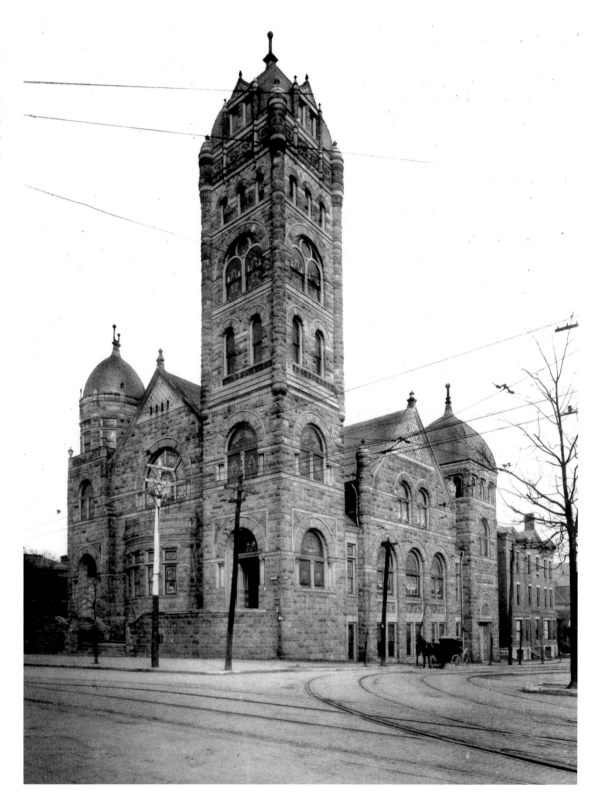

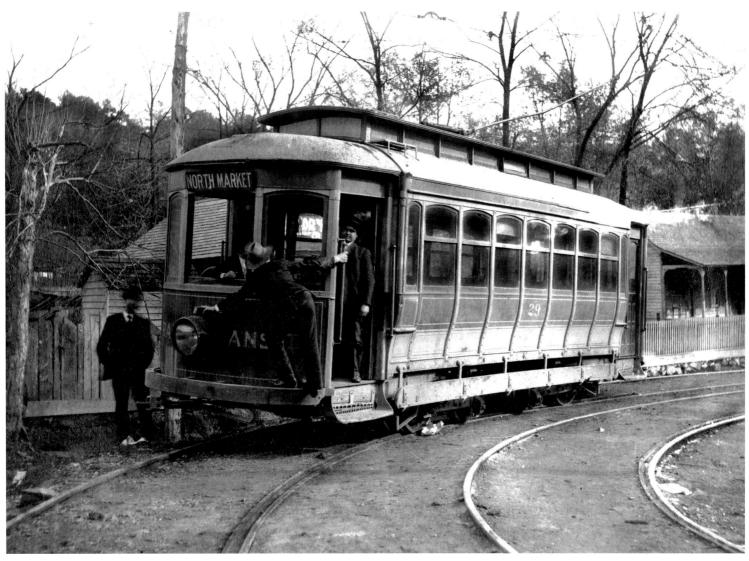

Streetcars were a familiar sight to Chattanoogans from 1875 until 1947, when buses became the
standard public transport. Route sign on this car reads "North Market," indicating this car is headed to
North Market Street in Hill City. (ca. 1908)

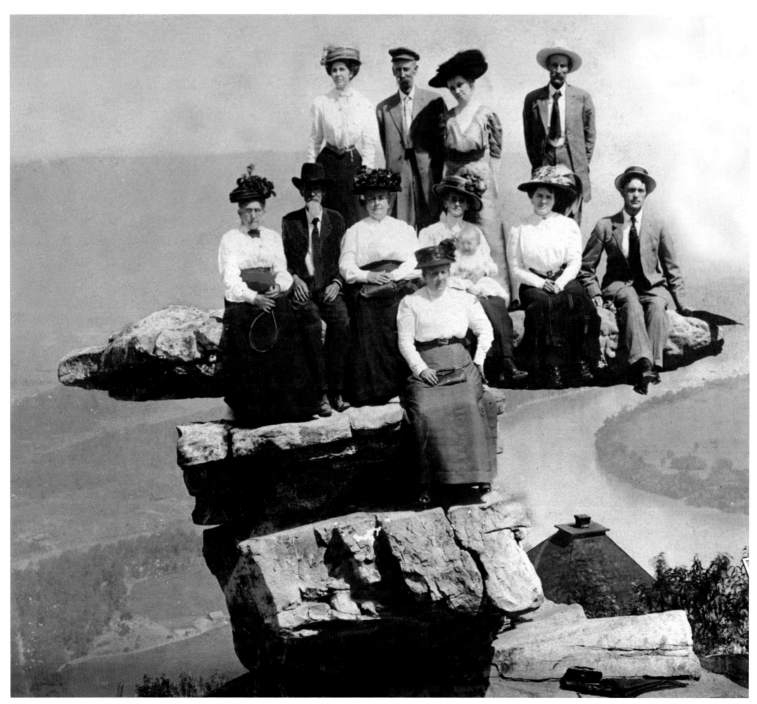

The ever-popular Umbrella Rock has hosted a potpourri of groups over the years. Here a group of Edwardian ladies and gentlemen pose for a photograph in August 1909. The roof of the Point Hotel is visible to the lower right of the photograph.

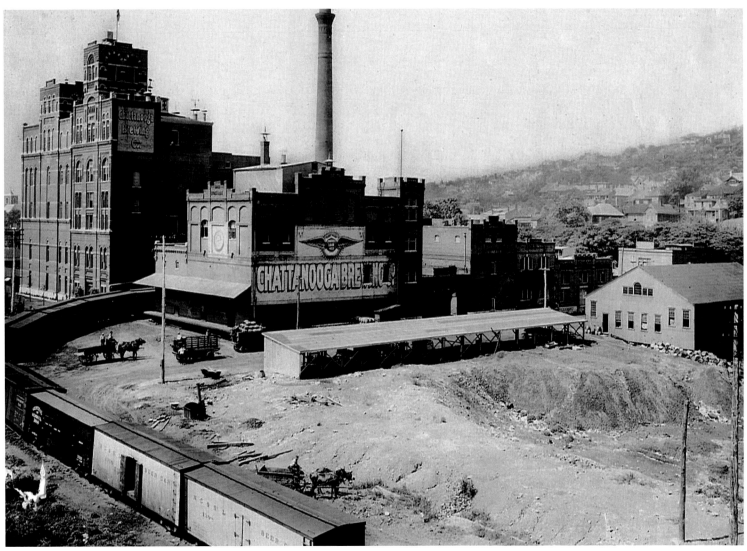

The Chattanooga Brewing Company concocted beer and made ice as well. But the era of prohibition made business difficult, and the brewery, which occupied a whole city block, closed in 1919 after forty years of fermenting. Eventually the Coca-Cola Bottling Company would establish its downtown operation on this site. (ca. 1910)

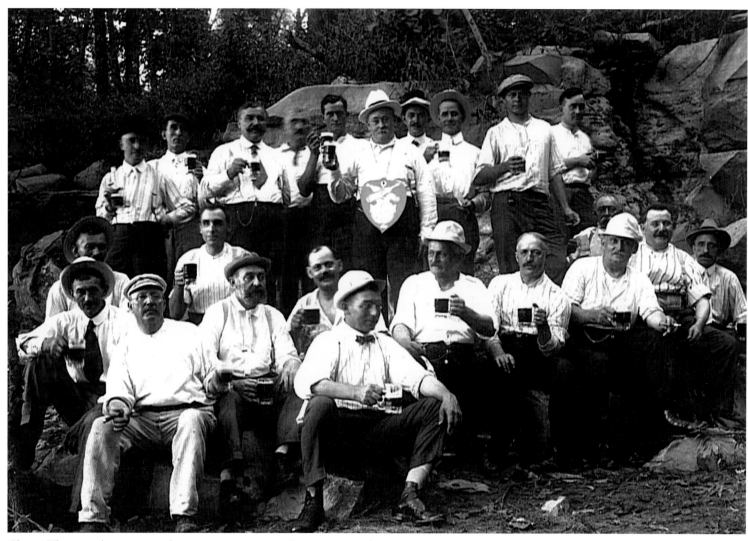

Cheers! These gentlemen are ready to enjoy some camaraderie over a good
drink. The man in front has evidently started before the rest.

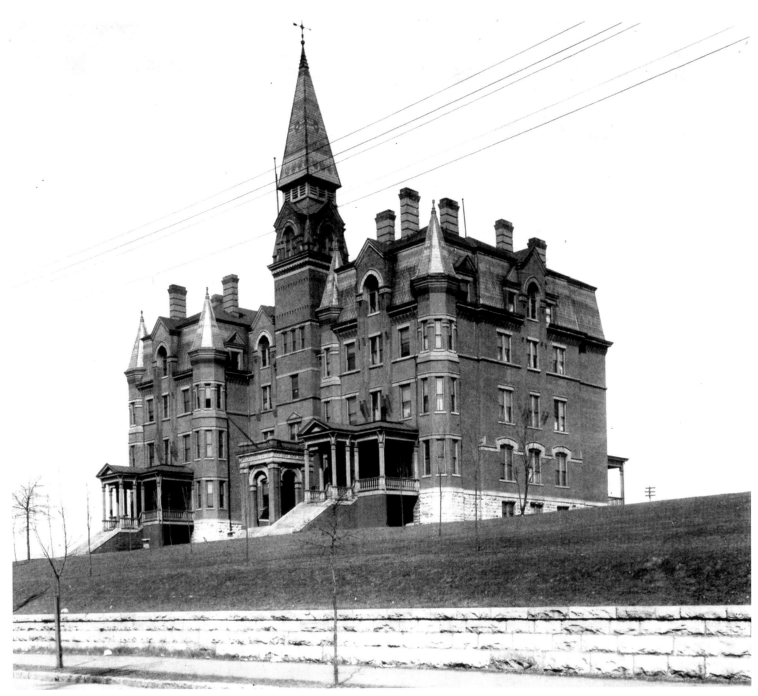

Building known as Old Main on McCallie Avenue was the center of
Grant University, which would become the University of Chattanooga.
Opened in 1886, it was taken down in 1917. (1906)

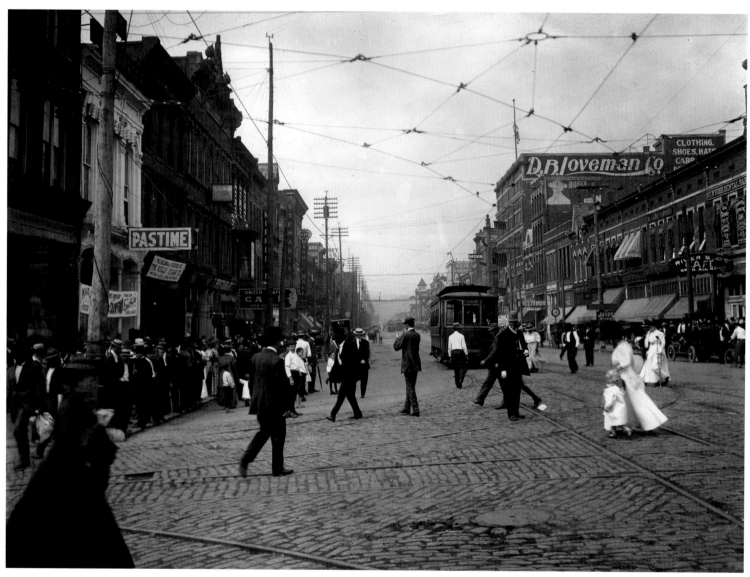

View of a busy day on Market Street as men, women, and children move ahead of oncoming trolley. One of Chattanooga's finest department stores, Lovemans, is visible to the right in this photograph of the downtown business district looking north. (1909)

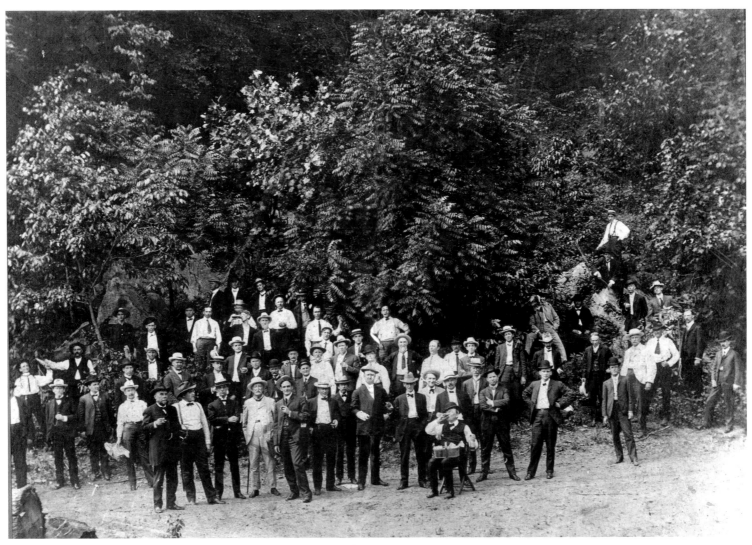

Chattanooga Bar Association Picnic in Blowing Springs (just south of St. Elmo).
Pictured in front row, 3rd from left is Alexander "A. W." Chambliss, and 9th
from left, James Burnet "J. B." Sizer, attorneys with Chambliss, Bahner and
Stophel. A.W. Chambliss, who founded the firm in 1886, was four-time former
Chattanooga Mayor, as well as Tennessee Supreme Court Justice (1924) and
Chief Justice (1947). J. B. Sizer joined the firm in 1910. (ca. 1910)

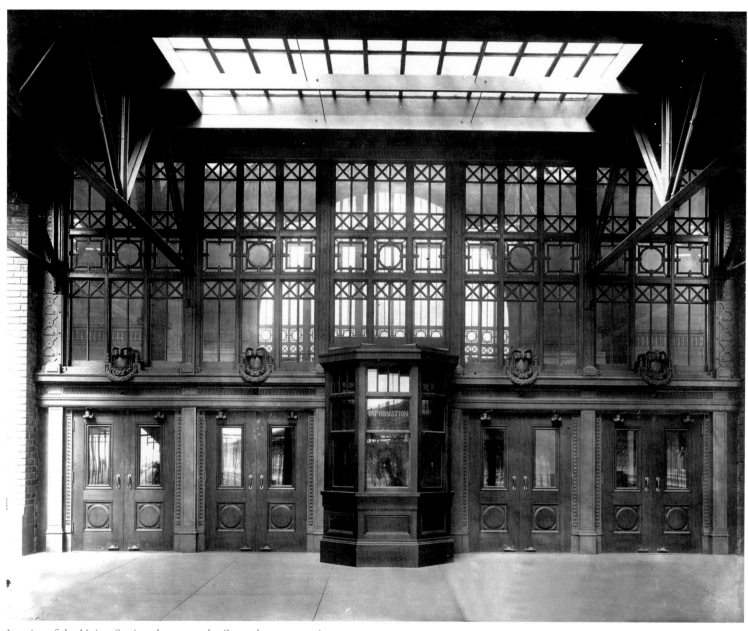

Interior of the Union Station that greeted rail travelers was spacious
and beautifully crafted. Light from the skylight above accentuated the
architectural details of fine walnut and marble. (ca. 1910)

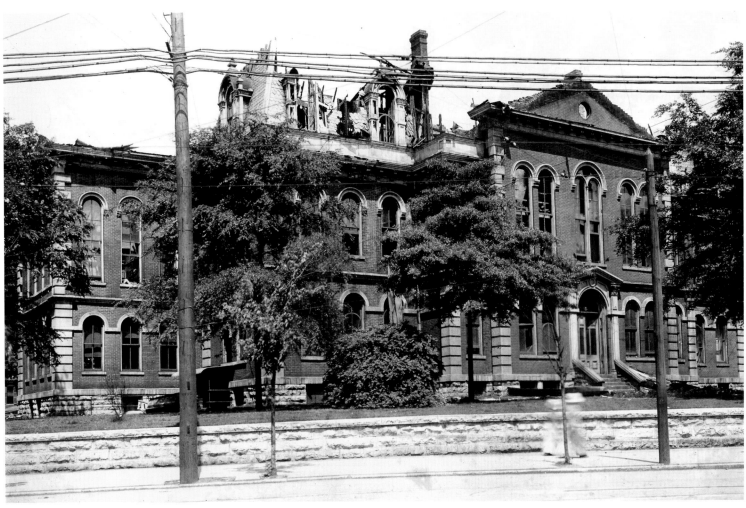

The Hamilton County Courthouse stands in ruins after a lightning strike from a spring thunderstorm set it ablaze. Located at the corner of Walnut and 7th streets, it was replaced with the current courthouse. Photograph by Stokes-Forstner (May 1910)

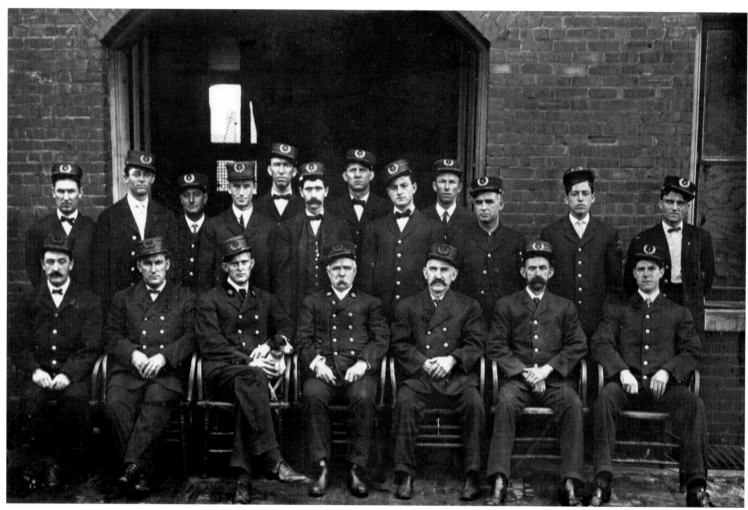

Chattanooga firefighters in front of Fire Station No. 1 at 1033 Carter Street.
Chattanooga's early firefighters were organized by the Union army because of the
large number of wooden buildings the troops erected during their occupation of the
city. (1906)

This view from Cameron Hill looking toward Lookout Mountain captures one of Chattanooga's early industrial settings. The land west of Cameron Hill was developed by Union army engineers to build rolling mills and other production facilities to aid the war effort. This land continues as a manufacturing site today. (ca. 1910)

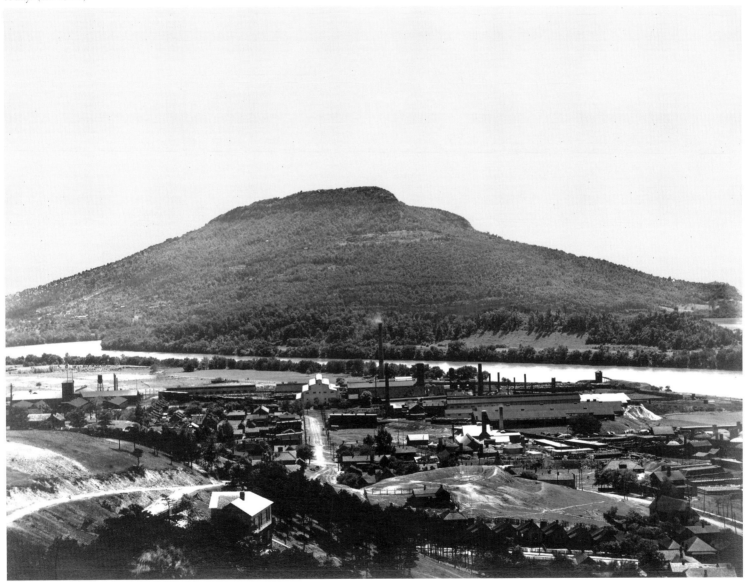

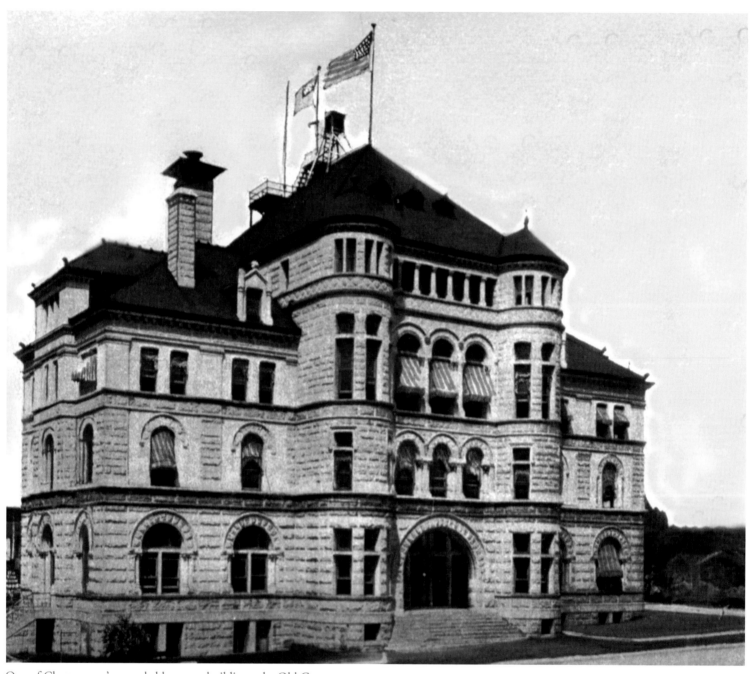

One of Chattanooga's remarkable extant buildings, the Old Custom
House, with its massive stonework and archways, is a classic example of
Richardsonian Romanesque architecture. Built in 1893 on 11th Street,
it was the home of the U.S. Post Office for forty years. (ca. 1900)

Constructed in 1908 on E. 11th Street, the Chattanooga
Municipal Building was designed by R. H. Hunt, probably the
most significant architect in Chattanooga's history. (1910)

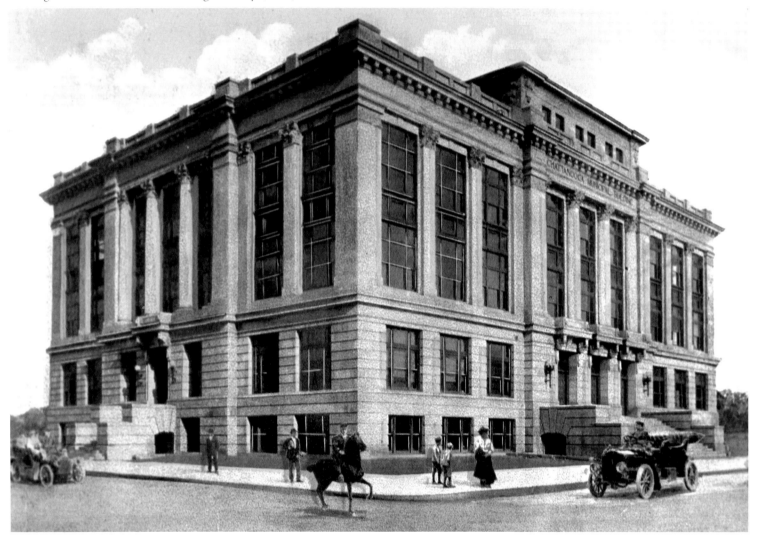

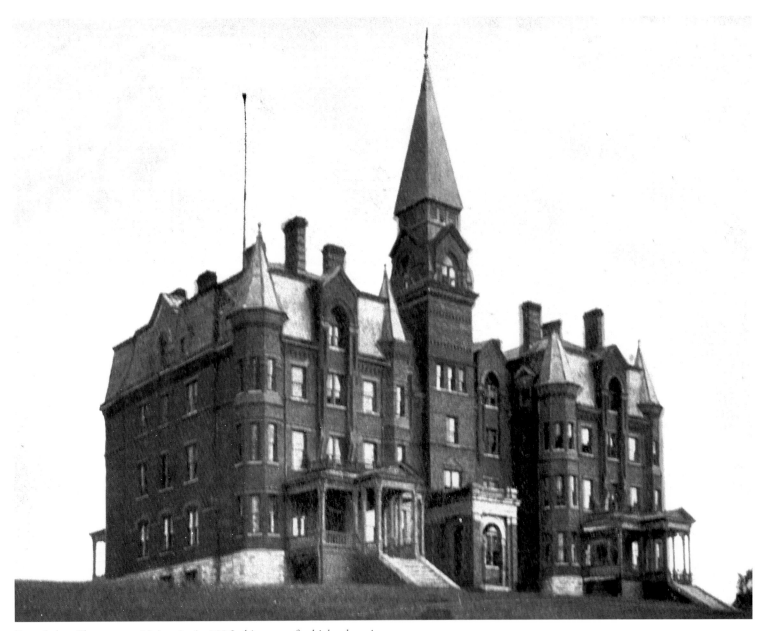

Founded as Chattanooga University in 1886, this center for higher learning
consolidated with East Tennessee Wesleyan University at Athens to form
Grant University, in 1889. In 1907, the name University of Chattanooga
was adopted. (1910)

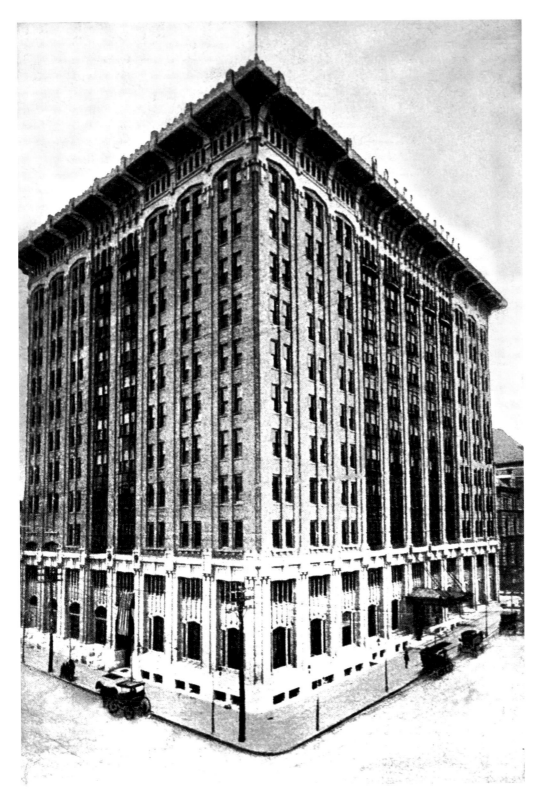

The Hotel Patten at Market and 11th streets was named for Z. C. Patten of the Chattanooga Medicine Company, who financed the construction of this building that still stands today. Often pictured with transmitting towers on its roof, the hotel became the home of Chattanooga's first radio station, WDOD, whose call letters stood for "Dynamo of Dixie," when it signed on in April 1925.

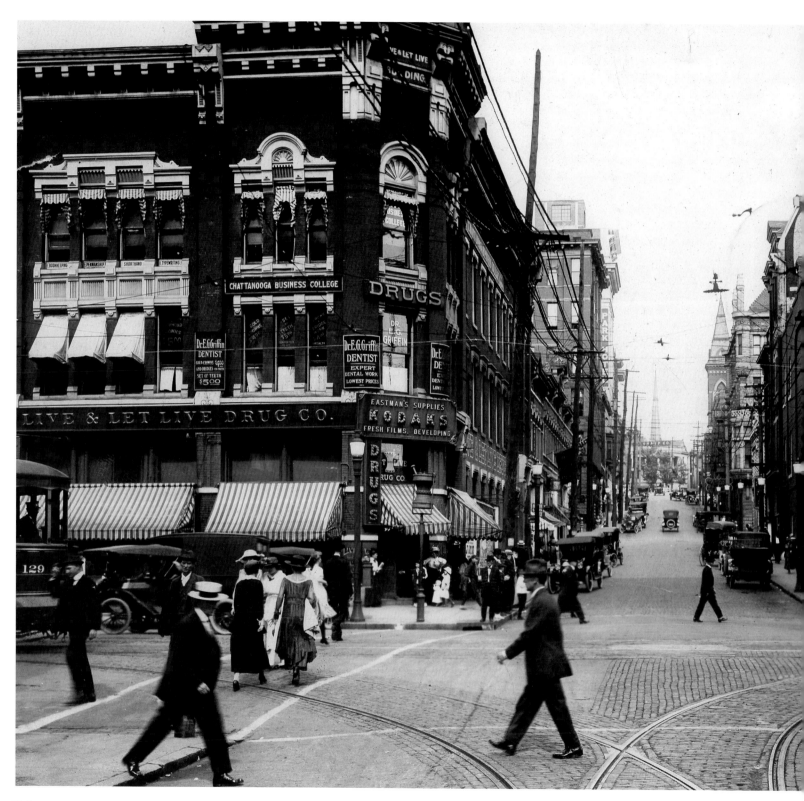

Street scene typical of Chattanooga circa 1910. Note the Live & Let Live Drug Company on the left and the George K. Brown Company on the right.

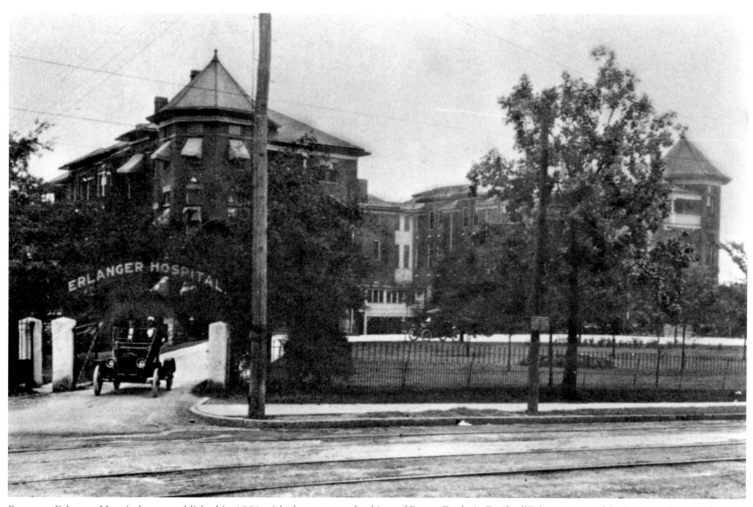

Baroness Erlanger Hospital was established in 1891 with the generous backing of Baron Frederic Emile d'Erlanger, a wealthy investor in several Southern railroads. It was completed and opened in 1899. Here Drs. Holtzclaw and Bogart leave the hospital at the end of the day in their Ford automobile. (ca. 1912)

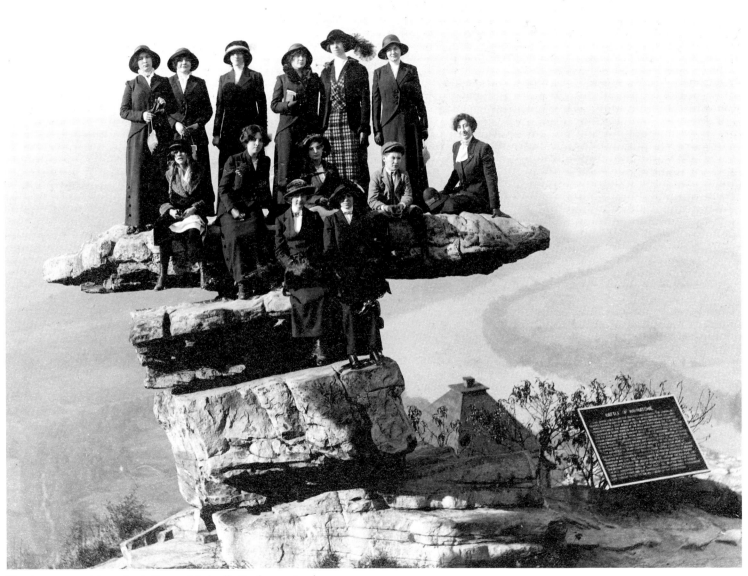

One boy poses with twelve ladies on Umbrella Rock atop Lookout Mountain. The sign to the right describes the Battle of Wauhatchie that took place in the valley below. The roof of the Point Hotel is visible next to the sign. (ca. 1912)

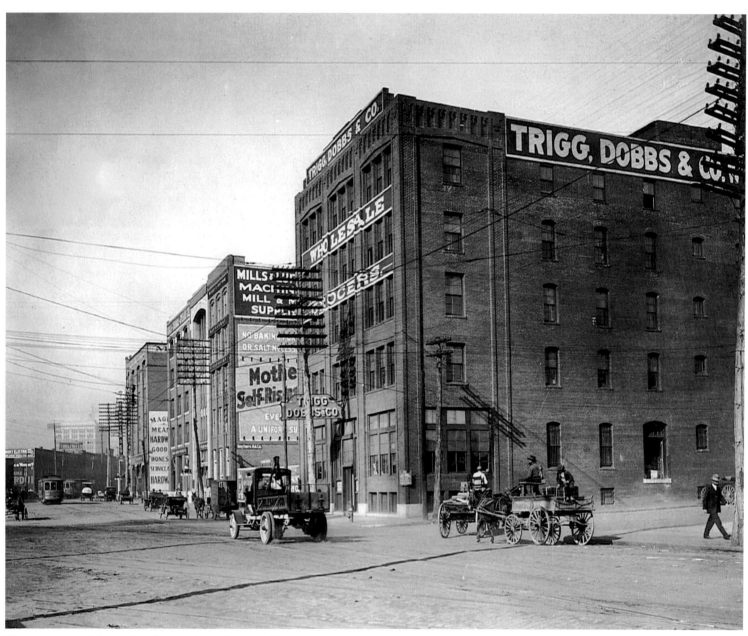

Wagons, automobiles, and trolleys are in evidence in this scene
on Market Street looking north. (ca. 1914)

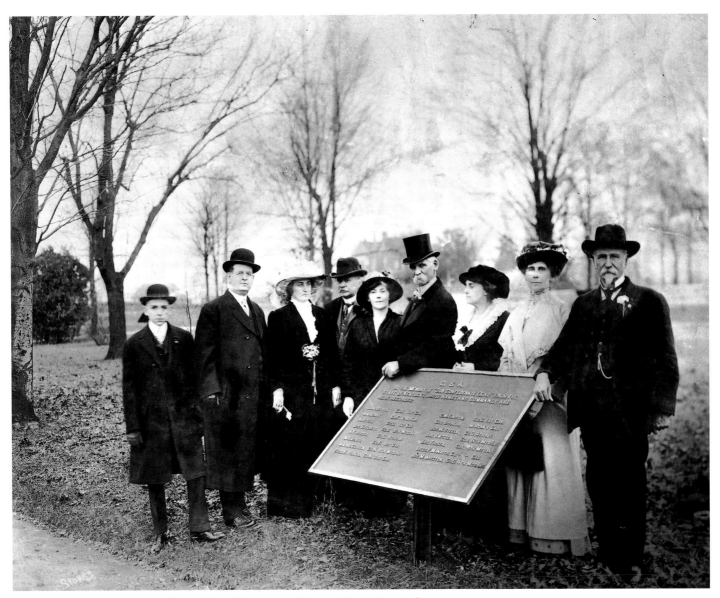

Two journalists, George Fort Milton of the *Chattanooga News* and S. A. Cunningham of the *Confederate Veteran*, stand with a proud group beside a marker at the Confederate Cemetery in Chattanooga. Visits to the cemeteries of the Confederate war dead were a common practice for many years. Photograph by W. H. Stokes (December 4, 1913)

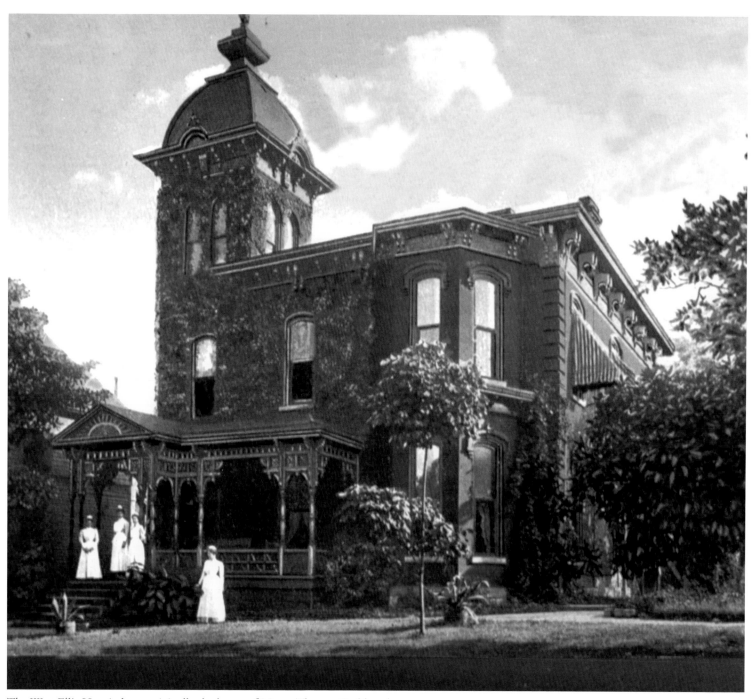

The West Ellis Hospital was originally the home of Mayor Thomas Carlile, who died in the yellow fever epidemic of 1878. Dr. George West and Dr. Manning Ellis converted the house to a hospital in 1904. In 1945 it became the Carver Hospital, serving the medical needs of the African American community. (1912)

This parade on Broad Street was part of the large Civil War veterans' reunion that took place in Chattanooga in 1913. Since the battle at Chickamauga was fifty years in the past, this gathering would be the last for many of the blue and the gray. (September 17, 1913)

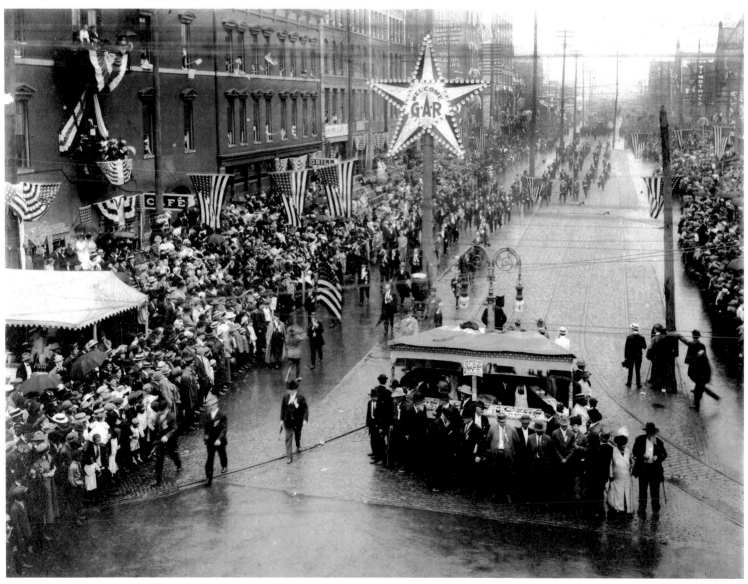

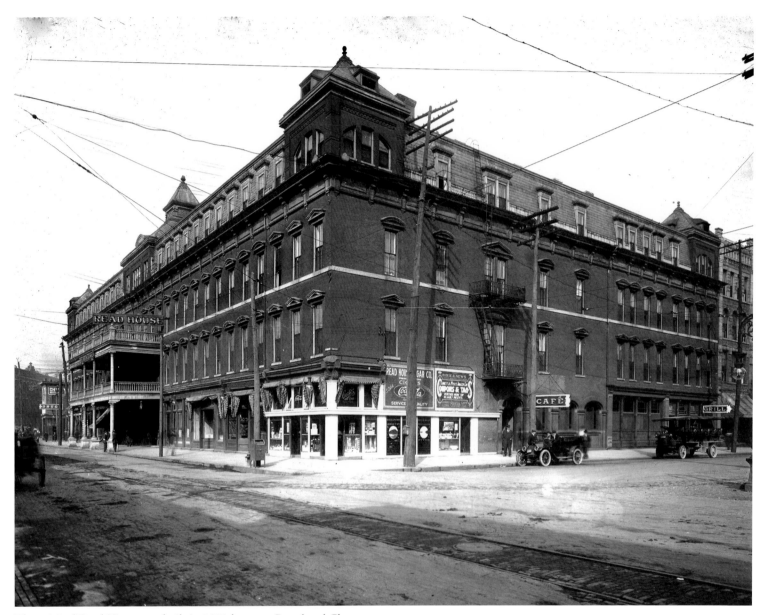

The original Read House was built in 1871 between Broad and Chestnut streets on the site of the Crutchfield House. The balcony on the side faced the Union Depot. Note the electric sign on the same side. Photograph by Stokes-Forstner (1914)

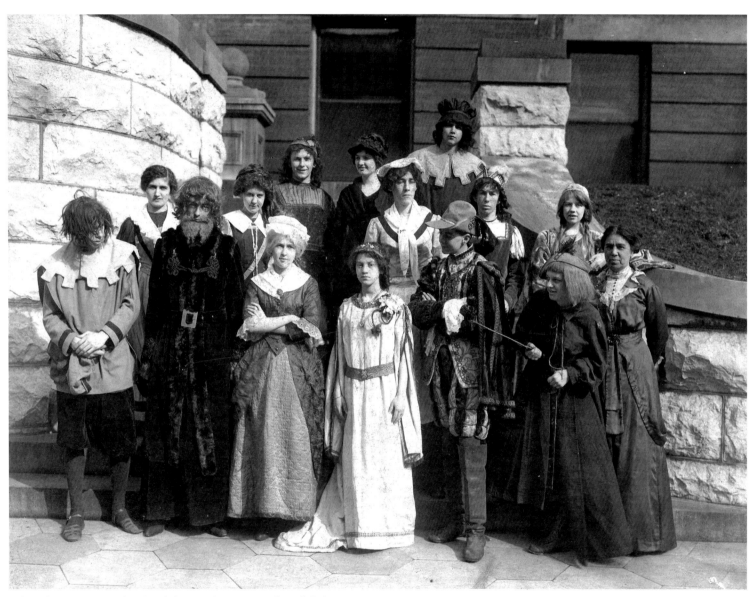

This Chattanooga High School theatrical group stands in full dress on the school steps. Certainly a great deal of energy was spent on the varied costumes, which suggest the performance of a Shakespearean play. (1914)

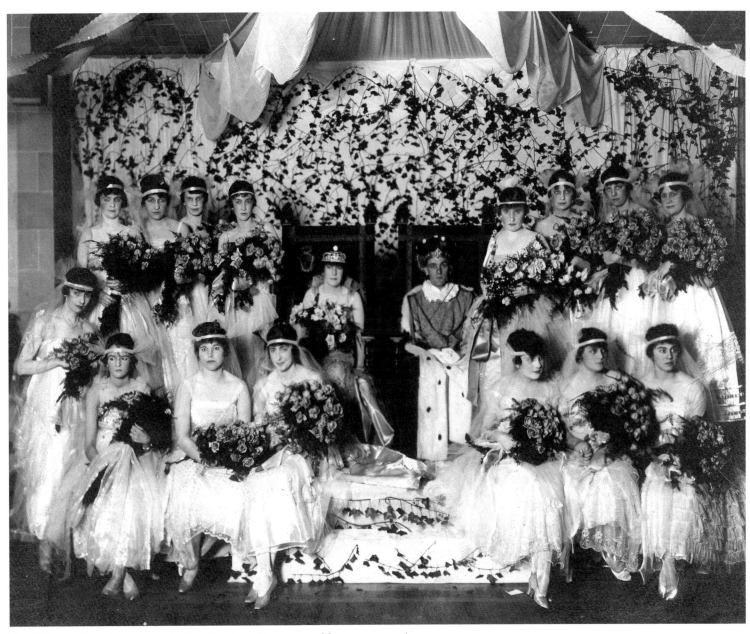

The Girls Auxillary debutantes with headbands and bouquets of flowers surround
the King and Queen of the annual Charity Ball. (November 8, 1916)

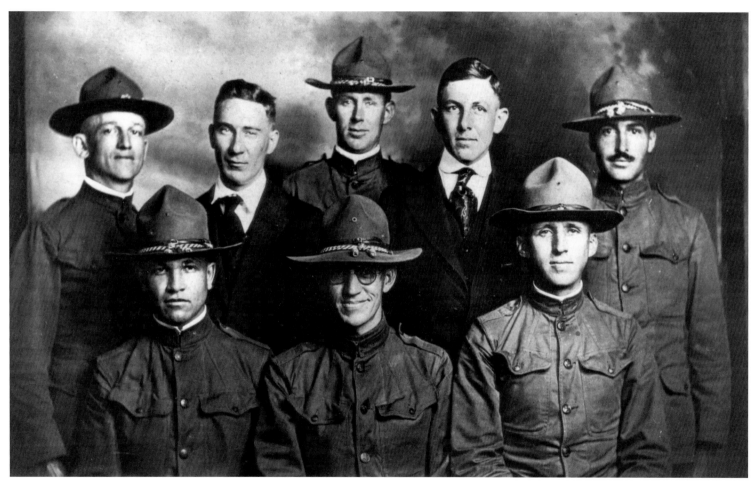

Named after the founder of the state of Georgia, Fort Oglethorpe came into being in 1902 when a camp was deemed necessary to replace the hastily built Camp Thomas near Chickamauga Park. These men most likely answered the call to duty during World War I and enlisted at the base. (1917)

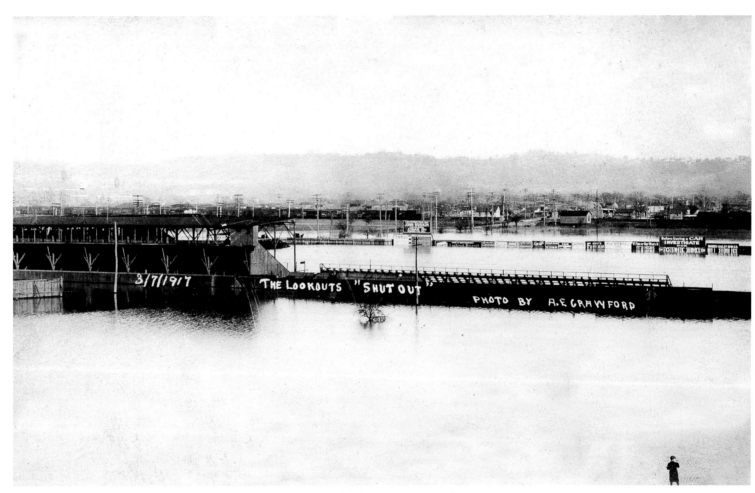

Writing on photograph reads "The Lookouts 'shut out'" meaning the local team, the Lookouts, would not be playing baseball with Andrews Field under water. However, not much baseball is played in early March, so this rain did not cheat any fans out of watching the game. Photograph by A. E. Crawford (March 7, 1917)

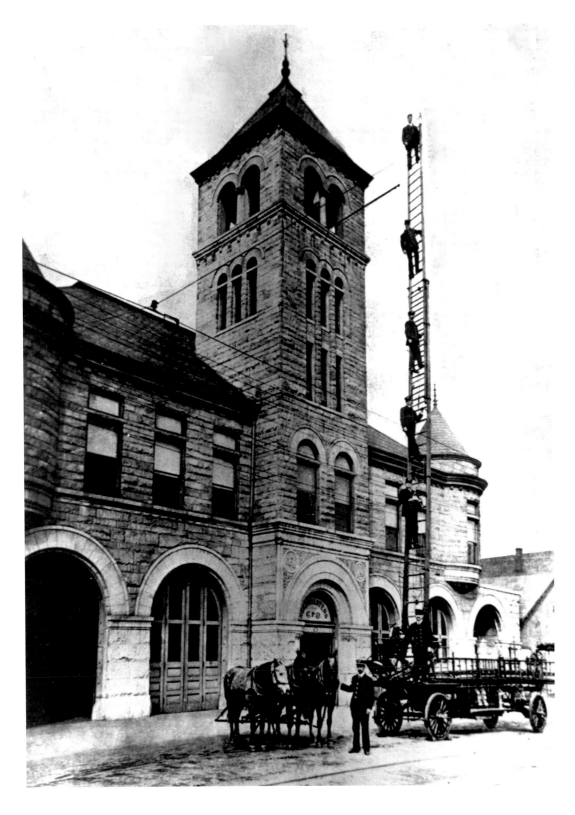

These firefighters demonstrate the meaning of teamwork and trust as they balance in front of Fire Station No. 1 on Carter Street. (1906)

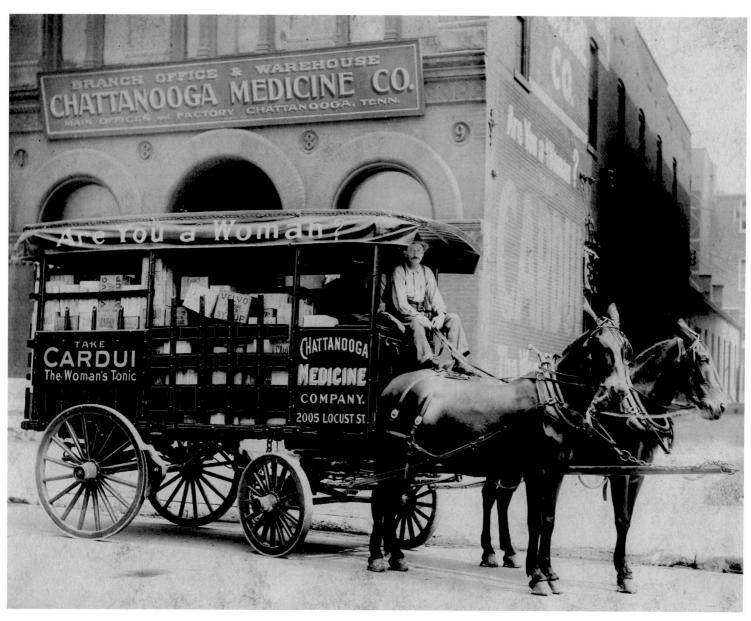

The Chattanooga Medicine Company, now known as Chattem, began in 1879 with two products. This wagon is filled with Dr. McElree's Wine of Cardui, a tonic for women, and Black Draught, a laxative. (ca. 1900)

Lone figure on rock takes in stunning vista of the Tennessee River
as it curves around Moccasin Bend. To the right is the Point Hotel.
Photograph by J. B. Linn (ca. 1905)

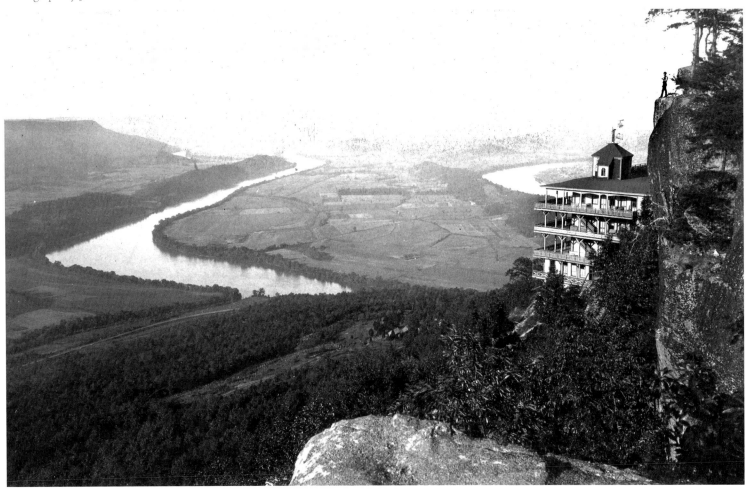

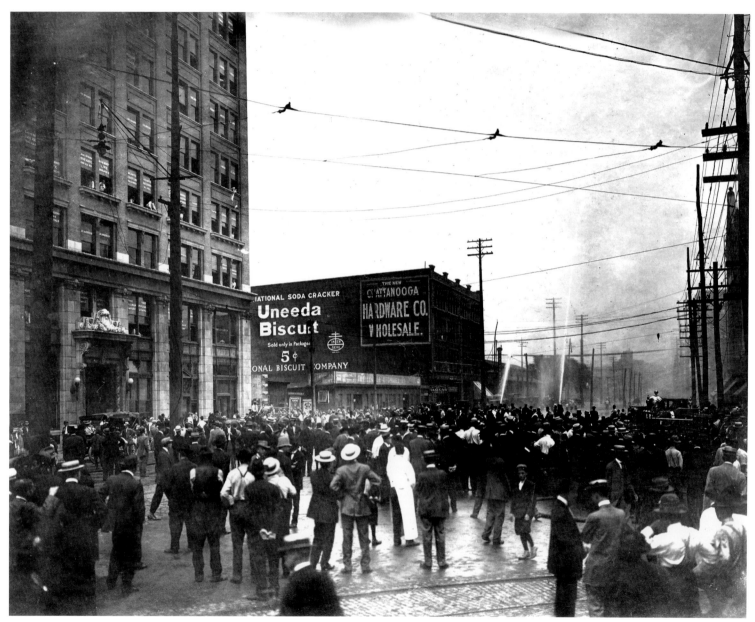

Crowd gathers on Broad Street to watch a demonstration of a fire engine,
the "T. S. Wilcox," as it shoots jets of water into the sky. To the left stands
the James Building, built in 1906. (June 1910)

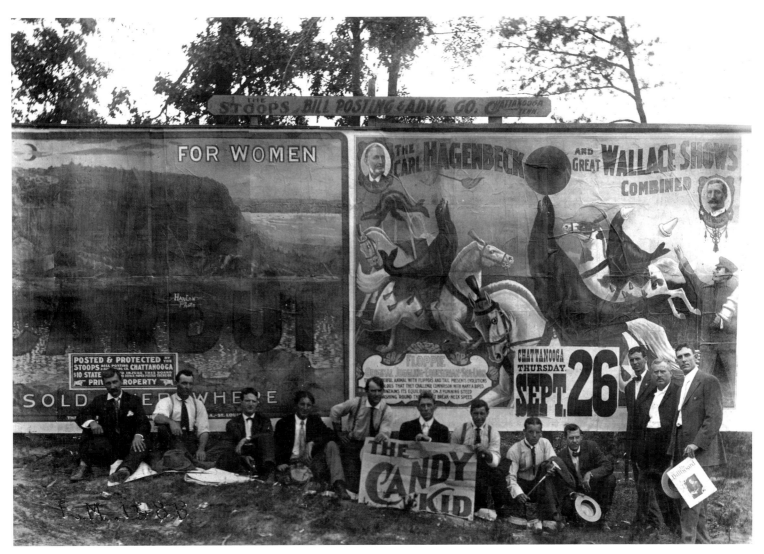

Circus promoters stand in front of a Stoops Company billboard advertising the combined shows of Hagenbeck and Wallace. Headliners include the Candy Kid and Floppie, "the original juggling equestrian sea lion." (ca. 1915)

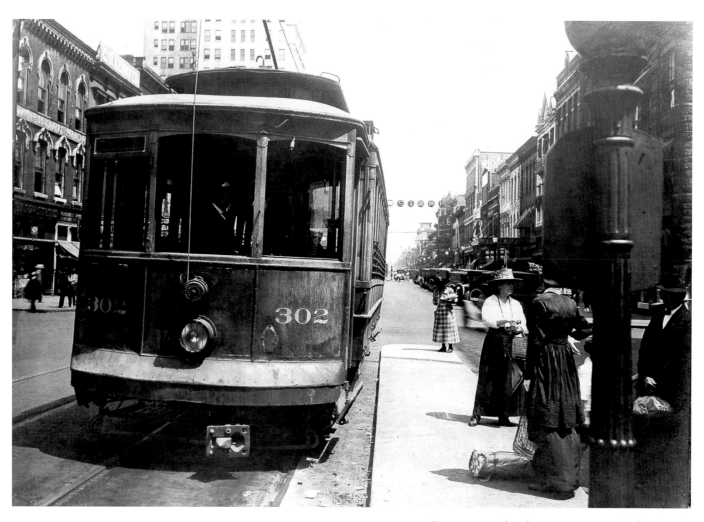

On a summer day three women on a platform at 8th and Market streets wait as the Chattanooga Railway and Light Streetcar approaches. Photograph by William Stokes (1919)

THE FIRST WORLD WAR
AND A DEVELOPING METROPOLIS

1918-1939

By the 1920s, prosperity was spreading throughout Chattanooga, jobs were plentiful, and the population of the town had been growing steadily for two decades. The downtown skyline was enhanced by fine commercial architecture, such as the striking McLellan Building, the original home of Provident Life and Accident Insurance Company. In 1921, the Tivoli Theater on Broad Street presented Chattanoogans with a regal and intimate site for watching the magic of moving pictures. And the completion of the Dixie Highway would put Chattanooga on the great American tourist map, bringing new travelers to the Scenic City of the South.

The year 1925 saw the opening of Lake Winnepesaukah, an amusement park still in operation today; and, a Lookout Mountain entrepreneur, Garnet Carter, created a game called Tom Thumb Golf, played with a putter and fanciful obstacles that spread throughout the country as miniature golf. For fans of the national pastime, Engel Stadium became a reality as the decade of the thirties began. Named for gregarious baseball personality Joe Engel, it was the scene of one of baseball's grandest promotions—the giveaway of a new house on a lot to one lucky fan during the Great Depression. Fans at the fabled park would also witness a southpaw female pitcher named Jackie Mitchell strike out Babe Ruth and Lou Gehrig in the same inning at a spring exhibition game.

The Great Depression of the 1930s hit the people of the Tennessee Valley as hard as the blues sung by Chattanooga native Bessie Smith. But some in the town were able to prosper. Two entrepreneurs saw an opportunity in these tough times to introduce Chattanoogans to an inexpensive meal called the Krystal hamburger. Also undeterred by the economics of the era, the Carters created Rock City out of a fancy for gardening and fairy tales, and nearby a determined spelunker would open Ruby Falls for all to see. When Franklin Roosevelt announced plans to begin the Tennessee Valley Authority, prominent Chattanoogans made sure their city would be the location of one of the first dams built on the river. And in 1936, the opportunity for good jobs and a chance to see the unpredictable Tennessee River tamed began to take shape as land was cleared for the construction of the Chickamauga Dam.

U.S. Army Mass Band concert on the Hamilton County courthouse lawn
during World War I. (1918)

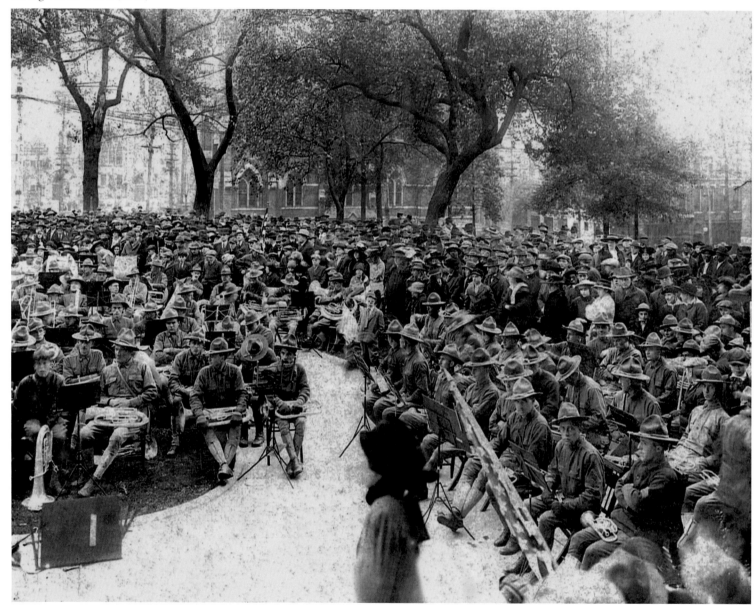

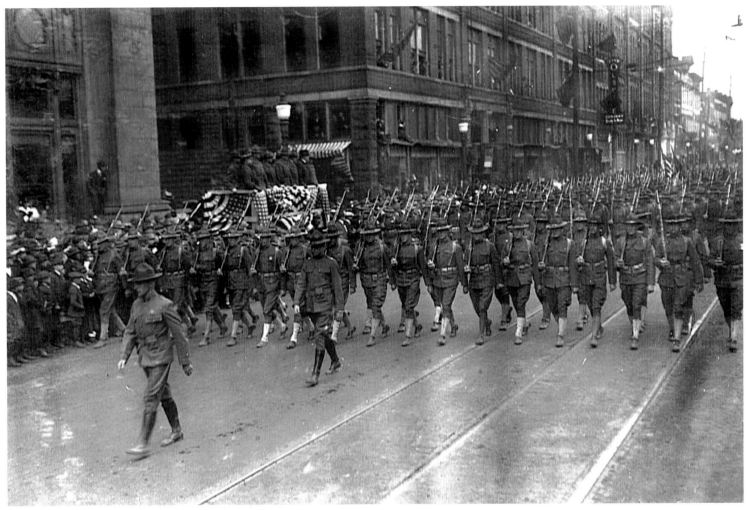

Soldiers march past a reviewing stand in the 3rd Liberty Loan
parade in 1918. The sale of war bonds was important to
financing World War I. (April 1918)

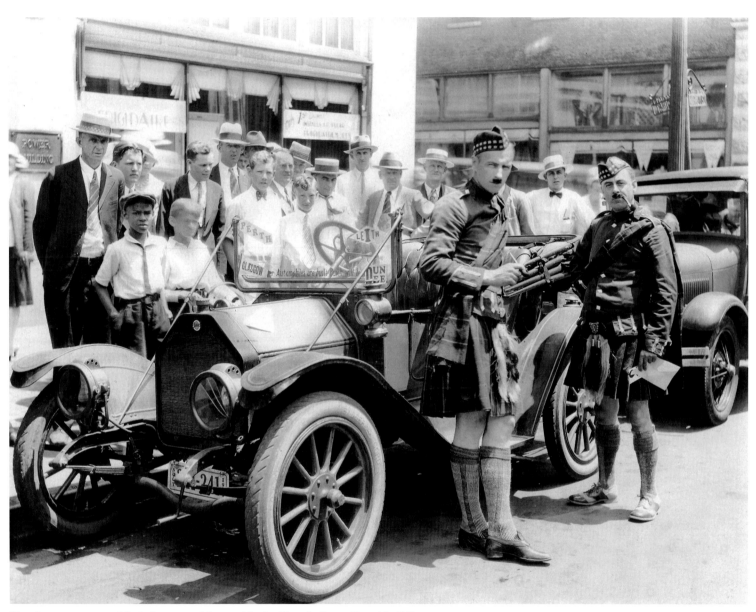

Two Scotsmen pose with their automobile outside the Electric Power Board building.
Automobile events, often sponsored by the Dixie Highway Association, were popular
ways to promote the need for good roads in Tennessee. (ca. 1919)

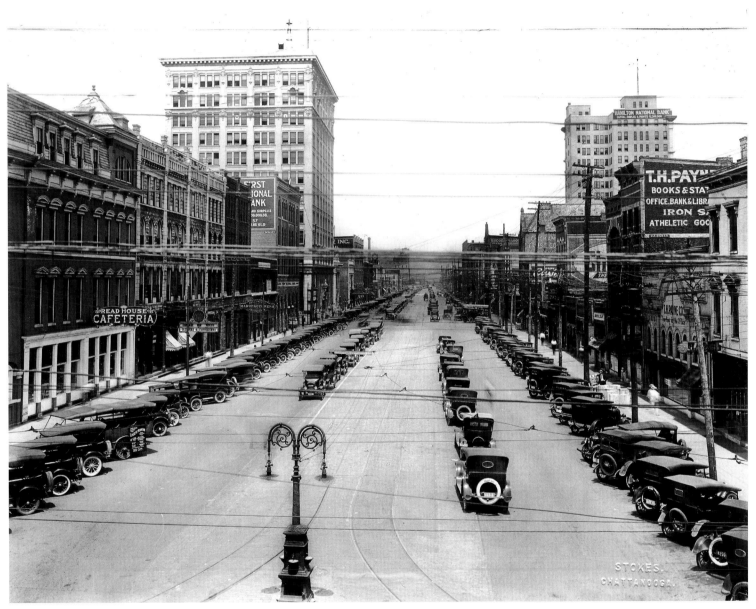

All the parked automobiles indicate business is booming on Broad Street. The wrought iron structure in the center is the Women's Christian Temperance Union water fountain. Photograph by William Stokes (1921)

The business use of mail for correspondence and advertising saw rapid increases in the 1920s. This metered mail machine helped to organize mass mailings. (ca. 1924)

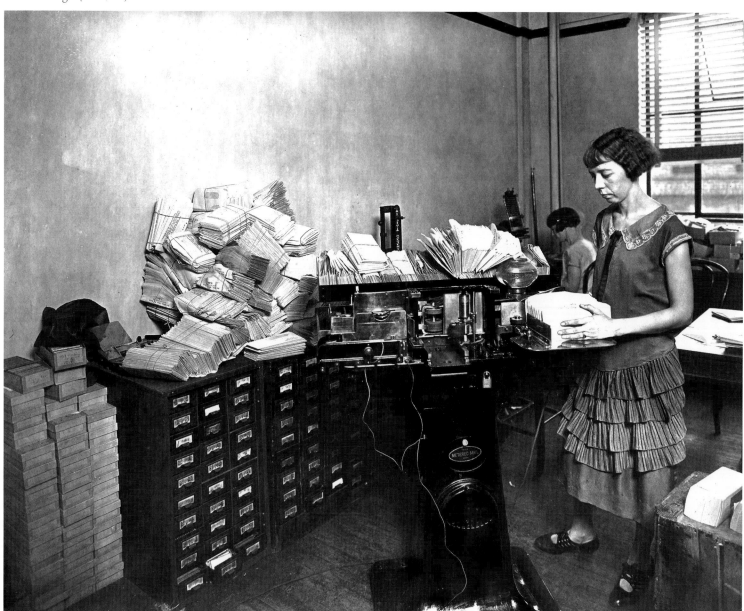

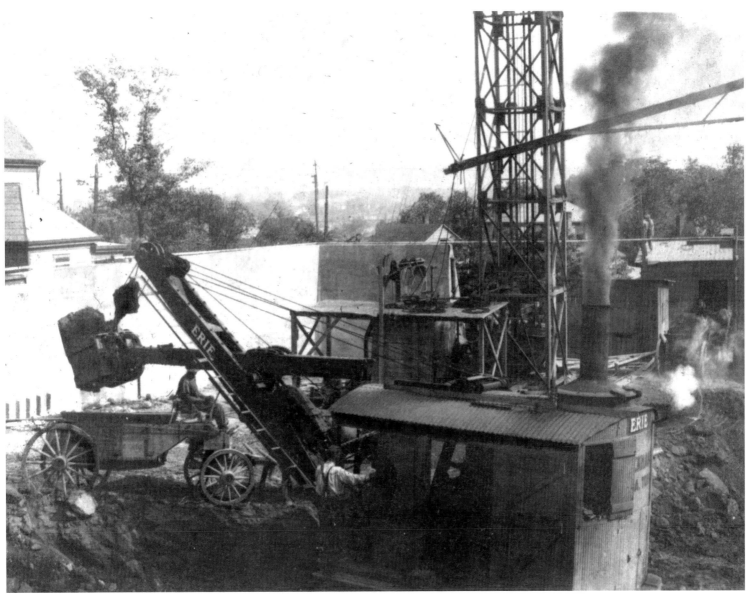

Chattanooga's growth in the 1920s spurred on many building projects. Here
a steam shovel works full bore on the water company basin or reservoir area.
(July 31, 1925)

One of Chattanooga's handsomest structures, the twelve-story MacLellan Building on Broad Street was built in 1924 as the home of the Provident Life and Accident Insurance Company. Designed by Chattanooga architect R. H. Hunt, the office building has a sloping mansard roof topped with green tile. (ca. 1925)

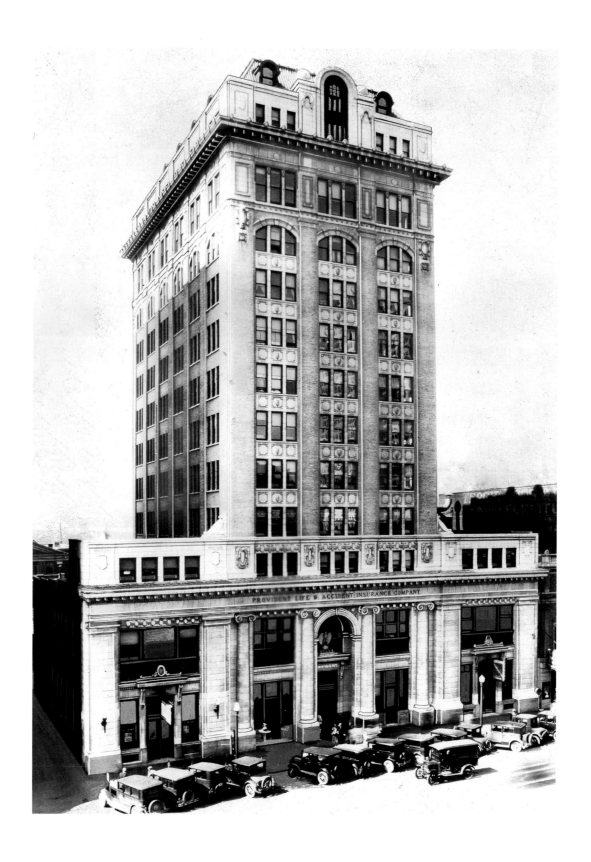

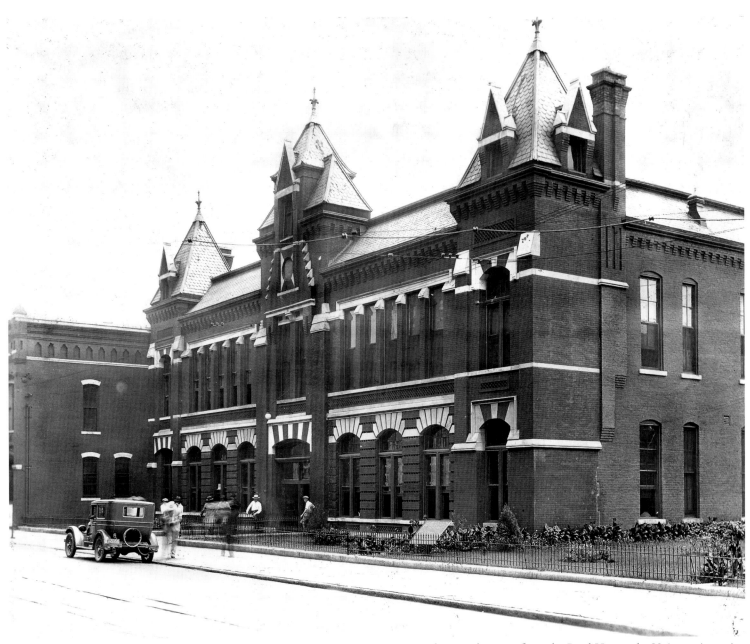

Located across the street from the Read House, the Union train station signaled the importance of Chattanooga as a national rail center. This brick Victorian-style station with slate roof was completed in 1882; it fell victim to the wrecking ball in 1973. (ca. 1924)

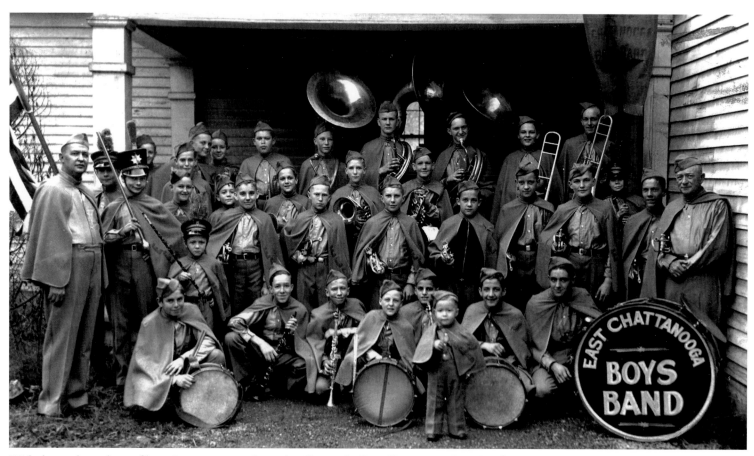

With three tubas, a bevy of brass instruments, and caped uniforms, the East Chattanooga Boys Band
must have been a lively addition to any parade. (ca. 1925)

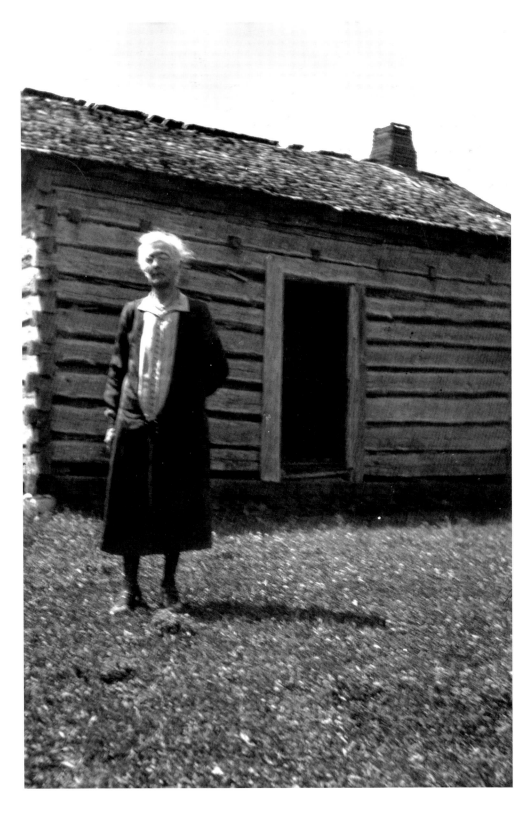

Julia Snodgrass Reed stands on the Chickamauga Battlefield in front of her family home on Snodgrass Hill. The house on Snodgrass Hill was the site where General Thomas—the "Rock of Chickamauga"—and his Union troops made their stand, thus preventing a complete rout at Chickamauga. (1927)

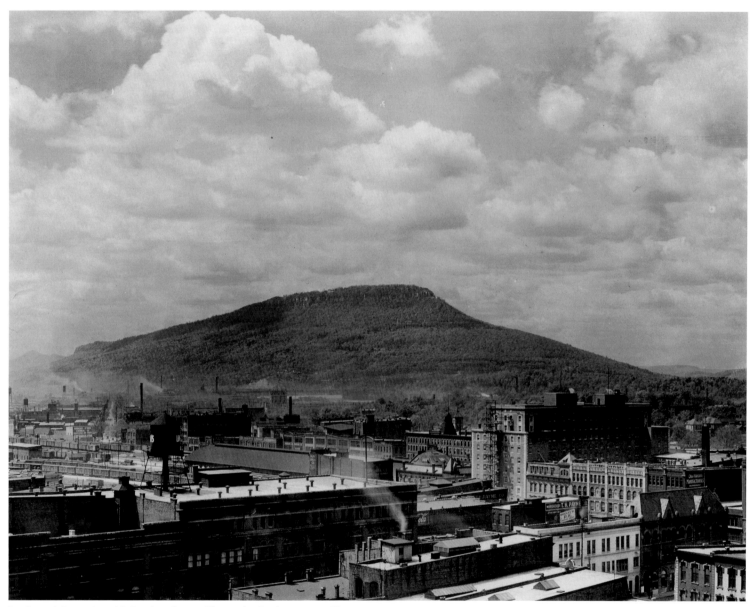

Lookout Mountain with its singular profile overlooks downtown Chattanooga.
The tallest building to the right of center is the Read House; the many smokestacks
to the left indicate the industrial section south of downtown. (ca. 1930)

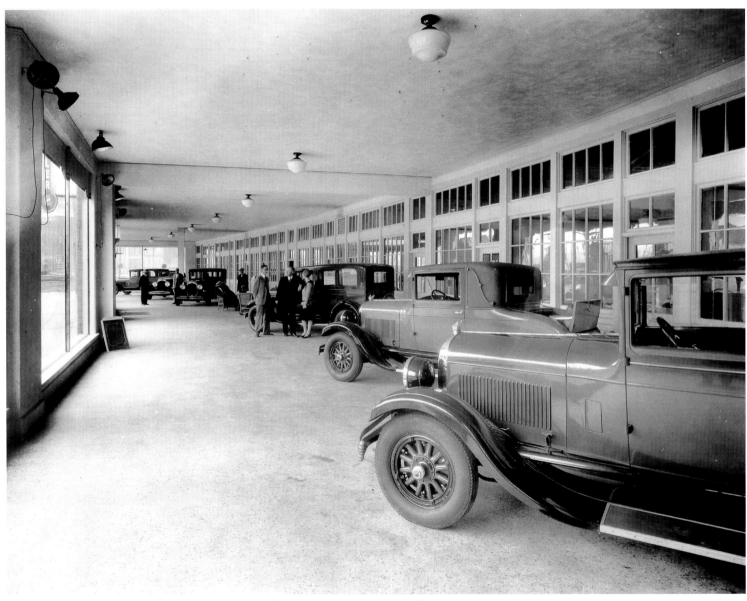

Showroom floor of the J. H. Alday Motor Company from 1928 to 1929. Founded by
Joseph Howard Alday, the company sold Chrysler automobiles. (1928)

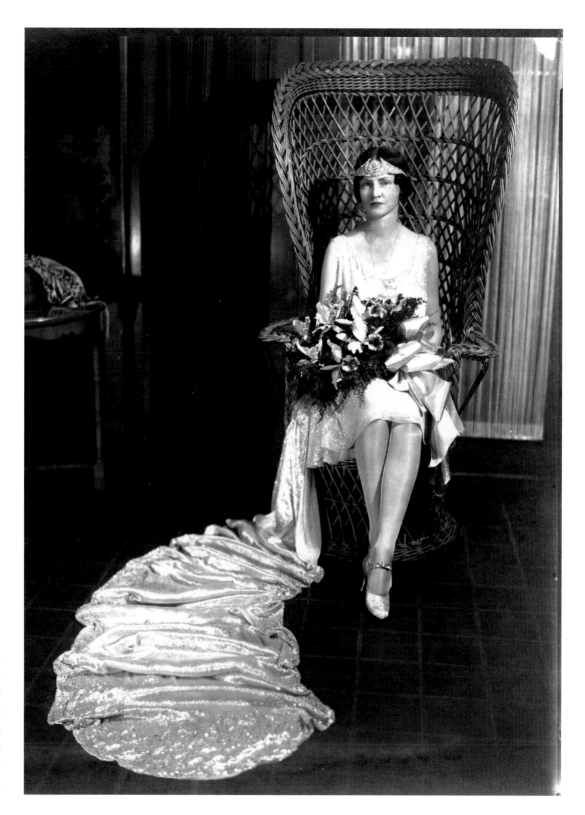

Dressed in satin splendor on a wicker throne, Mrs. Samuel C. Hutcheson reigned as queen of the Junior League Ball in 1928. The former Miss Katherine Andrews would become a major benefactor of the vision care center at Erlanger Hospital.

Built in 1886, the Hotel Northern was located at 8th and Chestnut streets.
John Ott's tailor shop and a Turkish bath were two of the retail operations
on the ground floor. (1928)

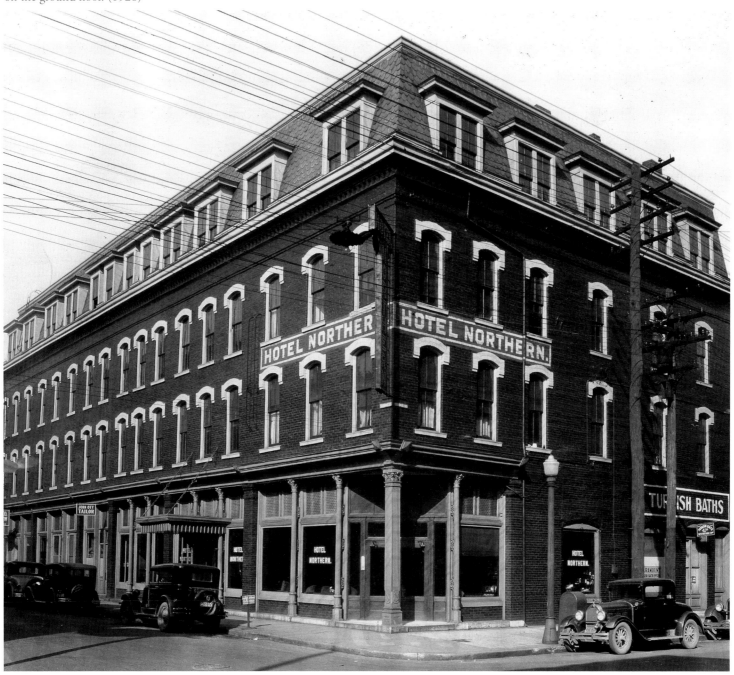

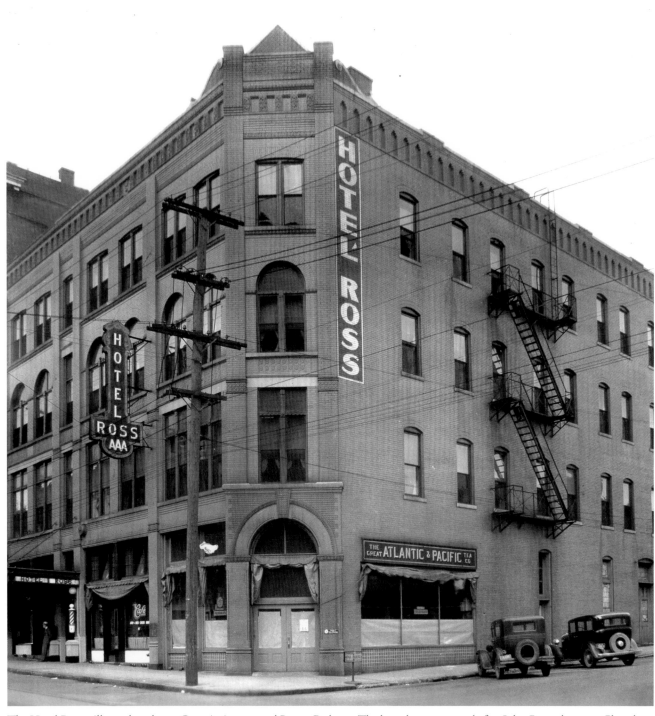

The Hotel Ross still stands today at Georgia Avenue and Patten Parkway. The hostelry was named after John Ross, the great Cherokee chief, who founded Chattanooga by establishing a ferry at Ross's Landing on the Tennessee River in 1815. (1928)

Lobby of the Tivoli Theater is decorated with promotions for coming
attractions. The theater employed painter Andrew Hill Wootten,
whose artistic creations grace the walls. (1929)

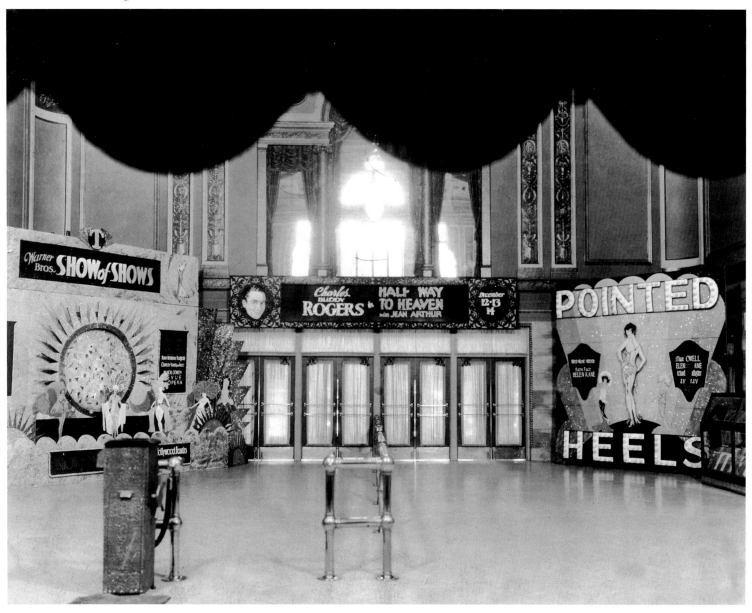

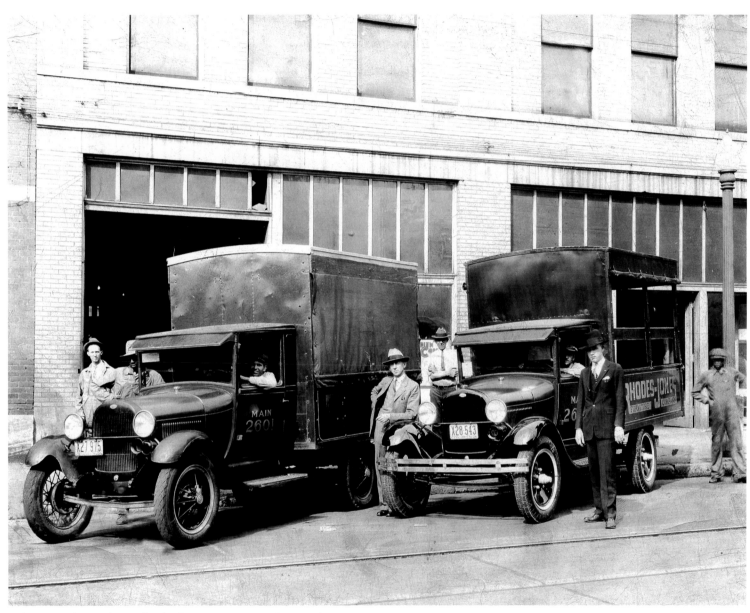

Delivery trucks stand outside Rhodes-Jones Furniture Store at 608
Market Street, where the store was located for twenty years from 1923
to 1943. (1929)

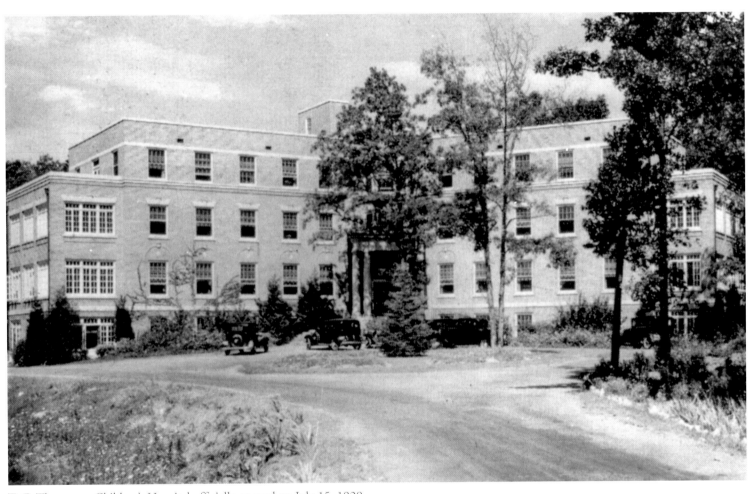

T. C. Thompson Children's Hospital officially opened on July 15, 1929, in the Glenwood area. Today the hospital continues serving children at the Erlanger Baroness campus where it moved in 1975. (1929)

Unusual depiction of the Walnut Street Bridge taken with infrared black-and-white film. Closed to automobile traffic in 1978, the structure is now considered the world's longest pedestrian bridge. (1935)

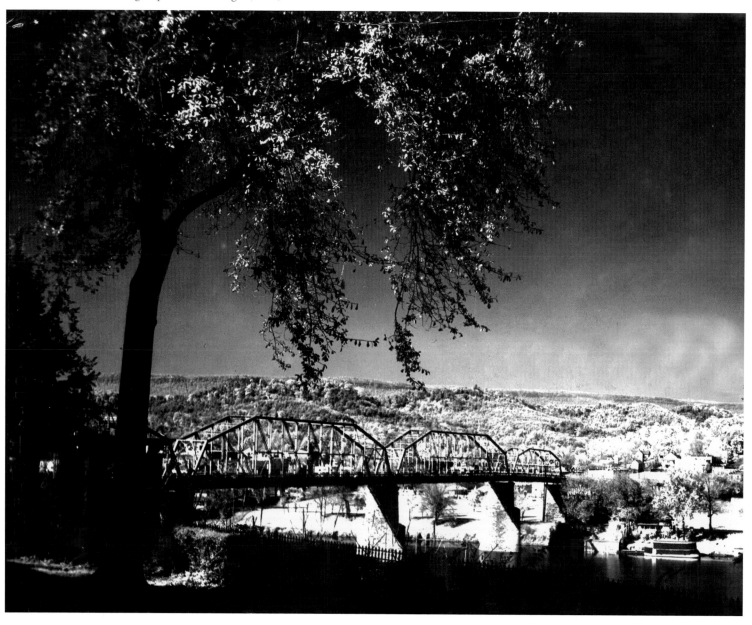

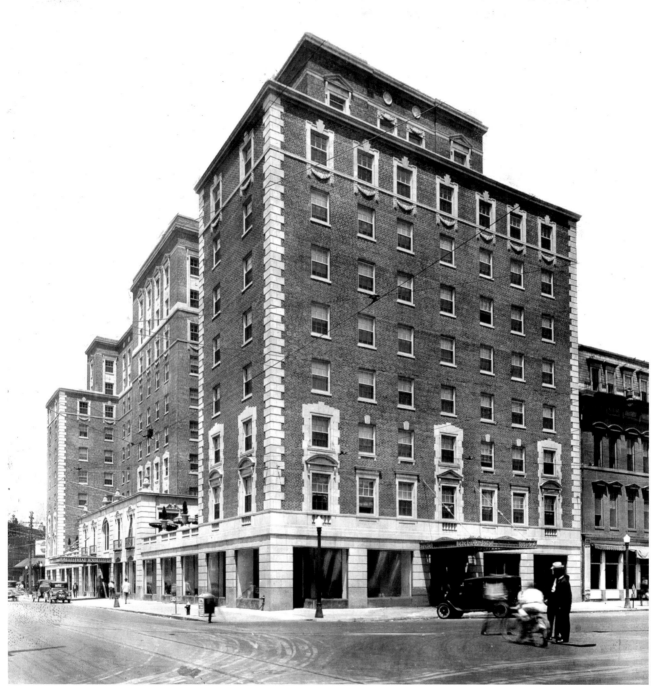

A blurry bicycle rider is visible in front of a Chattanooga landmark, the Read House. This ten-story building with its beautiful walnut-paneled lobby and terrazzo floor inlaid with marble was built in 1926, and replaced the original Read House that had stood on that spot since 1871. (1930)

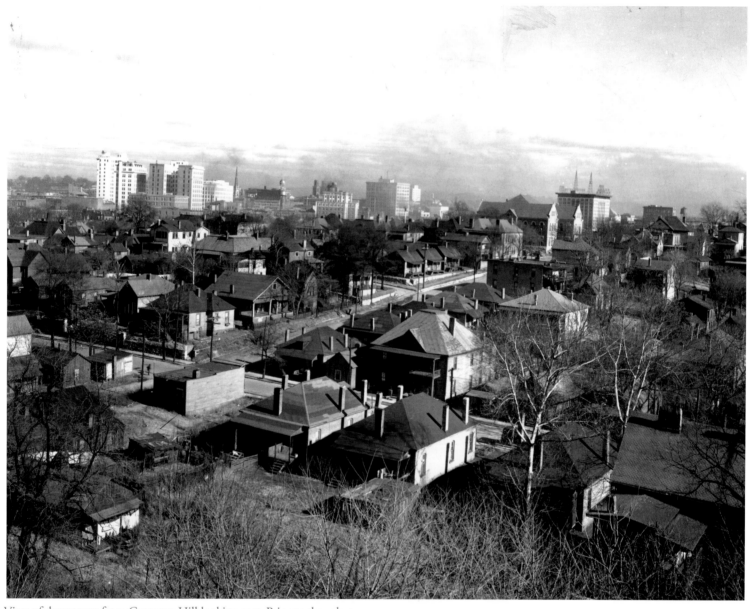

View of downtown from Cameron Hill looking east. Prior to the urban
renewal movement of the 1950s, Cameron Hill was heavily residential.
Photograph by Matt L. Brown & Co. (ca. 1930)

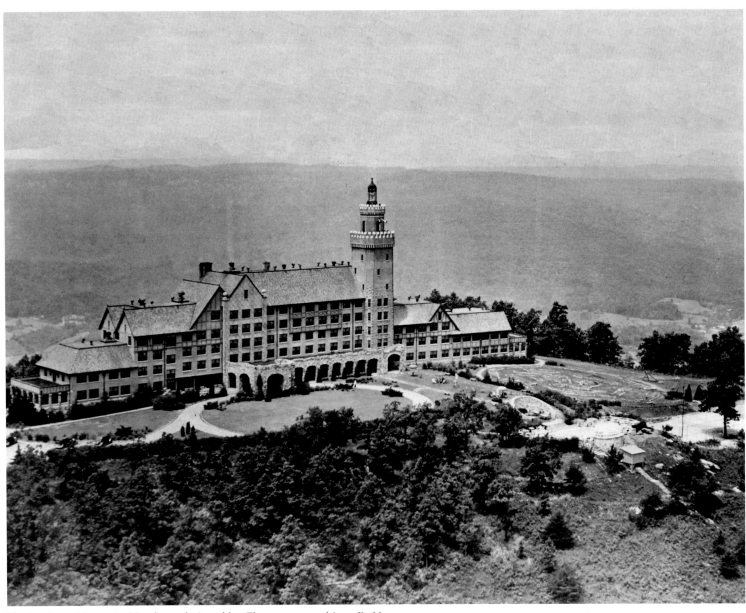

The Lookout Mountain Hotel was designed by Chattanooga architect R. H. Hunt and built by Paul Carter in 1927. Known for years as the "Castle in the Clouds," it became the campus of Covenant College in 1964. (ca. 1932)

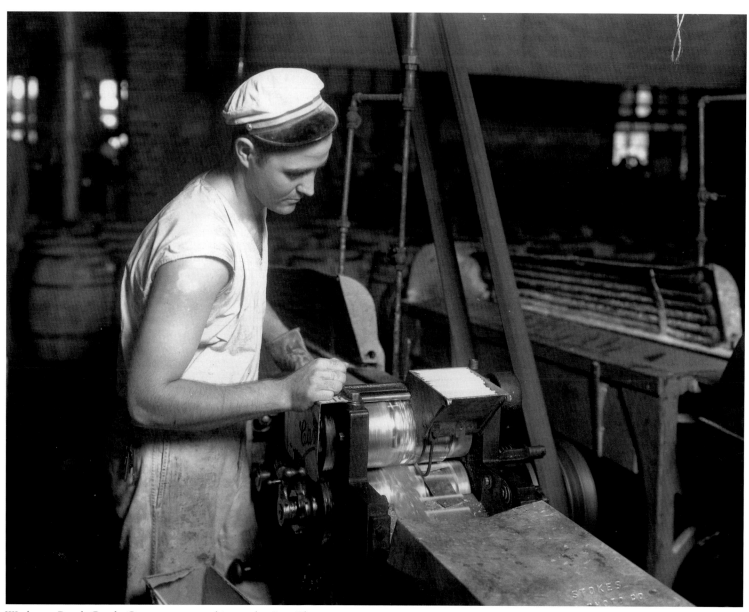

Worker at Brock Candy Company engaged in production. The sweets company
was started in 1909 by William E. Brock, who would later become a U.S. Senator
from Tennessee. Two generations later his grandson, William E. Brock III, would be
elected to the U.S. Senate from Tennessee. Photograph by William Stokes (1930)

The Signal Mountain bus seems to glide by the trolley as it heads for the end of the line. Hugh Parks, trolley operator, directs Number 51 on its final day on the tracks. The following day the "ugly duckling" replaced the streetcar on this route. (July 4, 1934)

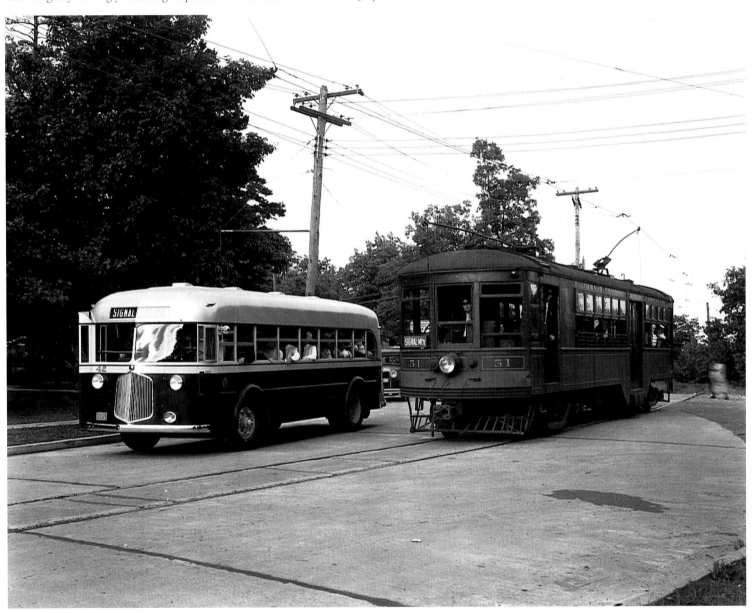

What finer way to spend an afternoon than to dine outside with good food and wonderful friends. The rock formations on the Chattanooga mountains can make convenient tables and the altitude serves as a deterrent to insects. (ca. 1930)

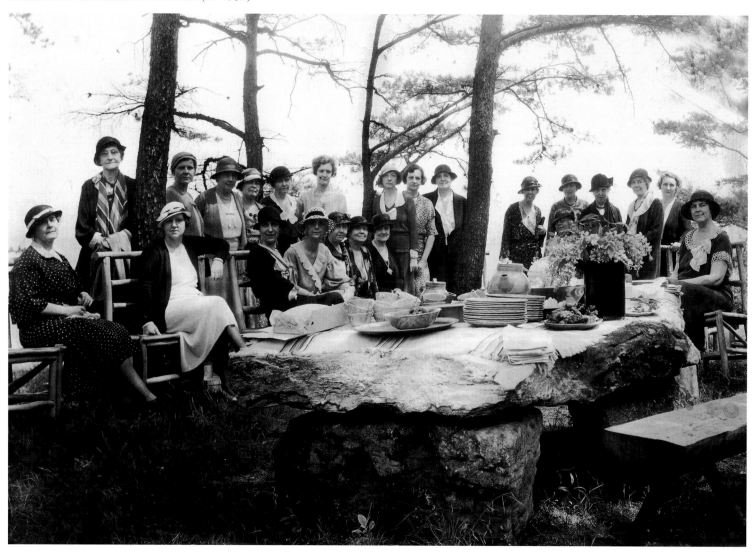

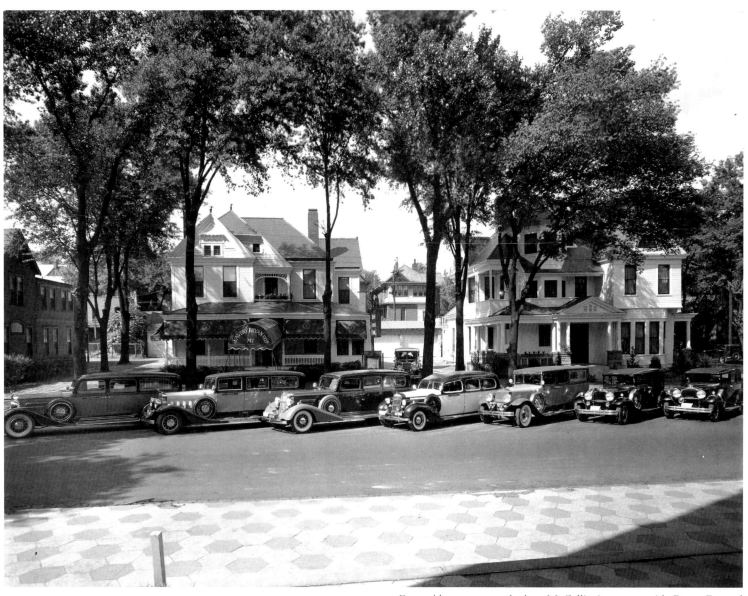

Funeral hearses are parked on McCallie Avenue outside Bryan Funeral Home, the former residence of R. B. Davenport. Begun in 1929, the funeral company is one of the oldest in the region. (ca. 1932)

Judge and Mrs. Will Cummings stand outside their home in Wauhatchie.
Judge Cummings was heavily involved in the promotion of the Dixie
Highway and the Chickamauga Dam project. (ca. 1932)

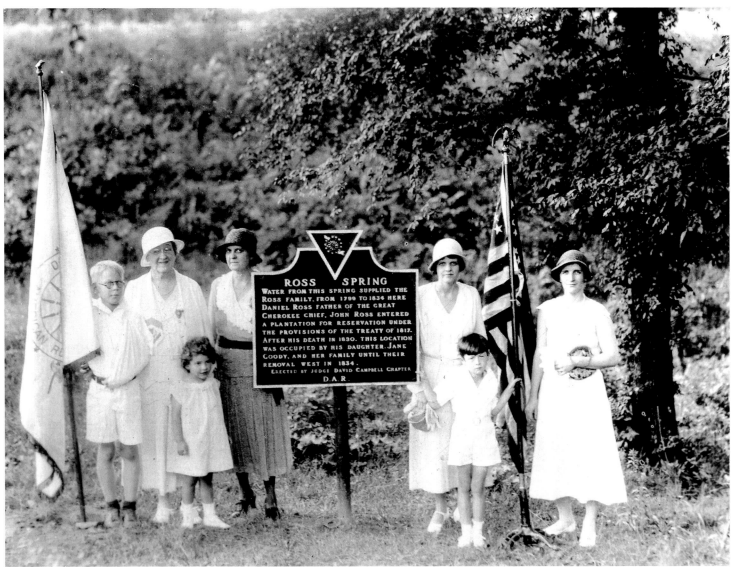

The sign in the image reads:

ROSS SPRING
WATER FROM THIS SPRING SUPPLIED THE
ROSS FAMILY. FROM 1790 TO 1834 HERE
DANIEL ROSS FATHER OF THE GREAT
CHEROKEE CHIEF, JOHN ROSS ENTERED
A PLANTATION FOR RESERVATION UNDER
THE PROVISIONS OF THE TREATY OF 1817.
AFTER HIS DEATH IN 1830. THIS LOCATION
WAS OCCUPIED BY HIS DAUGHTER. JANE
COODY, AND HER FAMILY UNTIL THEIR
REMOVAL WEST IN 1834.
ERECTED BY JUDGE DAVID CAMPBELL CHAPTER
D.A.R.

Daniel Ross, the father of the famed Cherokee leader John Ross, was one of Chattanooga's first recorded settlers. The Daughters of the American Revolution dedicate a plaque at the foot of Lookout Mountain to mark the spring where he lived. (1932)

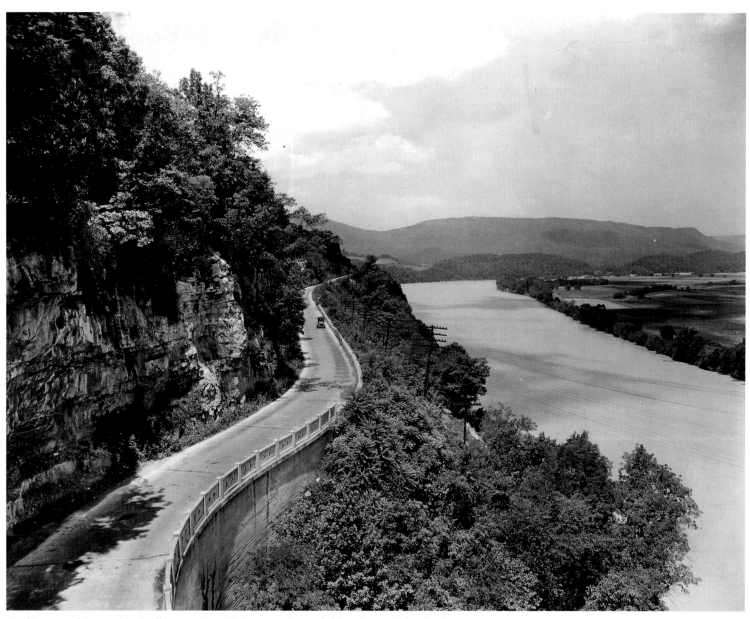

A solitary car drives on the Will Cummings Highway as the road skirts the south bank of the Tennessee River across from Moccasin Bend. The highway, named for the prominent judge in Chattanooga who helped promote road construction, opened in September 1930. (ca. 1932)

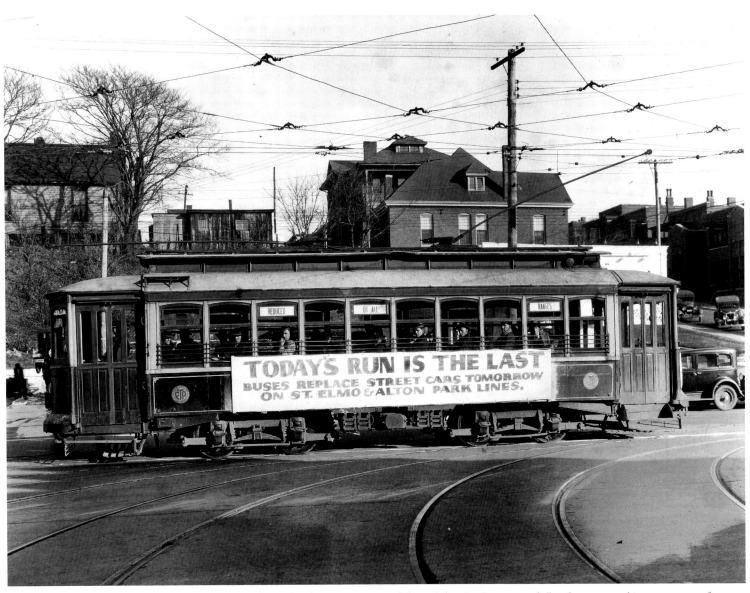

"Today's Run Is The Last" reads sign on side of trolley. The ubiquitous automobile and the city "motorcoach," or bus, were taking passengers from the trolley lines. (November 1932)

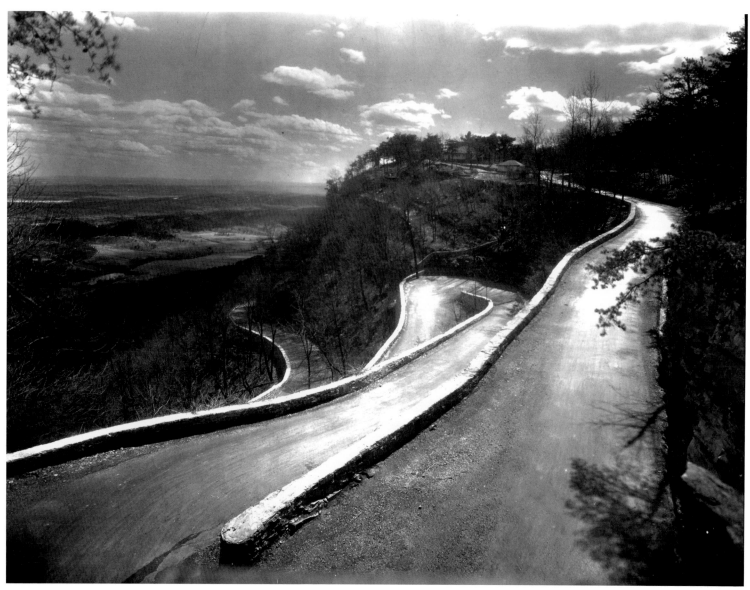

One of Chattanooga's most renowned roads is the "W" road on Signal
Mountain, so named because of the shape of the switchback curves.
Constructed in 1893 on the east side of the mountain, it followed a corduroy
or log road used during the Civil War. In 1927 the road was widened, and
mortared walls were put in place. Photograph by Cline (ca. 1930)

Chattanoogan Garnet Carter is generally credited with creating the first miniature golf course, which he called "Tom Thumb Golf." A master promoter, Carter organized a company to manufacture the courses with their obstacles in 1928, selling it a year later to an organization in Pittsburgh for a handsome profit. (ca. 1930)

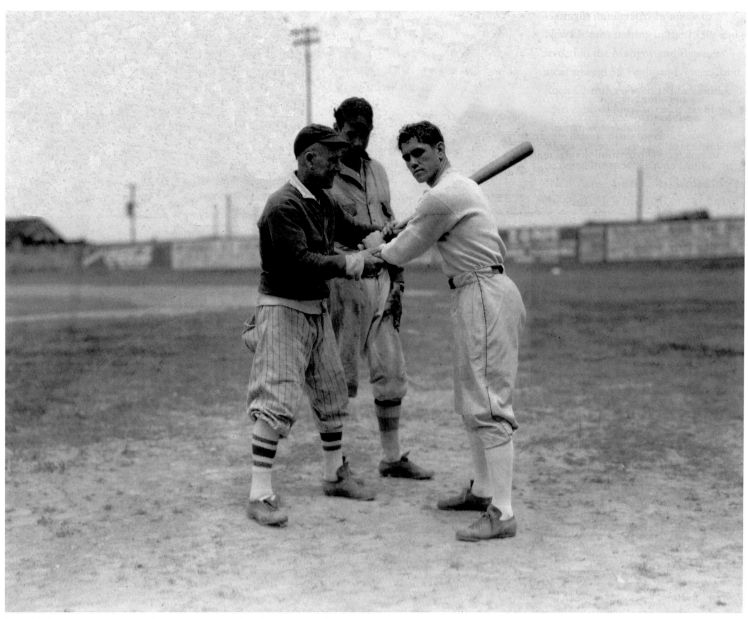

"Kid" Elberfeld working on hitting fundamentals with a young player. Norman Arthur Elberfeld played professional baseball with six teams including the New York Highlanders, who later became the storied New York Yankees. Known as the "Tabasco Kid", because of his fiery style of play, he was manager for the Chattanooga Lookouts on three different occasions. (ca. 1932)

This young ballplayer looks ready for a quick grounder from "Kid" Elberfeld. The 5-foot 5-inch Elberfeld was known as a competitive, temperamental athlete, whose legs were badly scarred from his aggressive style of play. A manager for many years in the minors, he and his family made their home on Signal Mountain.

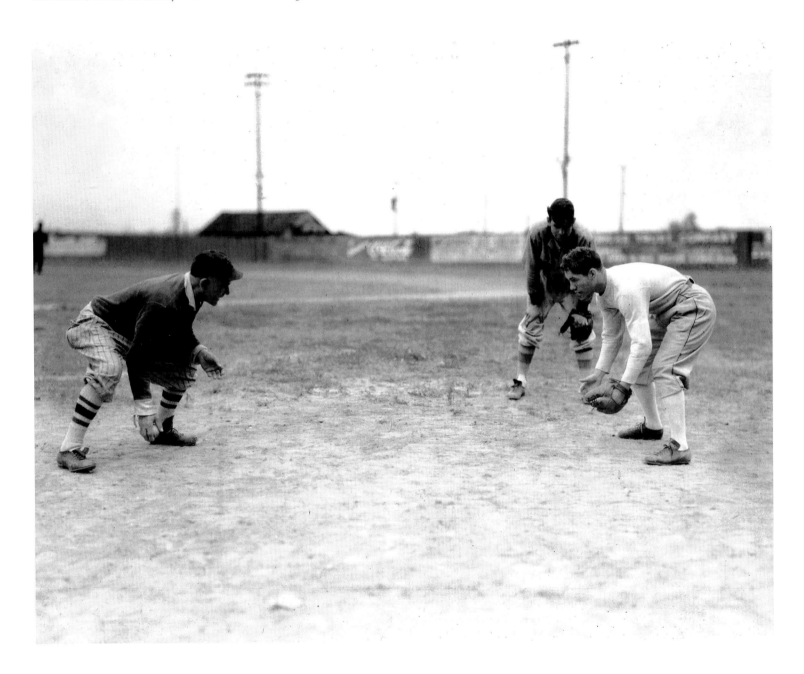

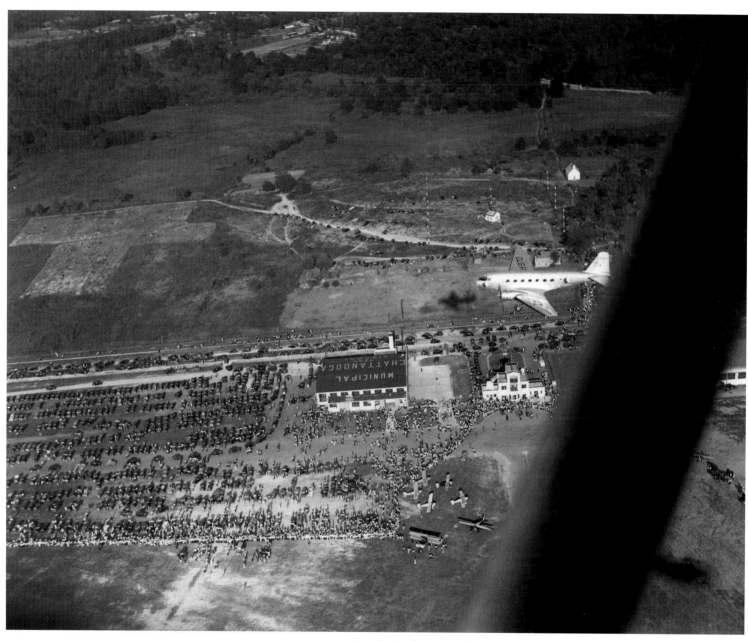

Hundreds of automobiles parked at the Municipal Airport indicate a crowd has gathered to watch an acrobatic air show. Also known as Lovell Field, the facility opened in 1930 on 130 acres of land in Brainerd, near Chickamauga Creek. John Lovell was a local aviation enthusiast and promoter, who once brought Charles Lindbergh to Chattanooga for a visit. Photograph by Roy Tuley (ca. 1935)

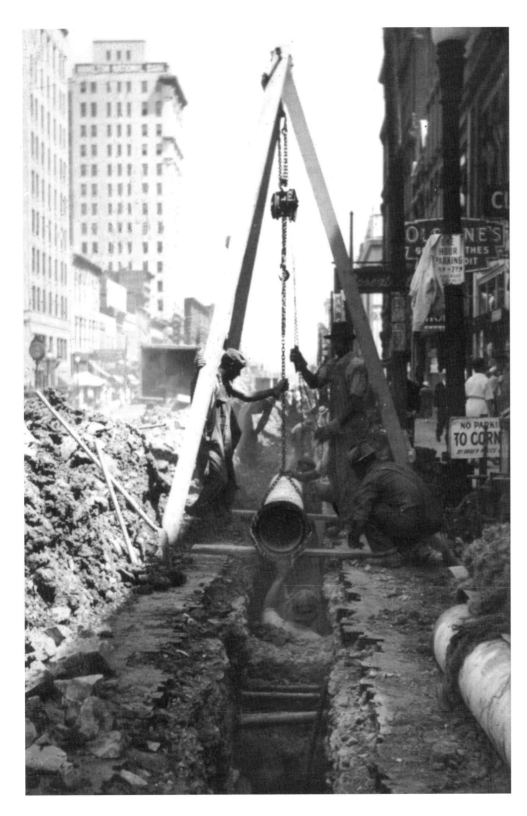

A busy city is always under construction. With the Hamilton National Bank looming in the background, workers guide a 12-inch pipe into a deep trench on Market Street. (June 1935)

Lights span Market Street at Christmastime. This nighttime
view was taken near 5th Street looking south. (ca. 1936)

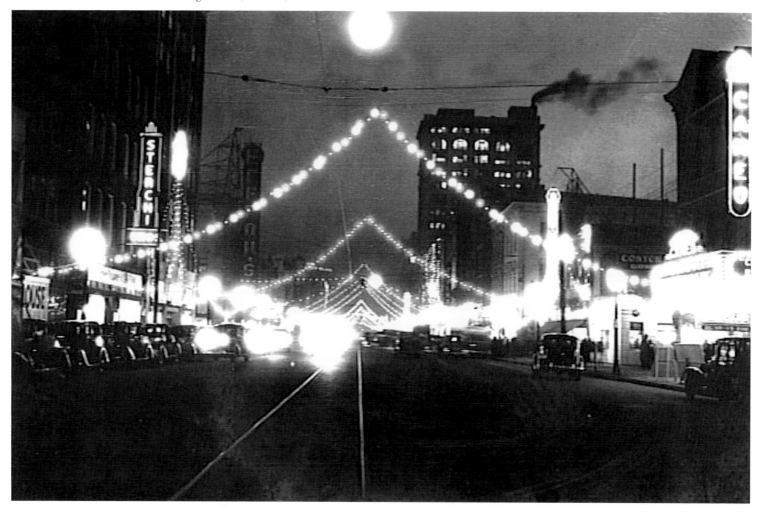

This young man was one of many who learned to fly at Porter's Flight School at Lovell Field. Owner Harry Porter, who first flew in 1923, had an active sixty-four-year career in aviation. At the age of ninety, he was recognized as the oldest active pilot in the United States. (ca. 1935)

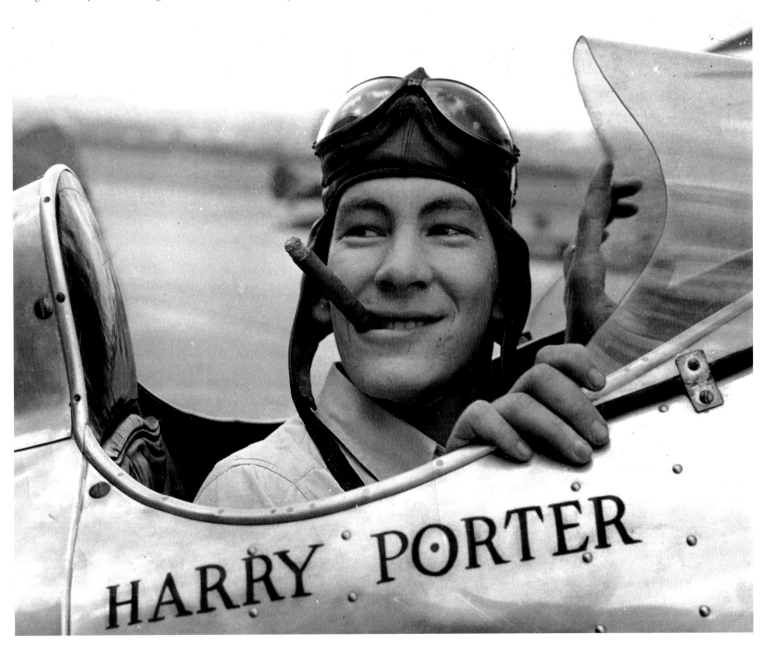

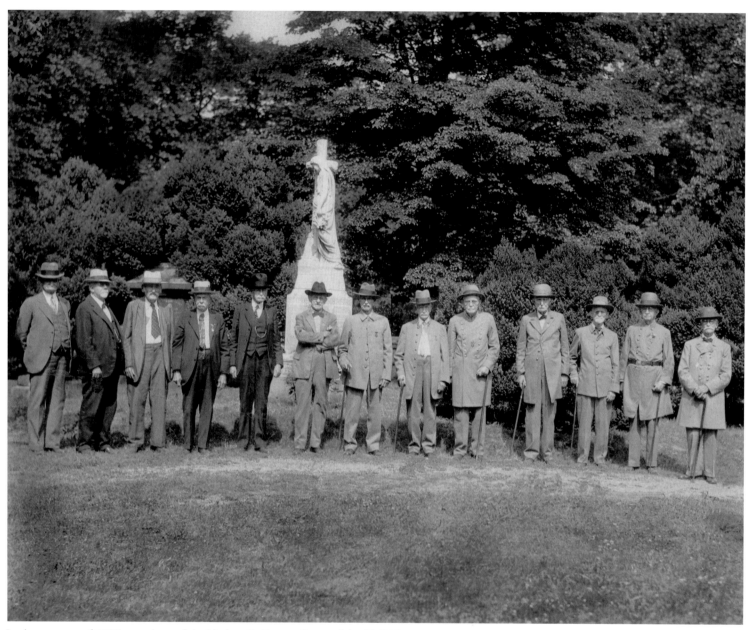

In the summer of 1937, members of the Nathan B. Forrest Camp of the U.C.V. were photographed at the Silverdale Cemetery. The cemetery was established primarily as a final resting place for one hundred fifty-five unknown Confederate soldiers who had perished in Chattanooga.

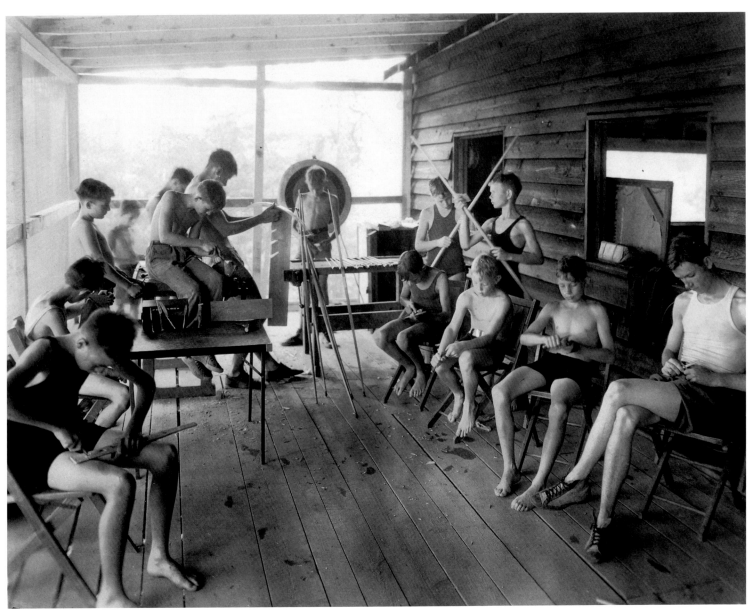

Working on a screen porch, summer campers seem deeply absorbed in woodcarving projects. The mountains around Chattanooga are home to many such woodland camps. (ca. 1936)

This view of the Tennessee River with Lookout Mountain in the distance was taken from Brady Point on Signal Mountain. The river winds around Williams Island, a site that archaeologists believe supported human habitation as far back as 5,000 years ago. (ca. 1938)

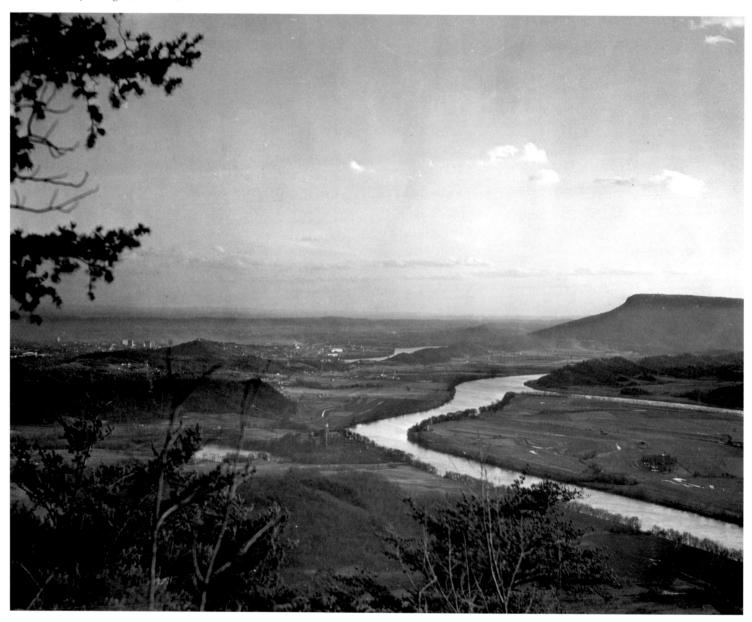

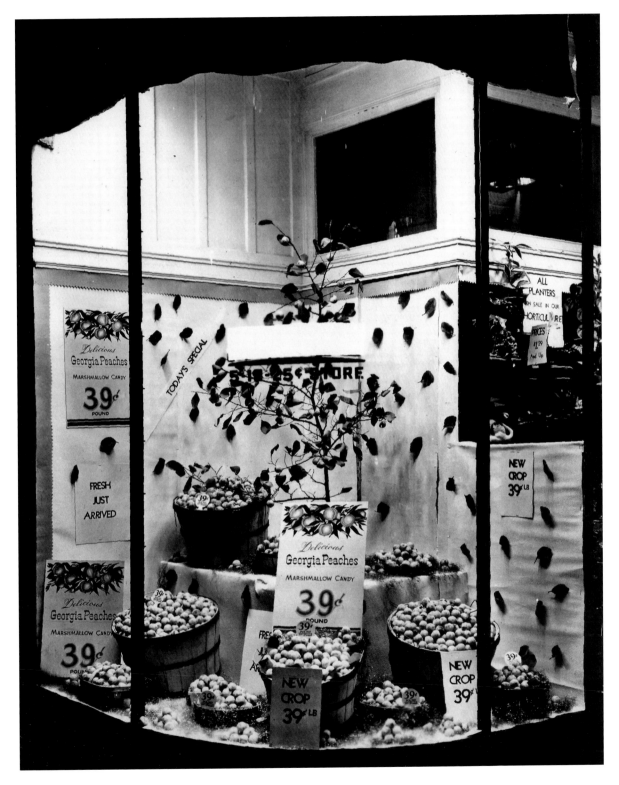

This enticing window display with fresh fruit indicates Chattanooga's 1930s agricultural surroundings. Though the city's economy was built on an industrial base, the roots of many citizens were in the mountains of east Tennessee and north Georgia, so good apples and fresh peaches were always a welcome sight. (ca. 1933)

A line forms in front of the Rogers Theater for the opening-day showing of *Three Guys Named Mike* with Van Johnson and Jane Wyman. Downtown movie theaters were thriving in the 1950s as this crowd demonstrates. Opened in 1951 with seating for 1,257 patrons, the motion picture house on Market Street closed its doors in 1976 as shopping mall movie screens became the choice of the viewing public. (1951)

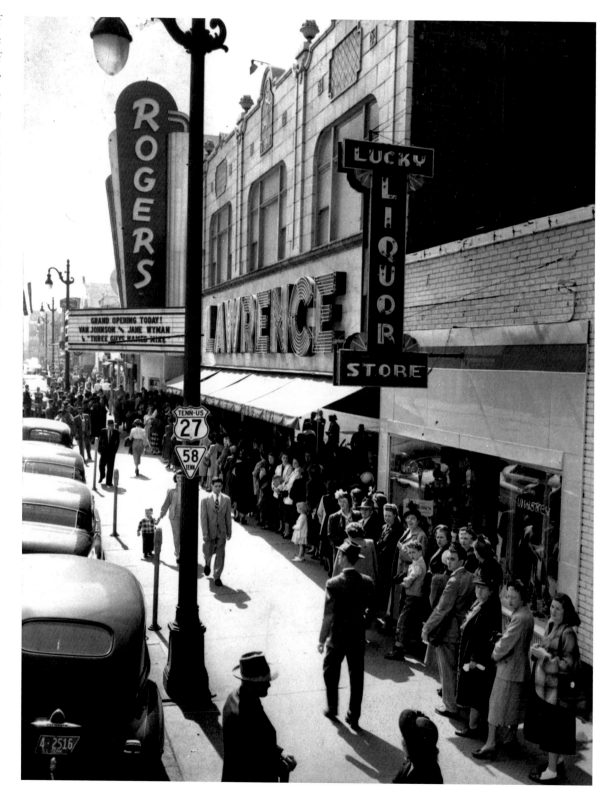

From the Forties to a Modern City
1940–1970s

On Labor Day, 1940, a presidential motorcade made its way north of town to the site of the newly completed Chickamauga Dam. There, Franklin Delano Roosevelt dedicated this public works project in a ceremony that was covered by three major radio networks and attended by thousands of people. Controlled by the Tennessee Valley Authority, the dam harnessed a wild river and turned it into an electricity-generating machine. It would lessen the cost of damaging floods and establish a lake that would be enjoyed by generations of Southerners. And certainly just as important was the creation of permanent jobs for many local families. A year later, Chattanooga was also garnering some free press when the hit song "Chattanooga Choo-Choo," by the Glenn Miller Band, became the first million-selling recording of all time.

Despite a slowly rising economic tide, all was not well as the clouds of World War II approached. Thousands of citizens enlisted in the service and many did their part on the home front, raising money for bonds and working in war support industries. Sadly, more than six hundred citizens of Hamilton County did not return from the fighting overseas. Change continued in Chattanooga as new businesses, like the photographic studio Olan Mills, moved to town in 1943, and the post at Fort Oglethorpe closed in 1946. When George Hunter of the Coca-Cola Company passed away, he left his mansion on the bluff to a local arts group, which opened the excellent Hunter Museum of American Art in 1952. Two years later there would be more than art to gaze at, as black-and-white television made its debut on WDEF-TV. The face of the city was changing as well, as parts of historic Cameron Hill were literally removed and over one thousand structures demolished. Some fourteen hundred families on the west side also were displaced as part of the city's "urban renewal" projects.

The decade of the 1960s affected Chattanooga like many cities with an industrial economic base. Manufacturing began to decline and jobs moved elsewhere. Years of unfettered pollution were taking their toll on the valley's air and water quality. And the railroad was quickly falling behind as the airways and the interstate highways became the preferred routes of travel. Chattanooga's last passenger train, the *Georgian,* would pull out of the station in 1971. The civil rights movement made its presence felt with a series of well-staged sit-ins in 1960. The community would decide that segregation's time had run out, and the public schools began integration in 1962.

Though Chattanooga had some difficult problems to solve as 1970 rolled around, the city's citizens would overcome. Decades of pollution would give way to a markedly cleaner environment. Before the century's end the city returned to the river, building an impressive aquarium on the site of Ross's Landing and bringing new life to downtown. Finally, the reopening of the popular Walnut Street Bridge would stand as a landmark preservation victory, keeping the modern city connected to its storied past.

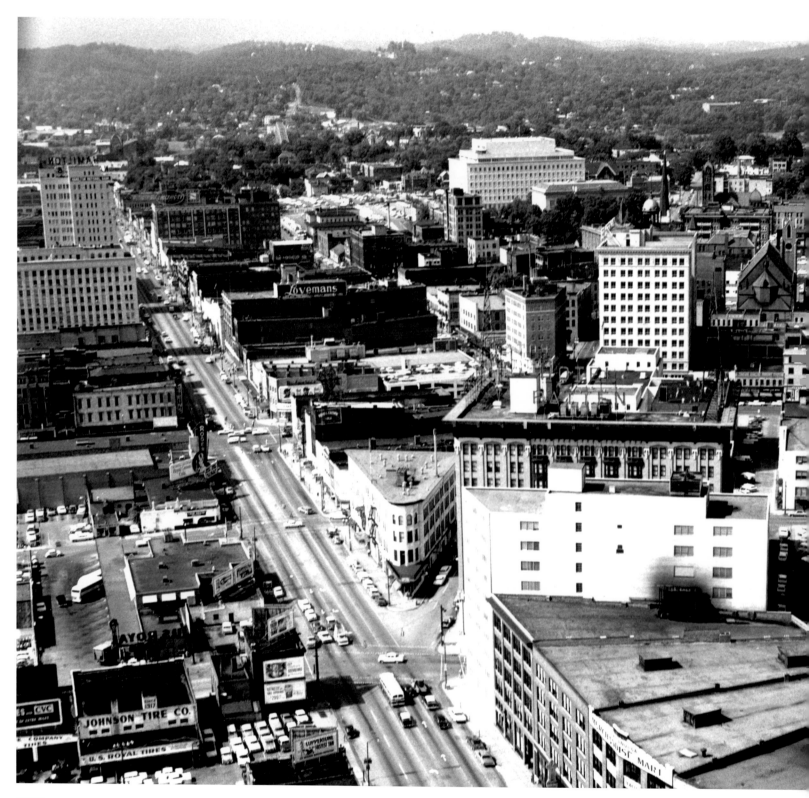

138

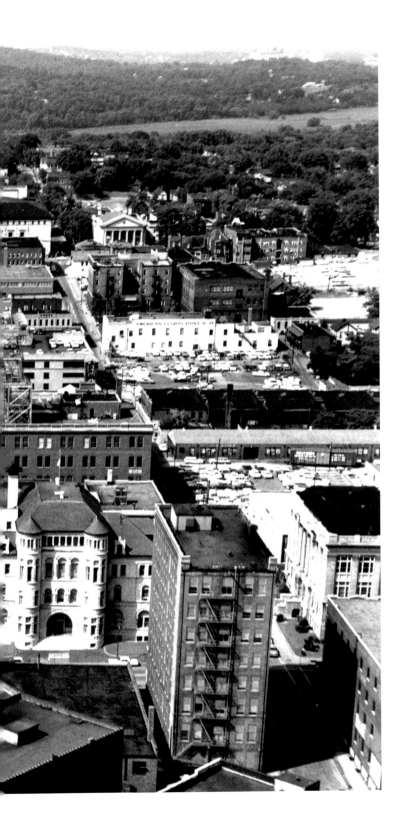

Aerial view of downtown Chattanooga looking north along Market Street. The hills of North Chattanooga are visible in the background. (ca. 1960)

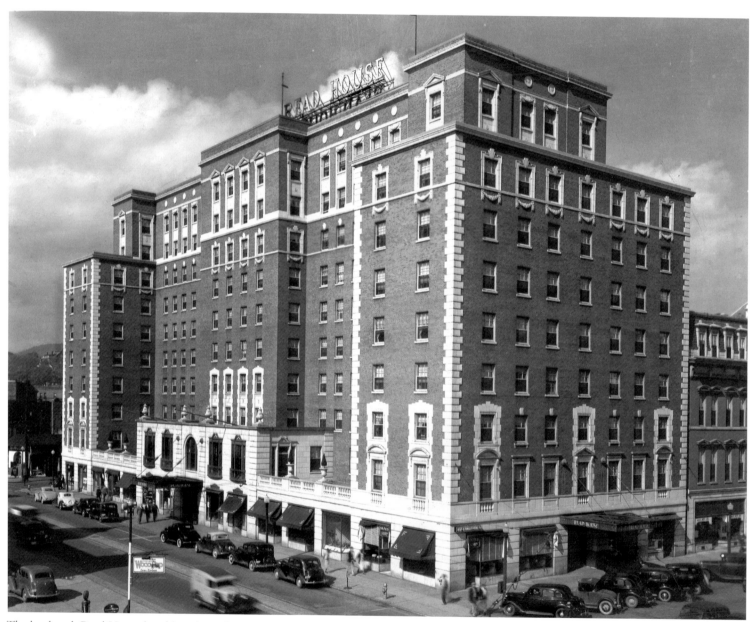

The landmark Read House hotel has always been a center of downtown activity. Located directly across from the Union depot, it has hosted a number of well-known personalities including Winston Churchill and Tallulah Bankhead. (ca. 1940)

Chattanooga's Municipal Building was built in 1908, replacing the previous one at Market Square. Commonly referred to as City Hall, it still houses the mayor and administrative offices. Photograph by Matt L. Brown & Co. (ca. 1940)

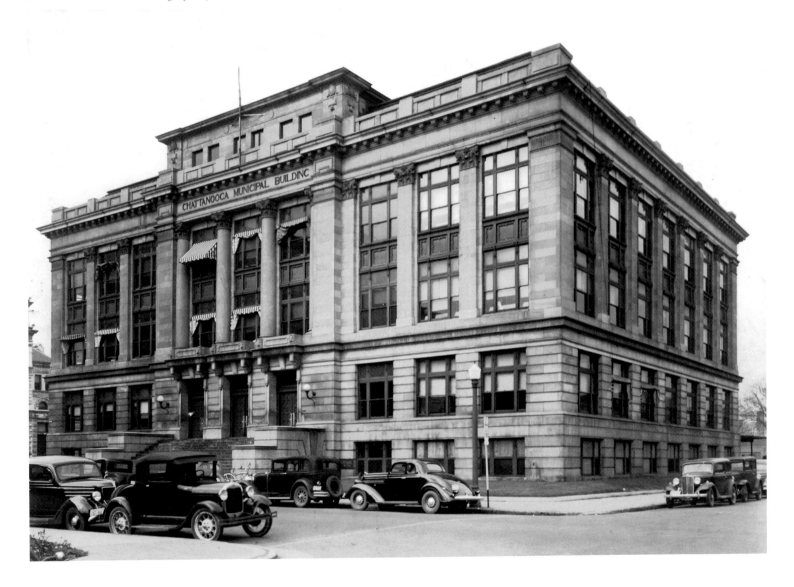

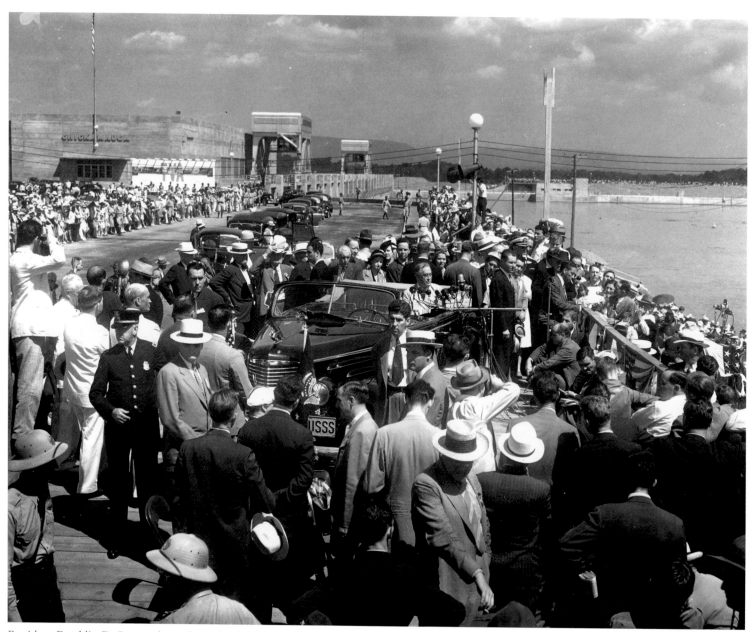

President Franklin D. Roosevelt speaks at the dedication of the Chickamauga Dam on September 2, 1940. The dam project brought badly needed jobs to the valley during the hard times of the Great Depression and made the Tennessee Valley Authority a permanent part of life in Chattanooga.

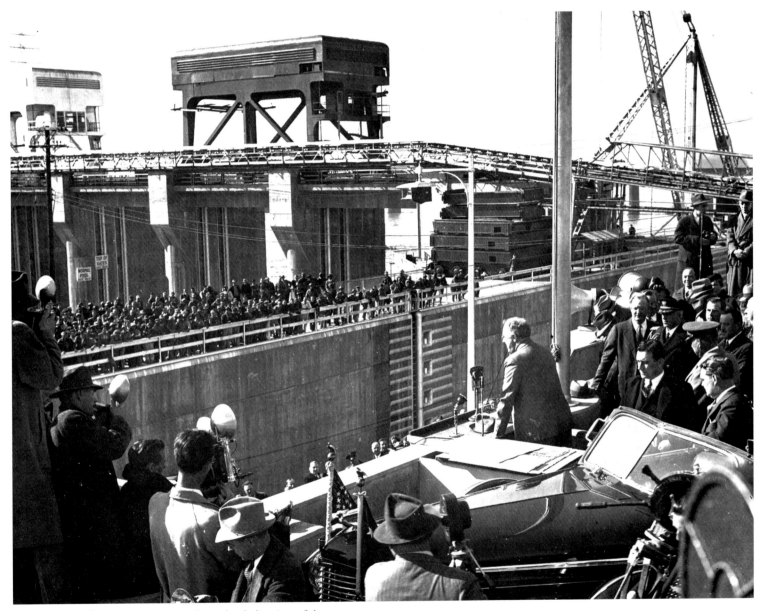

President Franklin D. Roosevelt speaks at the dedication of the
Chickamauga Dam on September 2, 1940. The view from behind
his automobile reveals how he supported himself on the side of the
vehicle's doors. He would be elected to an unprecedented fourth
term in office two short months later.

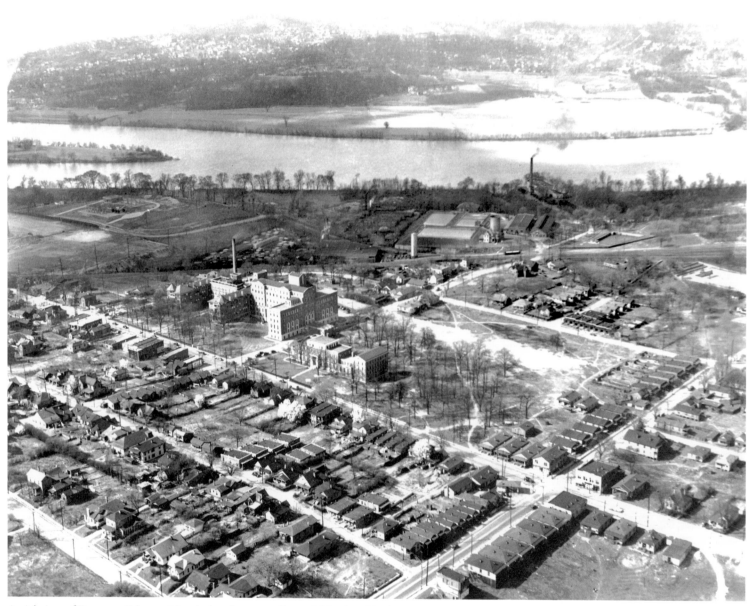

Aerial view of Baroness Erlanger Hospital and surrounding neighborhood looking north across the
Tennessee River (1941)

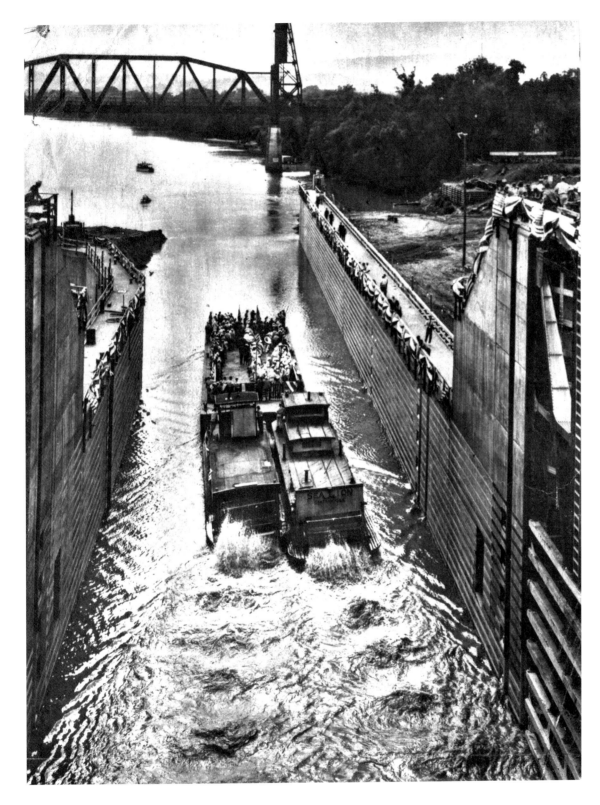

Sternwheelers head through the locks of the new Chickamauga Dam as part of the festivities celebrating completion of construction. Not only did TVA bring much-needed flood control to the river, it improved the navigability of the channel significantly. (1940)

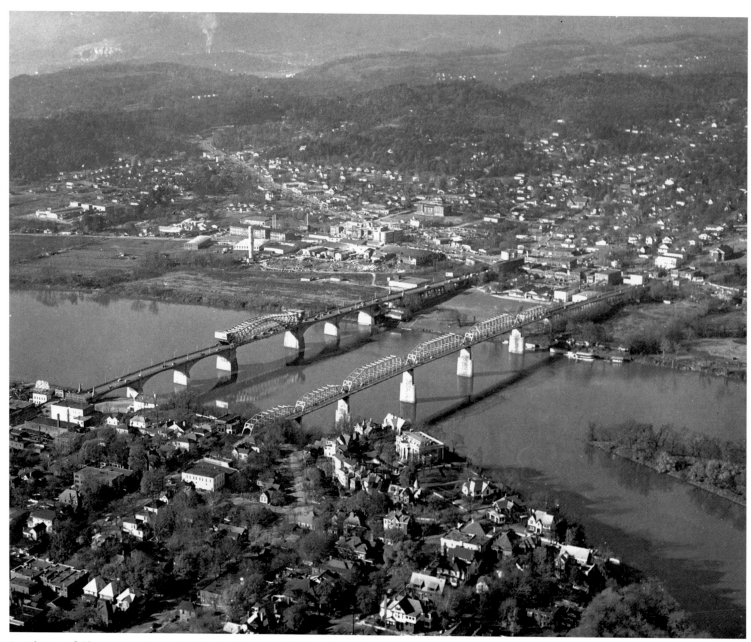

Aerial view of Chattanooga shows the Market Street and Walnut Street bridges over the Tennessee River. Finished in 1917, the Market Street Bridge (at left) is a concrete drawbridge that is now undergoing complete renovation. (ca. 1940)

The Hamilton National Bank building towers over this view of Market Street
looking north from 8th Street. Photograph by Matt L. Brown & Co. (1942)

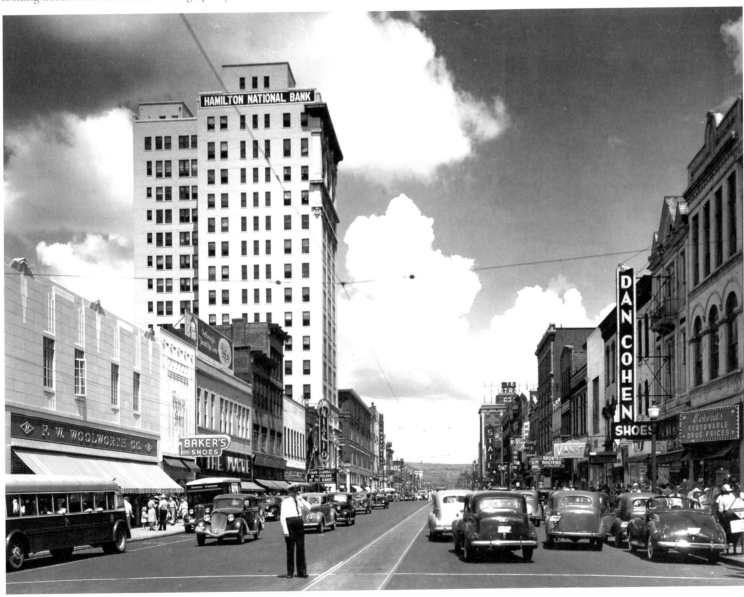

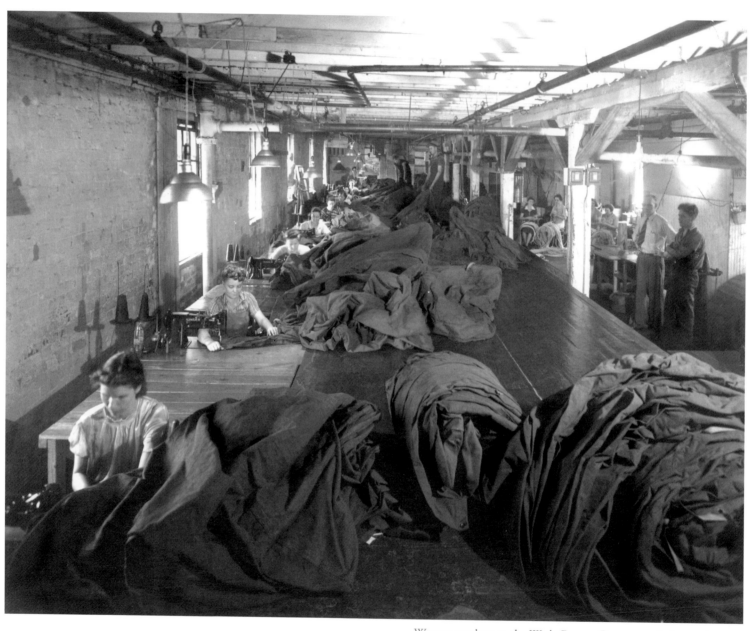

Women workers at the Wade Brown Company stitch together tent canvas as part of the industrial war effort to supply American troops fighting abroad. (ca. 1943)

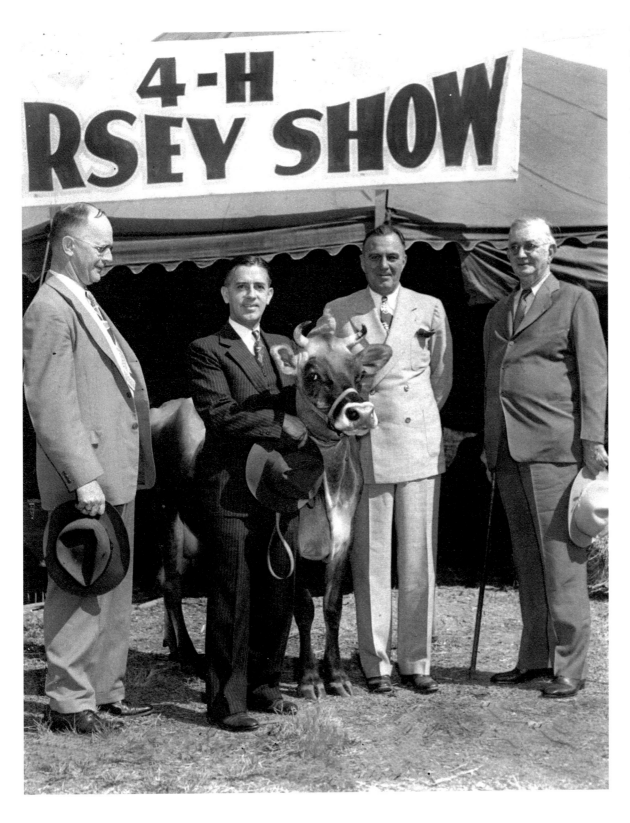

The county fair is an enduring tradition in Chattanooga as these notable people indicate. Standing with someone's prize cow are, left to right, Al Clark; Prentice Cooper, governor of Tennessee; Joe Engel, the owner of the Chattanooga Lookouts baseball club; and Ed Bass, who served as mayor of Chattanooga for twenty years—more than anyone else in the city's history. (1944)

Assembly-line work was one kind of job available to women. Three women workers at Brock Candy Company make sure these delicacies are ready for packing. (ca. 1945)

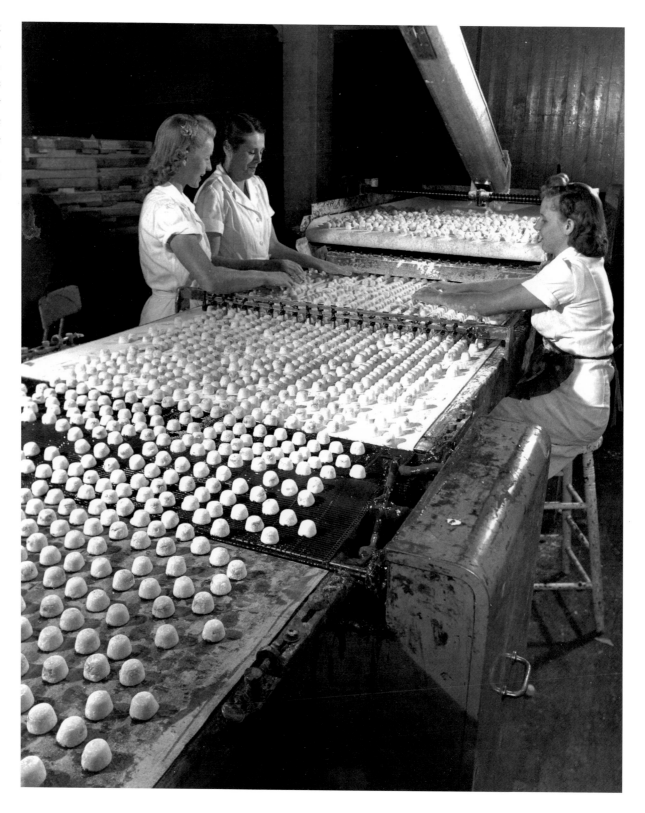

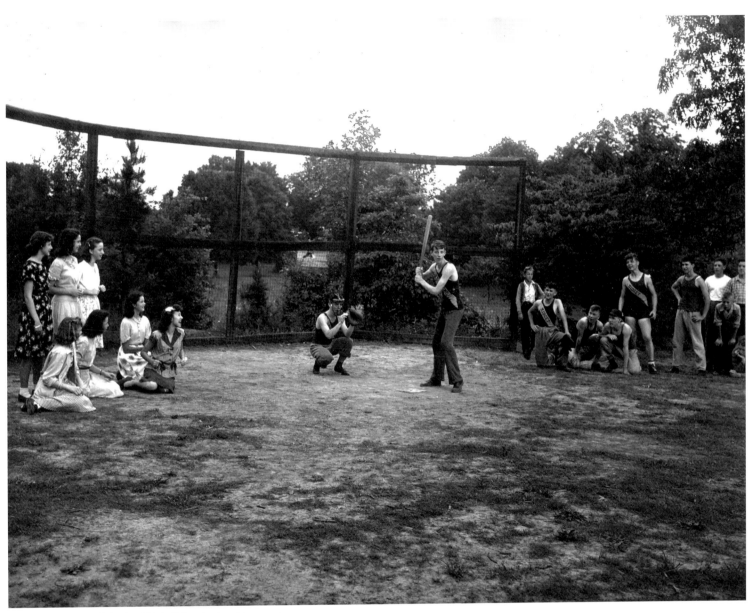

Student at Brainerd Junior High School takes his turn in
the batter's box while fellow students cheer him on from the
sidelines. (1945)

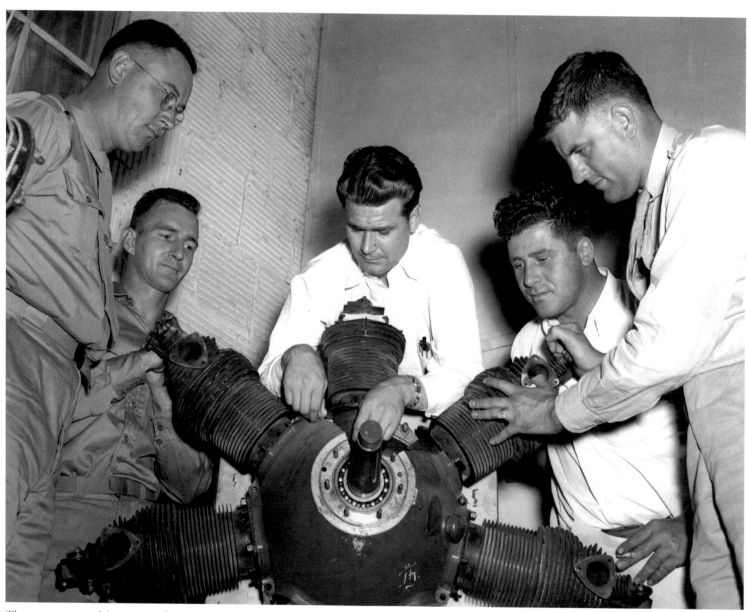

These men are studying engine dynamics at Porter's Flight School. The school,
which Harry Porter ran for more than thirty years, qualified as a certified U.S.
Army pilot training site during the Second World War. (ca. 1945)

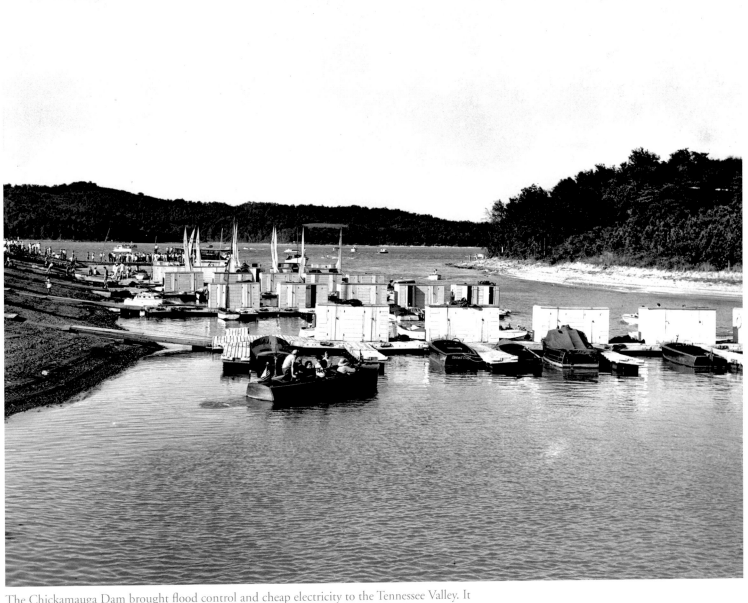

The Chickamauga Dam brought flood control and cheap electricity to the Tennessee Valley. It also created Chickamauga Lake, which has been a source of fun and recreation for more than sixty years. (September 1945)

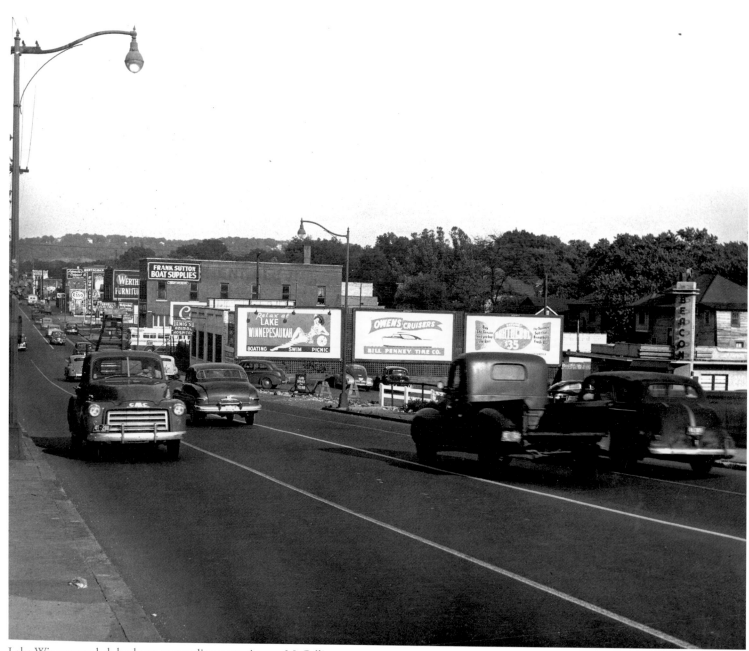

Lake Winnepesaukah beckons to speeding motorists on McCallie
Avenue. Named for one of Chattanooga's oldest families, McCallie
Avenue runs east from Georgia Avenue in downtown Chattanooga to
Missionary Ridge, which is visible in the distance. (ca. 1949)

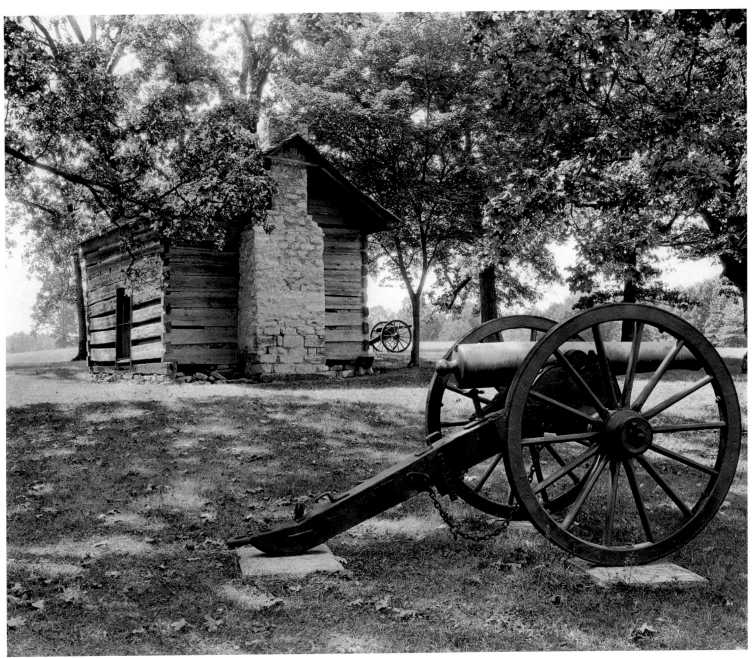

Just south of Chattanooga lies the Chickamauga battlefield, a site of fierce fighting that left the South with a stunning victory. The Brotherton house was the site of a relentless charge by Confederate General Longstreet's troops that put the Union soldiers in rapid retreat in September 1863. (ca. 1940)

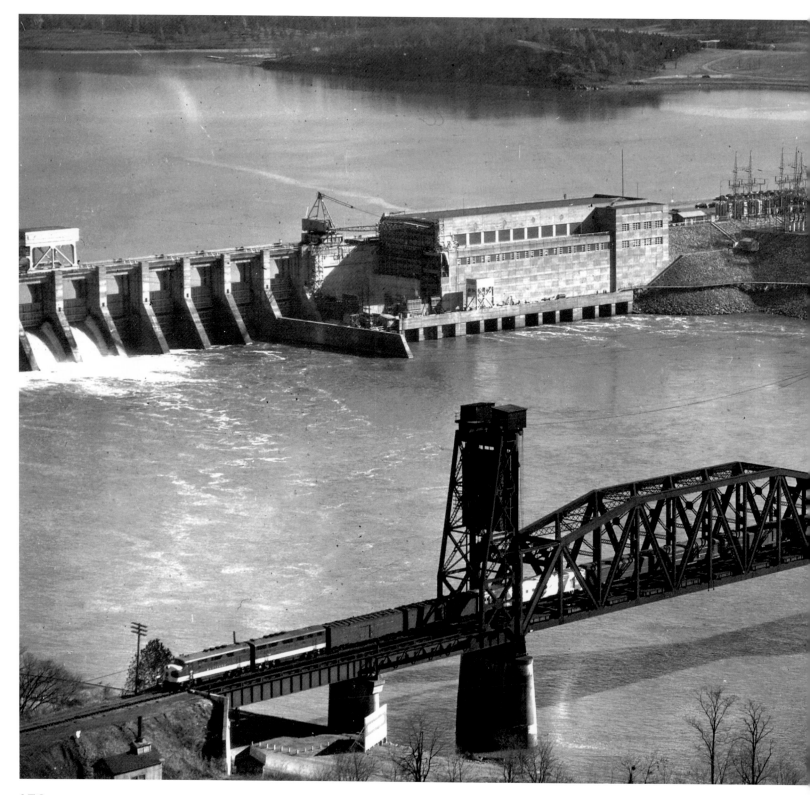

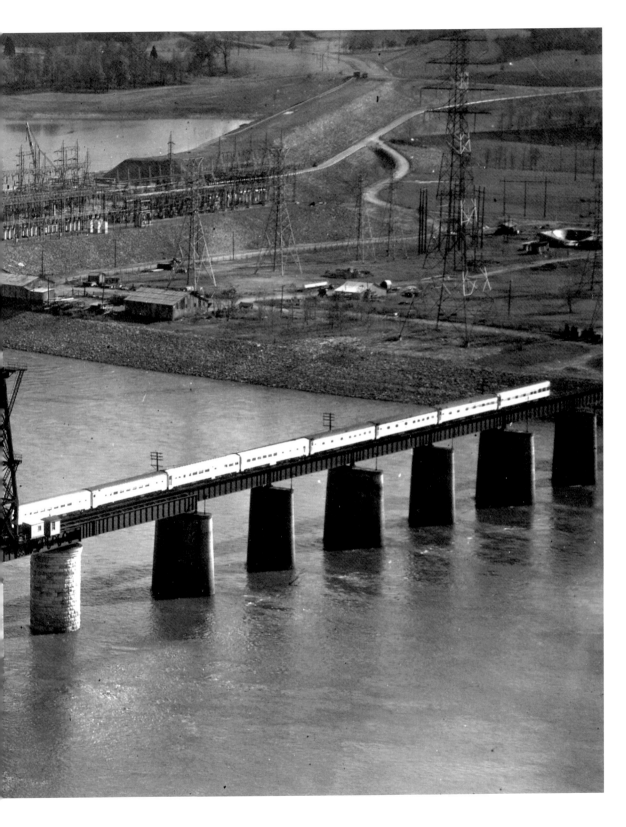

Rivers and rails are a constant theme in Chattanooga history. This aerial view shows the Cincinnati Southern Railway bridge across the Tennessee River with the Chickamauga Dam in the background. (ca. 1945)

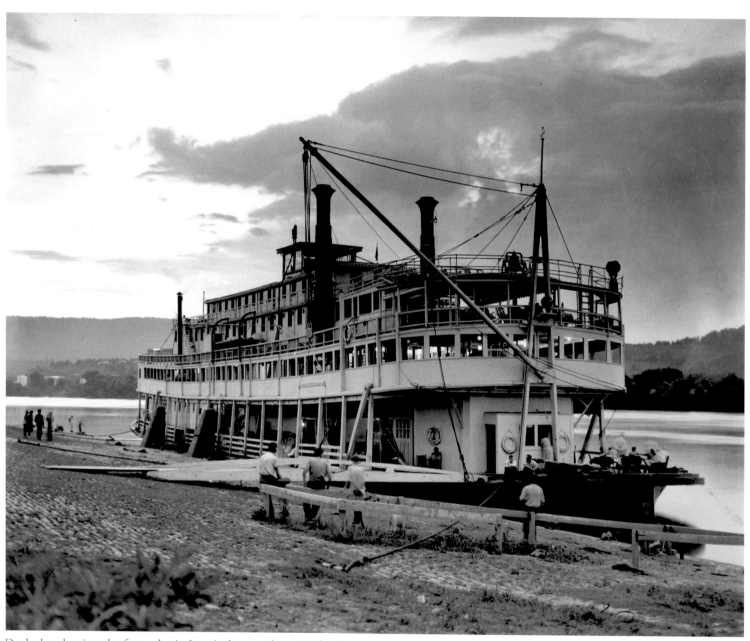

Docked at the city wharf on a day in June is the steamboat *Gordon Greene*.
Built in 1923, it was in service until it was retired in 1952. The boat then
became a floating hotel before sinking in 1964 at St. Louis. (1946)

The Chattanooga Lookouts have been the hometown professional baseball team for over a century. Here they are shown playing at Engel Stadium, their field of dreams where they featured such greats as Harmon Killebrew and Ferguson Jenkins. In 2000 they moved to their new facility, BellSouth Park, downtown overlooking the Tennessee River. (1947)

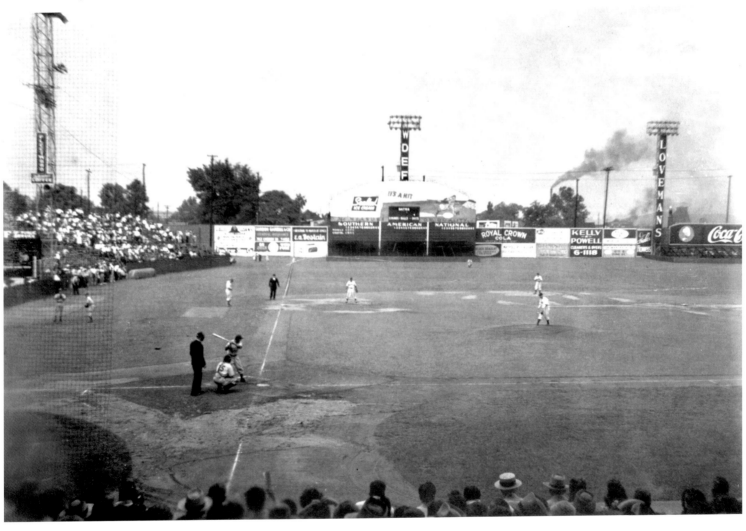

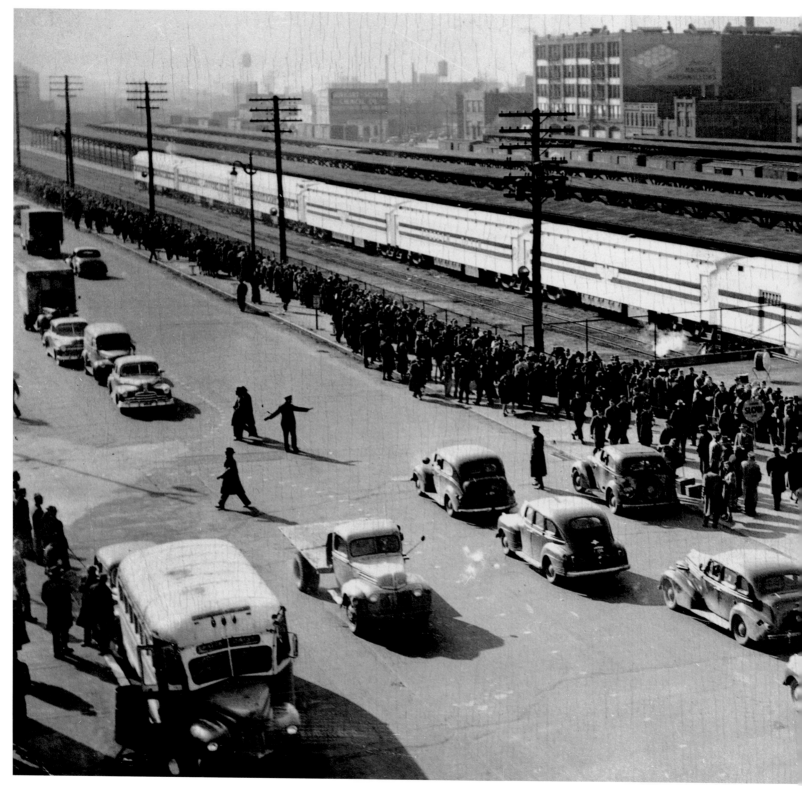

160

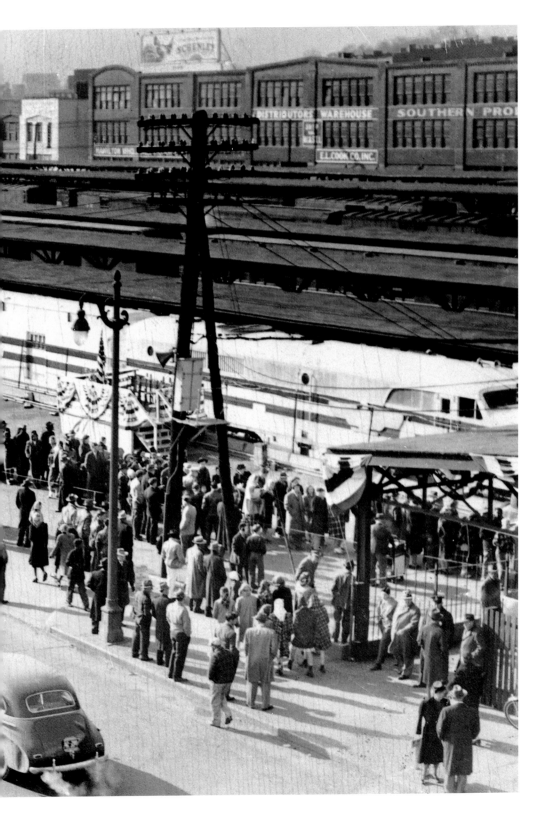

Chattanoogans line up to see the Freedom Train with its important historic documents. Some 12,000 Chattanoogans came to see the treasures, many of whom waited as long as three hours. Among the artifacts were Thomas Jefferson's draft of the Declaration of Independence and George Washington's copy of the Constitution.
(January 2, 1948)

These two students at Chattanooga High School seem to be quite pleased with their art projects. Photograph by A. Charles Hinkle Studio. (1948)

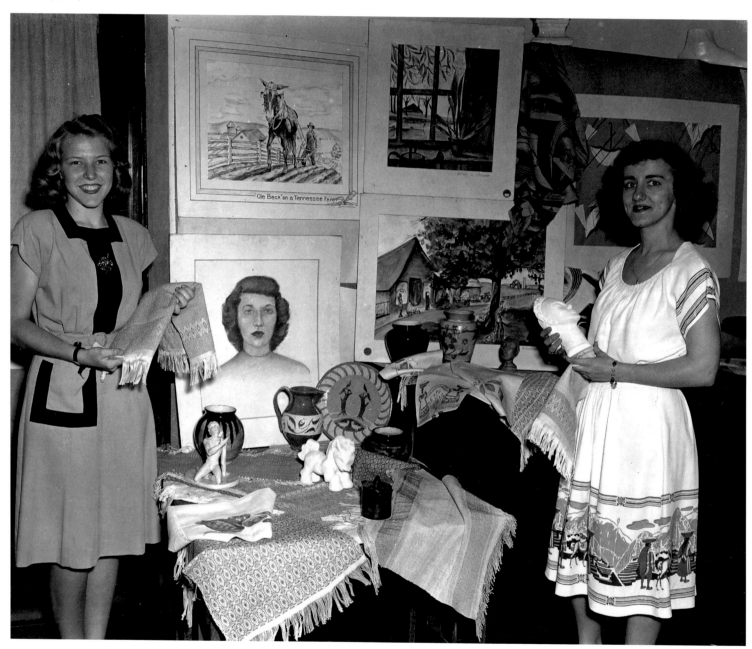

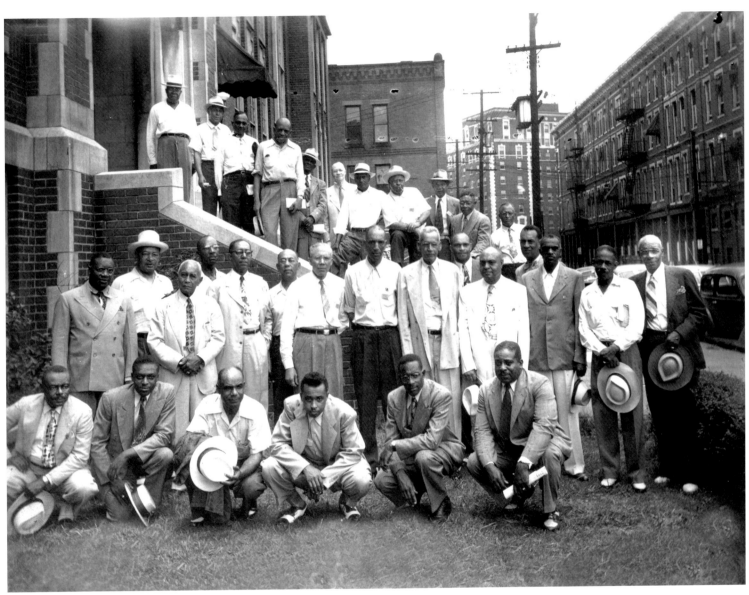

Members of the Pan-Tennessee Dental Association take time to
assemble for a group portrait at their fifteenth annual convention. A
growing class of medical professionals was vital to the African American
community in the segregated South. (1948)

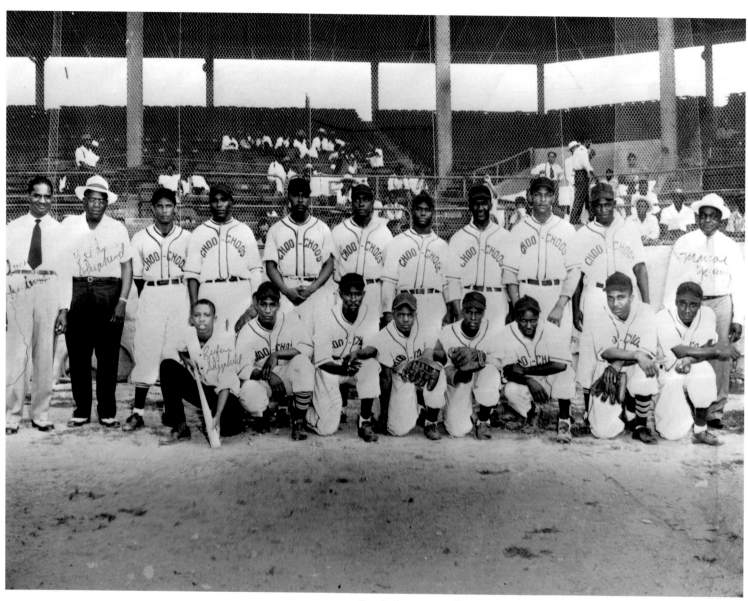

Baseball was a racially segregated sport for years and Chattanooga had its own African American team, the Chattanooga Choo-Choos. In the center of the front row of this photograph kneels a young player named Willie Mays, who would someday join the Baseball Hall of Fame as one of the great center fielders. (1947)

Dedication of the Alexander Hamilton plaque at the Hamilton County Courthouse in Chattanooga. Present are members of the Central High School color guard. Judge Wilkes T. Thrasher accepts the marker on this occasion. (November 2, 1949)

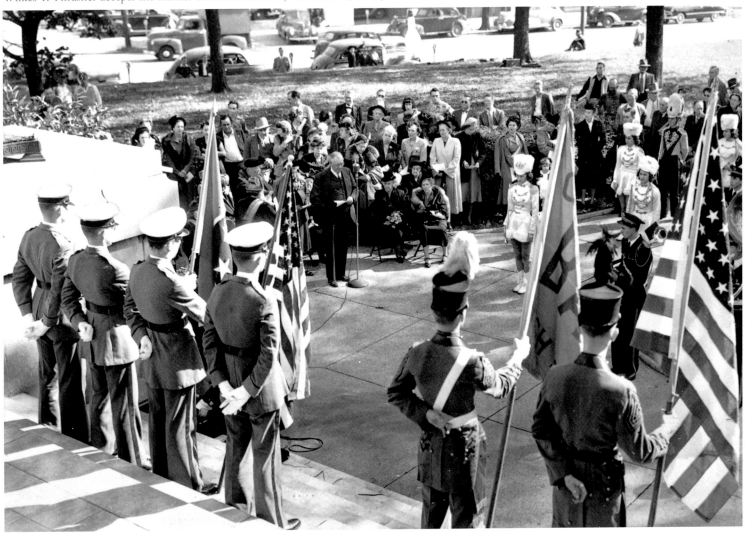

Members of the
Chattanooga Fire
Department and several
dignitaries display the new
Hugh P. Wasson aerial
ladder and fire truck in front
of City Hall. (August 25,
1949)

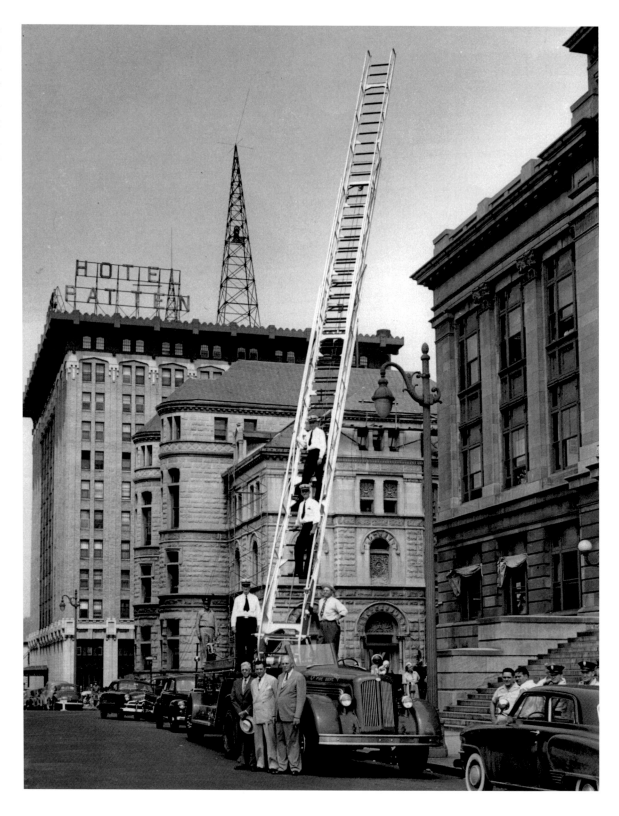

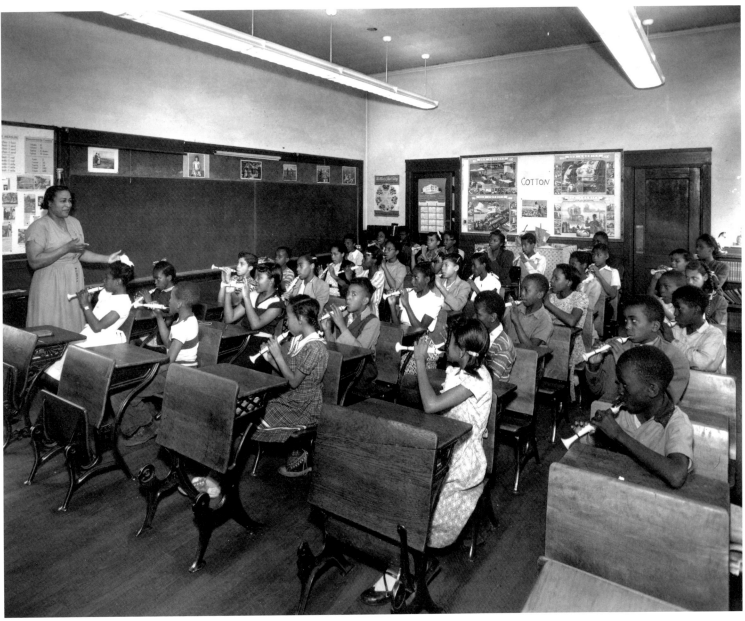

Sixth-grade students at Calvin Donaldson Elementary School practice
their scales using flutophones. (1950)

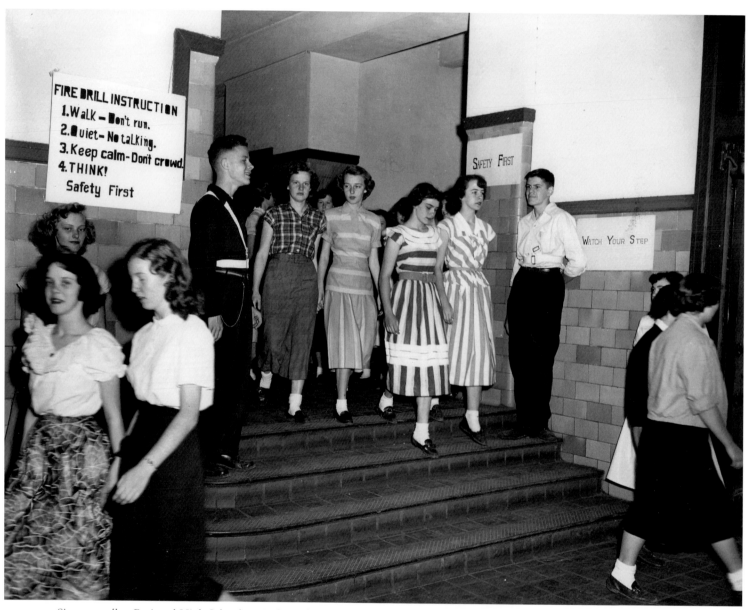

Sign on wall at Brainerd High School reminds students to "walk – don't run" as fire drill is carried out in orderly fashion. (1951)

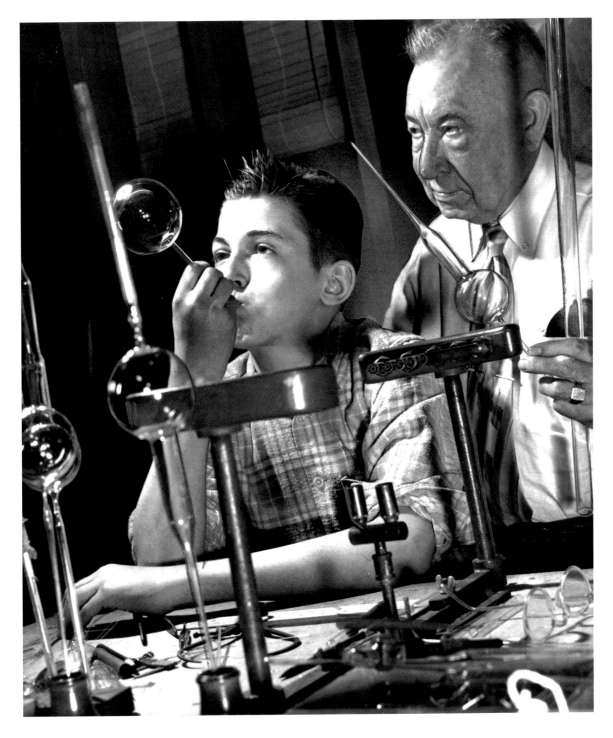

Young student tries his hand at the fine art of glass blowing under the guidance of artisan Ben Randolph. (ca. 1951)

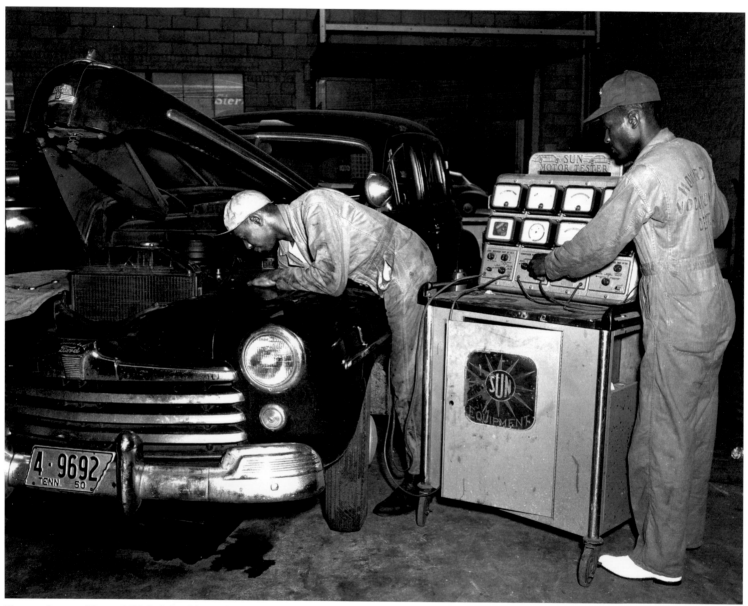

Two students at Howard High School hone their auto mechanic skills in vocational class. The school has its origins in the Howard Free School, which was begun in 1865 after the Civil War. Still in operation today, the school was named for General Oliver O. Howard, commissioner of Freedman's Bureau. (1950)

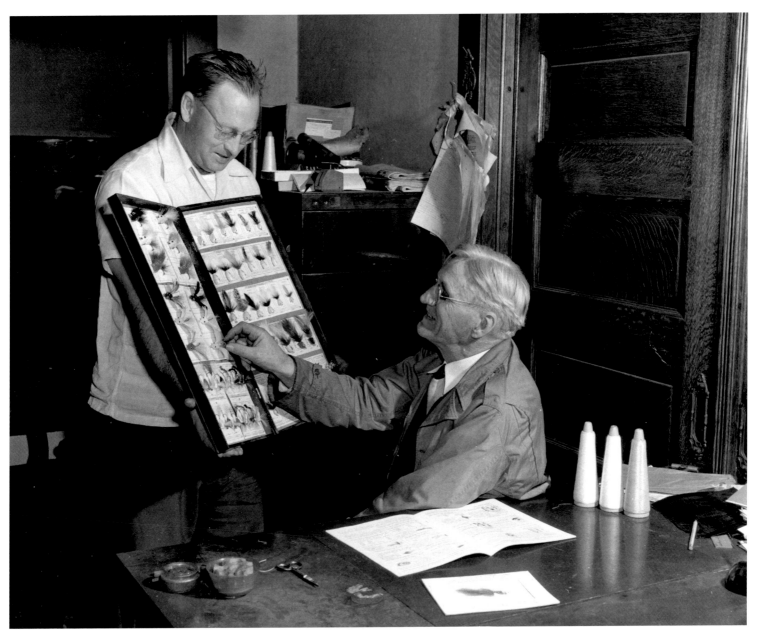

John F. Peckinpaugh and his father, Ernest H. Peckinpaugh (seated), examine some of the fishing flies they have manufactured since the 1920s. Ernest created his first cork-bodied lure in 1906, and later patented the well-known "popping bug" in 1928. (April 1950)

Nine legionnaires at the National Cemetery prepare to leave for a convention in Los Angeles in a replica of the train the *General*. The model was built by Fassnacht and Sons in 1938. Note smaller version of train on the Andrews' Raiders monument in background. Photograph by John Goforth (September 29, 1950)

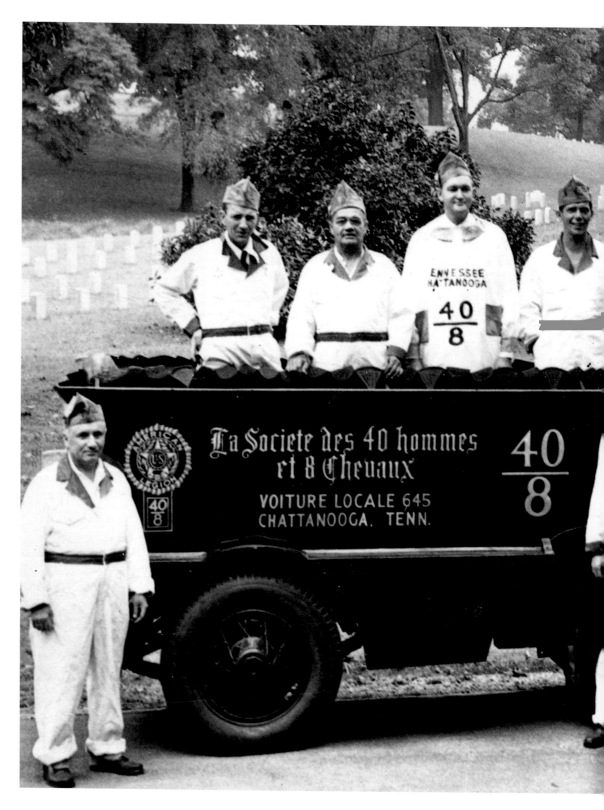

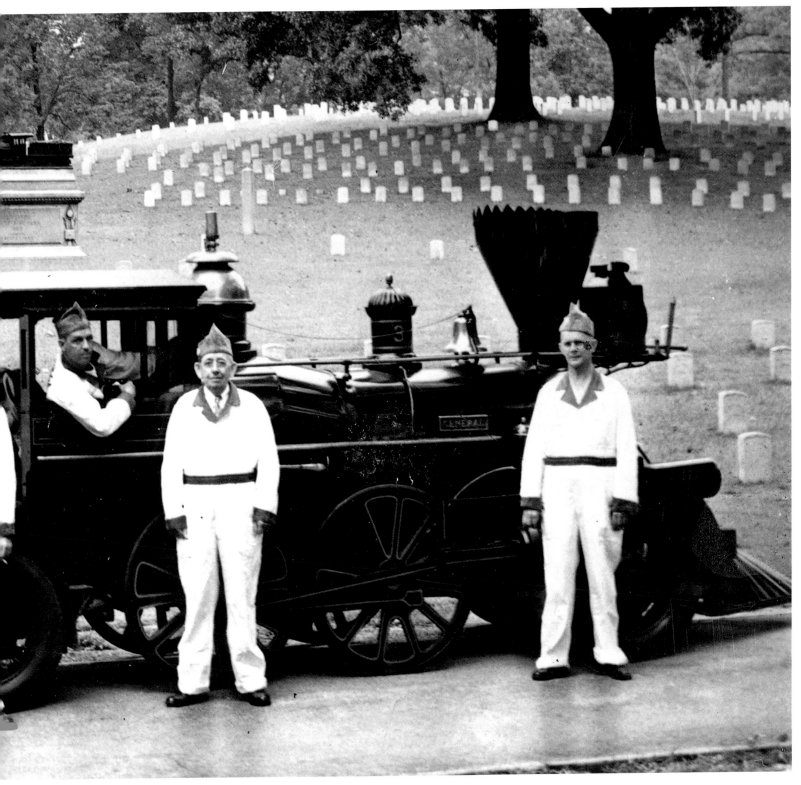

Photographers gather around model on sunny day. Variety of cameras—
35mm rangefinder, 2 ¼, and 4x5 Speed Graphic—suggest this is a
camera club outing. (ca. 1948)

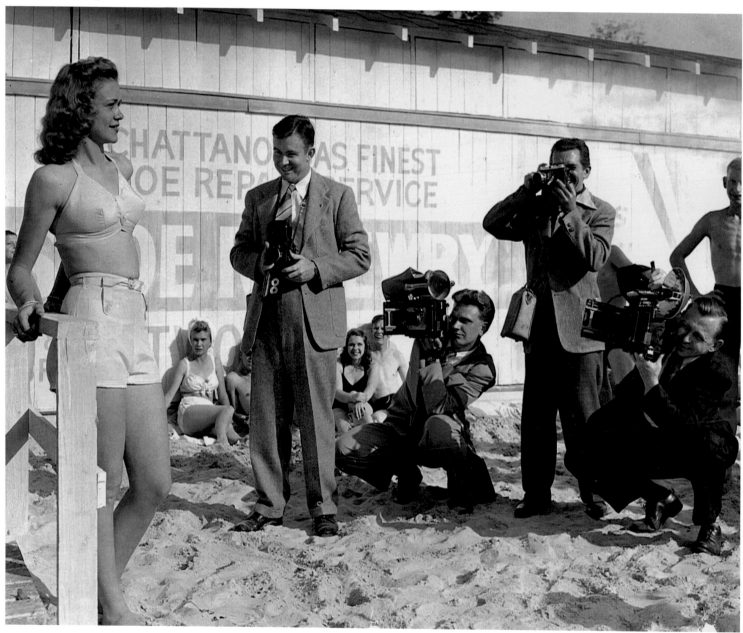

Two Southern belles pose before fluted columns patiently waiting for the photographer to make the perfect exposure. Photograph attributed to Bob Sherill (ca. 1948)

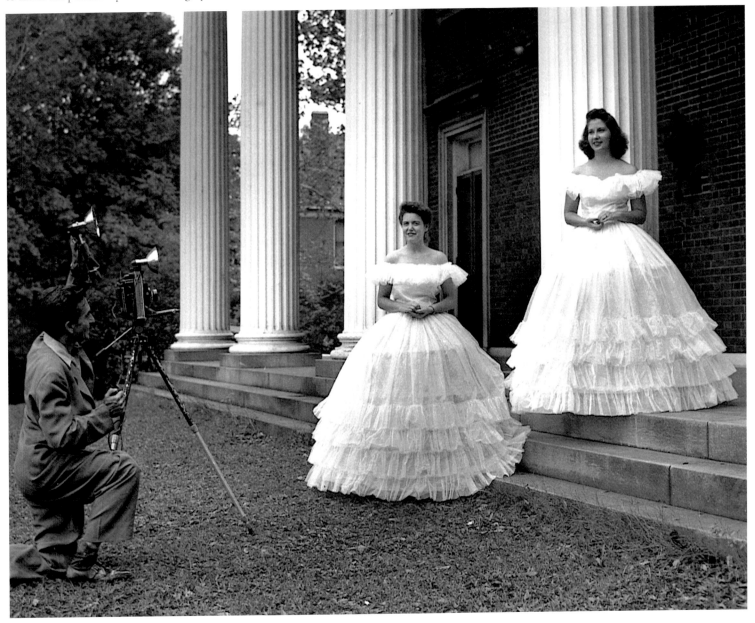

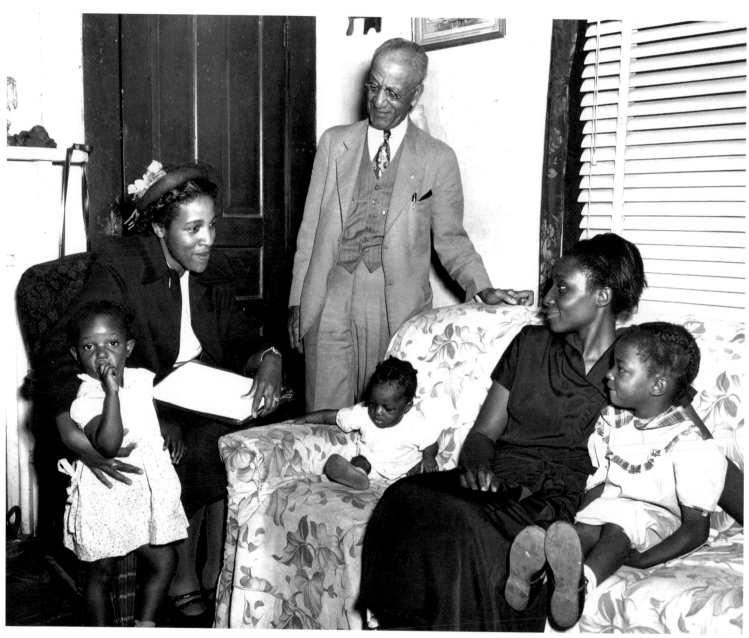

Teacher adds personal touch by making a home visit to young family in the community. Form on her lap indicates she may be gathering information for the school. (1951)

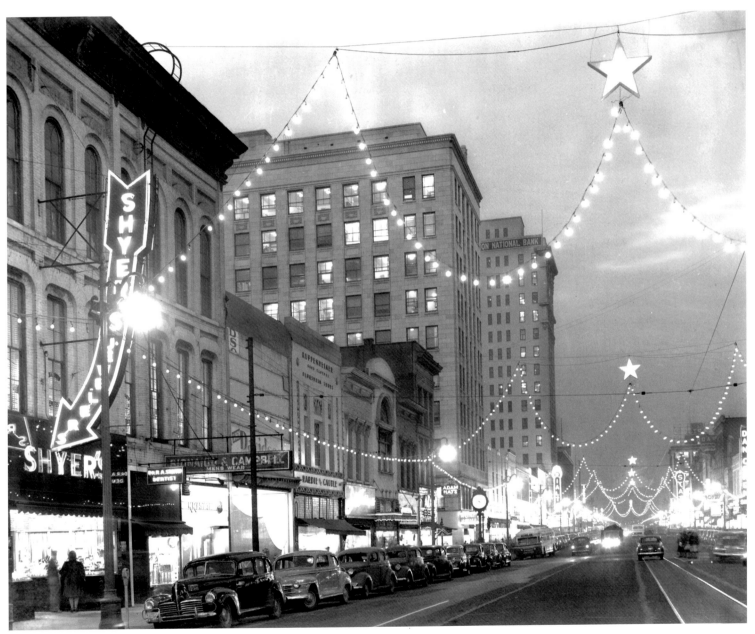

Christmas lights set Market Street aglow on a winter night. Before the advent of shopping malls, downtown stores were the place to do holiday shopping. Photograph by Roy Tuley. (ca. 1950)

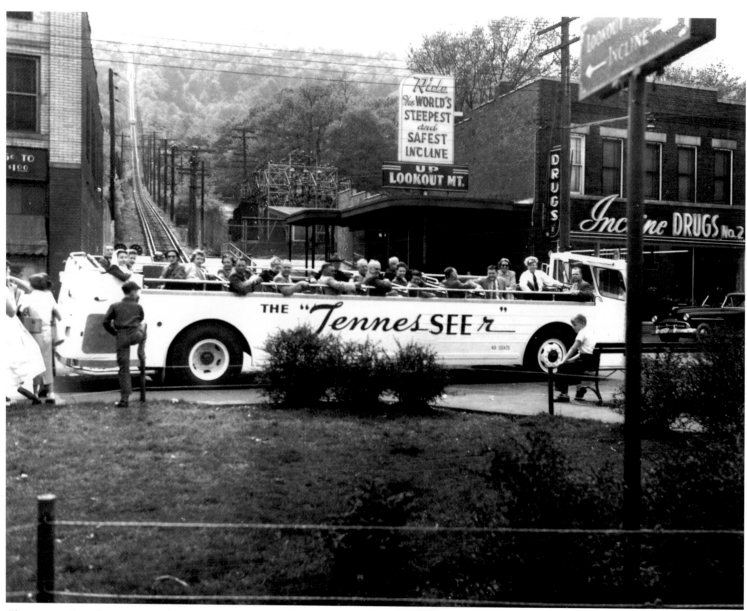

Chattanooga has always attracted tourists, and seeing the sights
in a roofless bus was a popular pastime in the 1950s. The vehicle,
"the TennesSEEr," sits in front of the perpetually popular Lookout
Mountain Incline, built in 1895 and billed as "America's Most Amazing
Mile," because of its steep grade. (April 18, 1952)

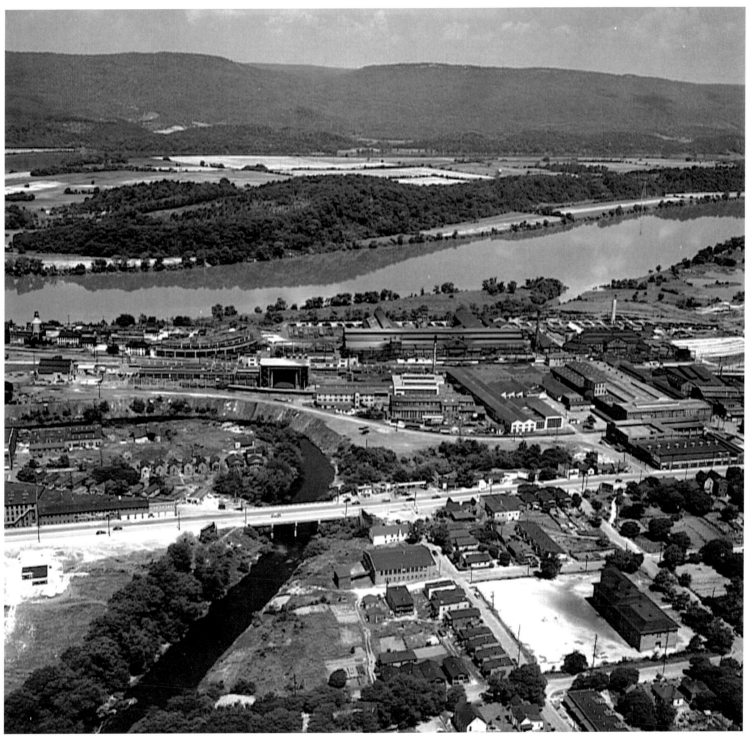

Aerial view of the Wheland Company and U.S. Pipe and Foundry operations on South Broad Street. Wheland, a business established in the 1870s, closed permanently in 2002. (ca. 1952)

Two workers operate buckets to pour molten iron into molds at the Wheland Foundry. In an era when the South was segregated and many jobs were closed to blacks, factory work provided African Americans with a steady income. (ca. 1952)

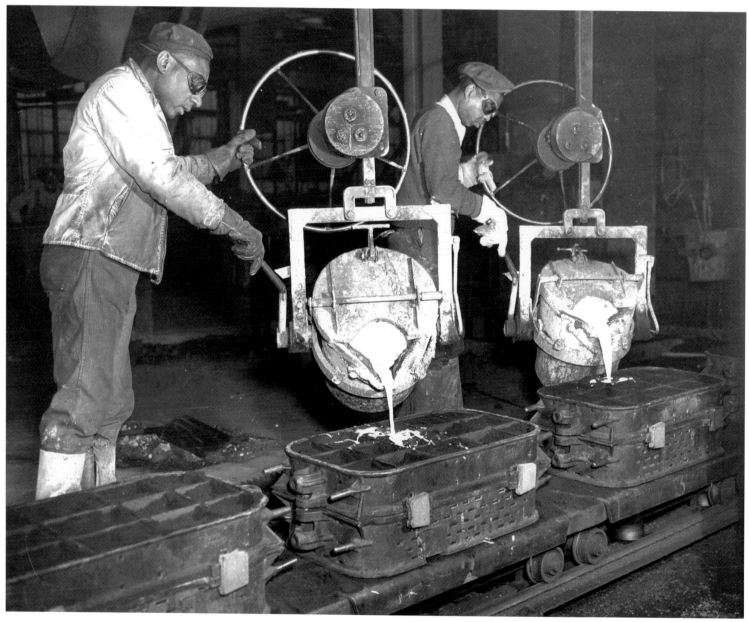

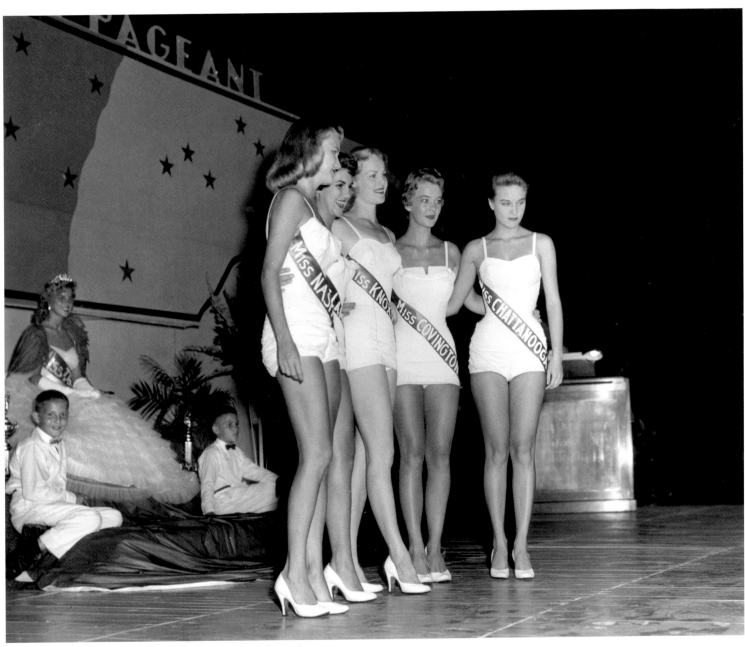

Chattanooga beauty Marilyn Harris (far right), and four other contestants pose
for judges at the Miss Tennessee Pageant in Madison County. (July 1955)

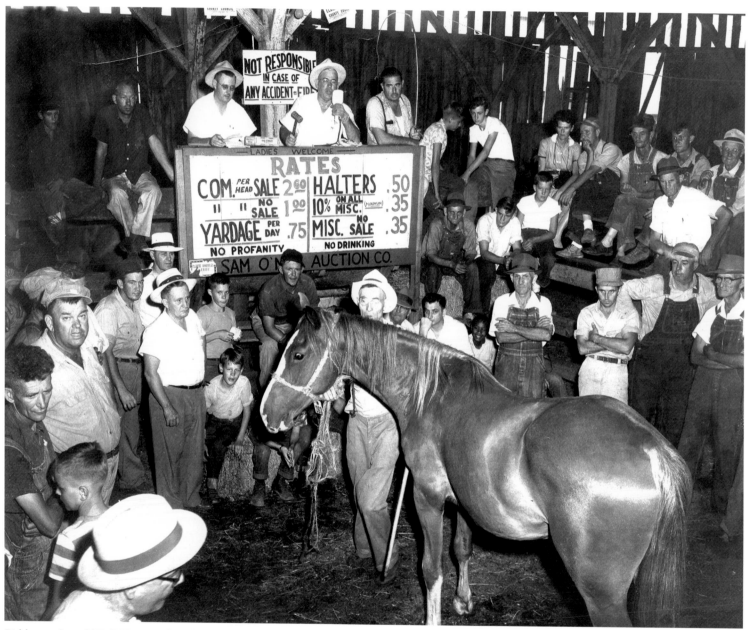

Bidders at Sam O'Neil Horse and Mule Barn in St. Elmo eye the horseflesh on display as the auctioneer entices buyers to bid. Sign below the podium reads "No profanity / No drinking." (ca. 1955)

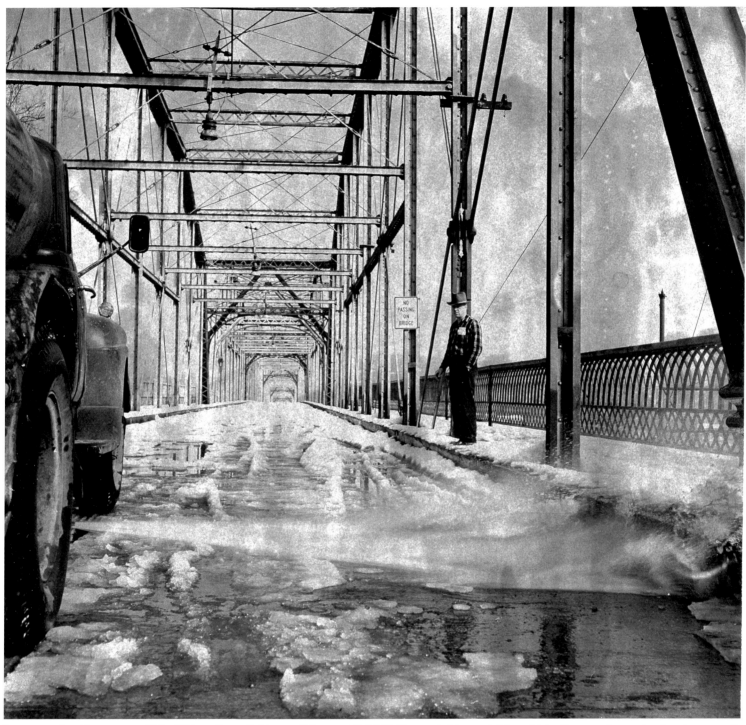

A street washer blows snow off the Walnut Street Bridge on February 17, 1960. Sign on bridge prohibits vehicles from passing each other, because of the narrow width of the roadbed. James Templeton of the Public Works Department stands to the right. Photograph by J. B. Collins

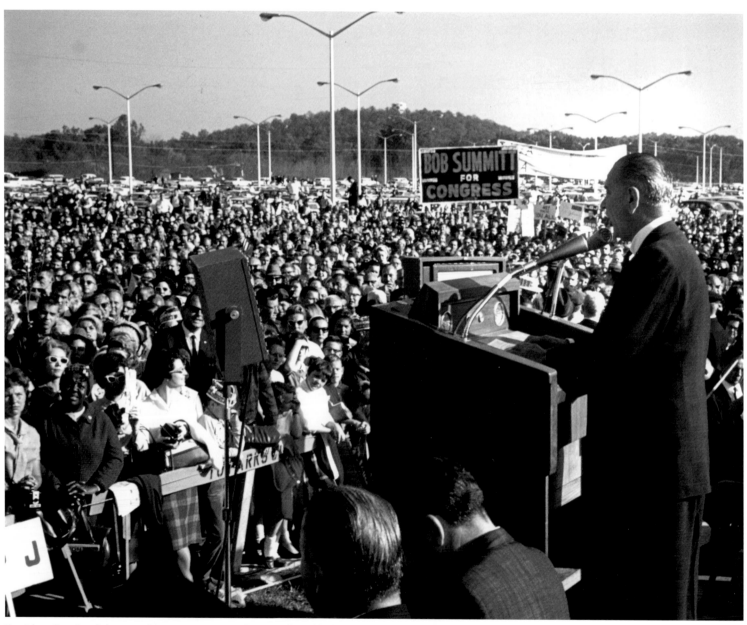

President Lyndon Johnson addresses a rapt crowd at Lovell Field, during
a presidential campaign visit in October 1964. Johnson was elected
in a landslide over Republican Barry Goldwater, carrying the state of
Tennessee comfortably. Photograph by W. C. King (1964)

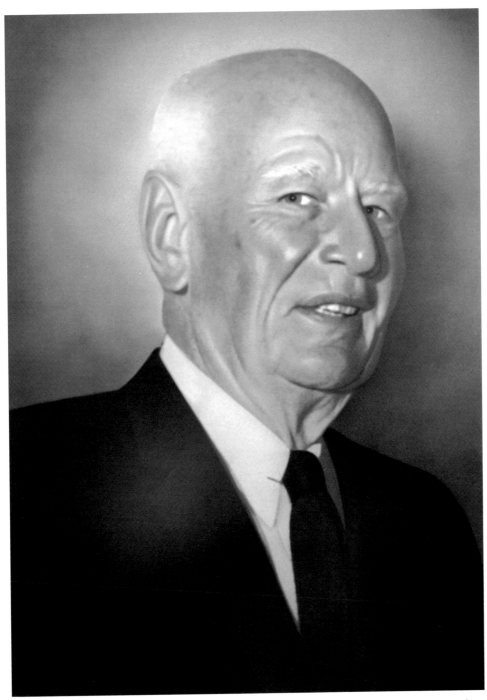

Attorney Burkett Miller, one of Chattanooga's earliest and most active entrepreneurs and philanthropists. In 1923 he and his brother, Vaughn Miller, joined with F. Linton Martin to form Miller & Martin, a firm that today operates out of Chattanooga, Atlanta, and Nashville with more than 170 attorneys and 40 practice groups.

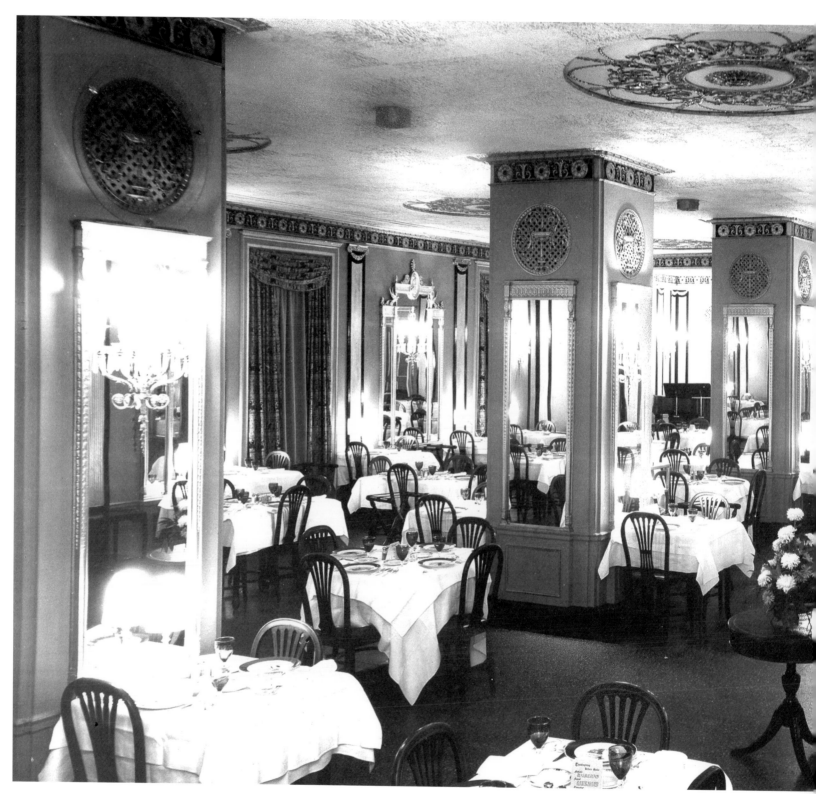

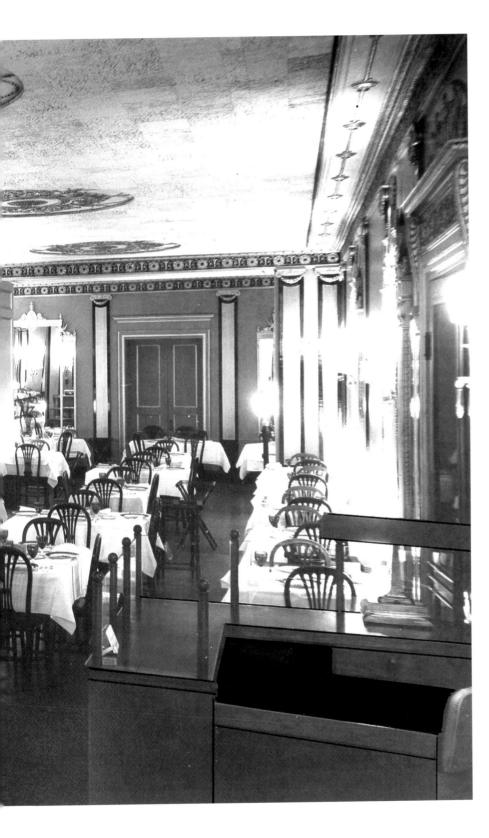

Gracious Southern dining was the hallmark of the Green Room at the Read House. Dinners were often accompanied by live music. Unfortunately, the Green Room was closed in 2004 when the hotel was renovated. (ca. 1968)

Tourists cross the "Swinging Bridge" at Rock City Gardens on Lookout Mountain. This fascinating group of natural rock formations was turned into a famous attraction in 1932 by Garnet and Frieda Carter. (1967)

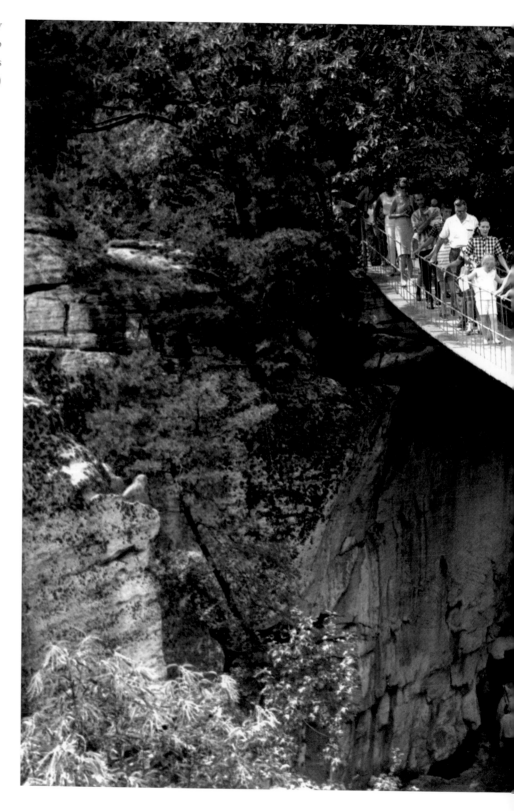

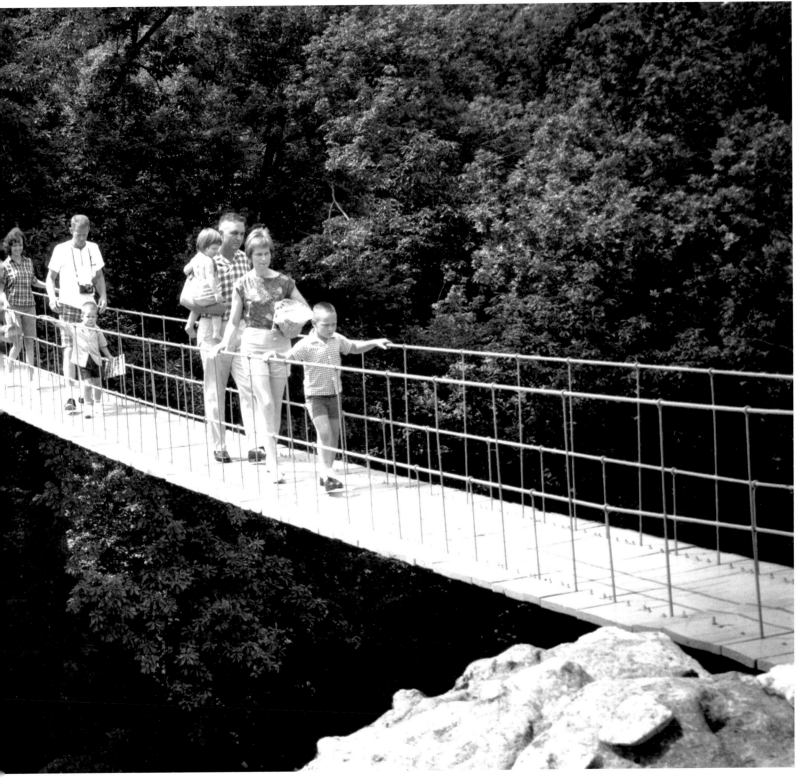

189

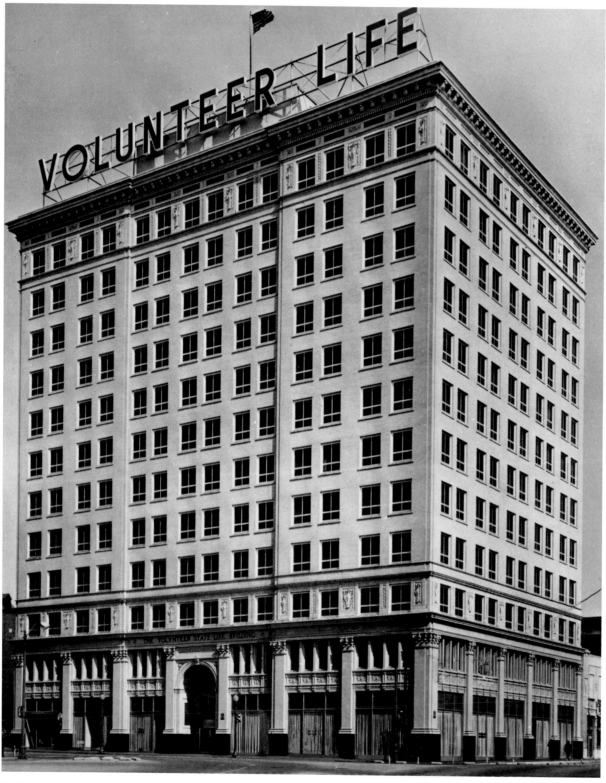

The Volunteer State Life Insurance Building was constructed in 1917. Also referred to as the Volunteer Building, this Neoclassical edifice on Georgia Avenue publicized its name by placing the sign on top of the roof in 1964. (ca. 1966)

NOTES ON THE PHOTOGRAPHS

These notes, listed by page number, attempt to include all aspects known of the photographs. Each of the photographs is identified by the page number, photograph's title or description, photographer and collection, archive, and call or box number when applicable. Although every attempt was made to collect all available data, in some cases complete data was unavailable due to the age and condition of some of the photographs a nd records.

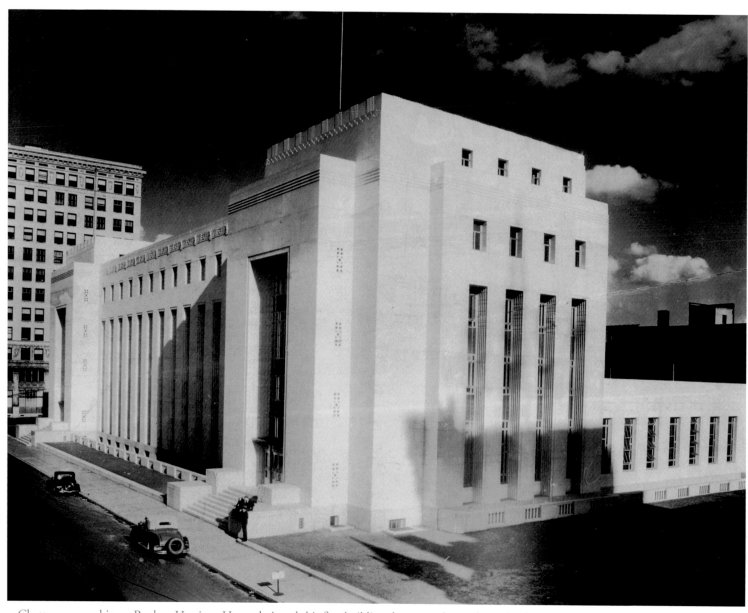

Chattanooga architect, Reuben Harrison Hunt, designed this fine building, known today as the Joel Solomon Federal Building. Finished in 1933 with an exterior of Georgia white marble and featuring impressive aluminum grillwork, the building contains a post office and federal courthouse. The interior includes a WPA mural as well as a courtroom that is trimmed out in myrtle. (1935)